The Object as Subject

The Object as Subject

STUDIES IN THE INTERPRETATION
OF STILL LIFE

Edited by Anne W. Lowenthal

PRINCETON UNIVERSITY PRESS

PRINCETON, NEW JERSEY

Copyright © 1996 by Princeton University Press
Published by Princeton University Press, 41 William Street,
Princeton, New Jersey 08540
In the United Kingdom: Princeton University Press, Chichester, West Sussex

Library of Congress Cataloging-in-Publication Data

The object as subject : studies in the interpretation of still life /
 edited by Anne W. Lowenthal.
 p. cm.
 Includes bibliographical references and index.
 ISBN 0-691-03354-4
 1. Still life in art. 2. Art. I. Lowenthal, Anne W.
N8251.S3025 1996
704.9'435—dc20 95-45798 CIP

This book has been composed in Linotronic Sabon
by The Composing Room of Michigan, Inc.

Princeton University Press books are printed on acid-free paper
and meet the guidelines for permanence and durability of the
Committee on Production Guidelines for Book Longevity
of the Council on Library Resources

Printed in the United States of America by Princeton Academic Press,
Lawrenceville, New Jersey

10 9 8 7 6 5 4 3 2 1

Contents

List of Illustrations

The Object as Subject

Introduction

> The appeal and power of still life, like chamber music, lie not only in its comprehensible scale, but in the fact that extraneous details are stripped away and what is left speaks to the responsive eye, simply and directly, of matters large and small. Of what do still lifes speak? Of relationships—connections, reflections, support, power, balance; of cause and effect; of things that have happened and will happen; of taste, touch, and smell; of man and nature; of markets and appetites and genetics and diet; of time, mortality, and regeneration. If we are to understand what a still life signifies, we must attend closely.
>
> —Jules David Prown, on Raphaelle Peale's
> *Fruit in a Silver Basket*

EACH of the six authors contributing to this collection has turned a responsive eye to still life, seeking among the depicted objects and their relationships clues to the kinds of significance Prown suggests.[1] This would seem to be an obvious, even trite, approach to interpreting a genre whose origins lie in antiquity, but in fact its potential has been inadequately explored. Indeed, still life itself has only recently been rescued from the margins of Western art, the last of the so-called lesser genres to enjoy the critical attention once reserved for history painting. As with any genre, the interpretive issues concerning still life are shaped not only by form and content but by the interaction between image and viewer as well. Thus, it is not surprising that recent interest has generated new methodological problems. Can the methods used for interpreting other genres simply be transferred to still life, or are distinctive and innovative approaches in order? The studies in this volume present a range of current possibilities, from Reindert Falkenburg's reconstruction of sixteenth-century Netherlandish diets to Nan Freeman's exploration of consumerism in twentieth-century America.

The scope is chronologically and geographically wide. Moreover, the discussions encompass the media of painting, graphics, the applied arts, book illustration, sculpture, and photography. Yet these essays are united by their primary focus on two-dimensional art and, more important, by

3

the common theme articulated in the title, *The Object as Subject*.[2] That is, they all explore the implications of the things—foodstuffs, tablewares, plaster statuettes, books—that form the subjects of the images. While building on our curiosity about and empathy with objects—the very stuff of everyday life—the writers enhance understanding of the objects themselves, the images in which they figure, and the minds and cultures that produced both. Because we can relate on such an intimate level to the objects in a still life, such images can touch us, even across centuries, with a special immediacy. While in this respect still lifes communicate as "simply and directly" to us as they did to viewers of past times, our experience can be enriched by the historian's efforts to recover the meanings and associations that objects had for the artist and the intended audience.

That search presents special challenges. The first is identifying an object accurately, not an easy task, since its two-dimensionality obviates picking it up and examining it at firsthand. Heft, surface texture, maker's marks, structural details—all those useful clues to origin and character are inaccessible. Making the most of whatever visual clues are provided, we can ask where and when was the thing made or grown? Was it produced locally or imported? Other questions follow: How and to whom was it marketed? What private resonance might it have held for the artist who depicted it or a patron who commissioned its representation? What broad cultural significance might it have had? Depicted objects also raise questions of working method and technique. How did artists gain access to the things, sometimes precious or perishable, that they depicted? What is the relationship between the object and the technique used to depict it?

In framing answers to such questions, the authors of these studies employ a range of methods that exemplifies current options. The essays are presented in a chronological order determined by the subject matter. Falkenburg's article on Pieter Aertsen's market scenes concerns proto-still lifes, precursors in the Netherlands of the independent still life that would soon spring up all over Europe. Although Aertsen's paintings are not still lifes proper, they announce the interpretive issues of still life and thus inform the history of the genre. Assessing how accurately Aertsen's displays of superabundant food reflect sixteenth-century eating habits, Falkenburg uses external checks: literary sources, such as cookbooks and herbals, and paleo-ethnobotanical research, which makes it possible to reconstruct diets of the past. He interprets his findings with the help of Erasmian rhetoric. In my essay, I discuss the origins and functions of the components of Willem Kalf's *Still Life with a Nautilus Cup* (Fundación Colección Thyssen-Bornemisza, Madrid; fig. 16; pl. II). Conjoining icon-

ographic and visual analysis with social history, I argue for a pictorial strategy that invites the viewer to participate in making interpretive choices. Julia Ballerini considers the implications of small plaster reproductions in the still lifes of three inventors of photography. She sees the mania for reproductive statuettes in the mid-nineteenth century as manifesting a search for cultural heritage at a time of rapid sociopolitical change. Ballerini argues that photographers' choices of objects and compositions were not only pragmatic but also self-revealing. Analysis of photographic techniques, biographical data, literature, and sociopolitical history supports her conclusions. Doreen Bolger uses such resources as archival records and technical examinations to devise a new interpretation of John Peto's early rack paintings as inventions designed to attract purchasers rather than faithful representations of existing models that referred to specific patrons. In doing so, she explores the counterpoint between Peto and his friend and artistic competitor William Harnett. Bolger finds that the early works, like Peto's late ones, contain self-reflexive elements. Petra ten-Doesschate Chu proposes a multilayered reading of Vincent van Gogh's still lifes, using as a model epigrammatic illustrations at the beginning and end of texts in nineteenth-century novels and collections of poetry. She relates the nearly fetishistic character of Van Gogh's objects to the cult of the Romantic hero and shows that such personal localization in inanimate objects was also important in the vignette tradition. Nan Freeman's study of Tom Wesselmann's *Still Life #30* (Museum of Modern Art, New York; fig. 83; pl. V) exposes the components of post–World War II American culture and the values and processes that brought them into being. The new consumerism emerges as a major and consciously cultivated mode of behavior. Freeman shares with Falkenburg an interest in the theme of consumption—dietary, economic, and aesthetic—that spans centuries and cultures and effectively brackets this collection of essays.

We make no claims to having devised a novel approach to still life. As early as 1968, Meyer Schapiro published a study that would have been appropriate for this book, "The Apples of Cézanne: An Essay on the Meaning of Still Life."[3] Characteristically, Schapiro turned to such richly diverse sources as Cézanne's life, ancient myth, classical and Renaissance poetry, Zola's novels, and Freudian theory as well as works by Cézanne and others, as he explored "the emotional ground" of the artist's frequent depiction of apples. Whereas other writers had regarded that choice of subject matter as insignificant, merely a pretext for the exploration of form, Schapiro found in Cézanne's apples a subject resonant with

personal and mythic meaning, expressions of eros sublimated by sober, objective study and aesthetic transformation. Schapiro accepted Cézanne's still lifes as major works of art, exploring their meaning with a nuance and depth unusual for the time.

Despite the complexity and range of our six essays, they only sample the cornucopia of still life. Several "golden ages" of the genre—the seventeenth century in Spain, to name only one—are unrepresented. We have not, however, attempted a survey; rather we offer options that can be used across chronological and geographical boundaries. The methods employed here open up a realm of possibilities for interpreting the genre. Falkenburg's approach might be productively applied to food still lifes of other times and places. In view of the importance of conventional groupings of objects in Kalf's and other Dutch still life, we should consider whether we have underestimated the significance of pictorial conventions as bearers of meaning in other seemingly "realistic" images. Ballerini, Bolger, and Chu variously explore artists' choices of particular objects, exploring deep strata of personal significance in ways that have broad applicability. Freeman's wide-ranging discussion demonstrates how still-life objects can be treated as artifacts of material culture.

Given our emphasis on objects, the primary data of material culture, that discipline might offer an especially useful approach to the problems of still life. "Material culture is the study through artifacts of the beliefs—values, ideas, attitudes, and assumptions—of a particular community or society at a given time."[4] We have, indeed, used artifacts, as well as natural objects, which are excluded from material culture, to study such beliefs. Our primary data are paintings and photographs, which are objects of material culture, and we have focused on another level of experience as well, *represented* artifacts. We view the latter, however, through the scrim of depiction, and no matter how much one discovers about an object in a still life—its physical properties, origin, or use—its meaning is affected by the form and content of the image. Connotations that arise from combined objects can, for example, imbue them with multivalent significance, which might have little to do with an object's actual function in daily life. Moreover, a still life is a gestalt, its character shaped by the artist's conception, which is inevitably more complex than the sum of individual meanings. Thus, the methods of material culture are necessary but insufficient for interpreting the work of art as a whole.

The term "still life" came into use only around 1650, when it appeared as *still-leven* in Dutch inventories, describing a painting of a motionless model.[5] The term has come to encompass a wide spectrum of images,

from the classic laden table tops of artists like Kalf to the trompes l'oeil of Peto and Harnett. Wesselmann teases by entitling a kitchen interior *Still Life #30*. Aertsen's paintings and some early photographic still lifes include prominent figures, absent in pure still life. Human presence is, however, at the very least implicit in any still life, even in a crumpled napkin that retains a gesture. A lute connotes the musician, a book the writer or scholar. However subtle, human presence is akin to other active forces in "still" life's interplay between the animate and the inanimate, the moving and the motionless, the quick and the dead. Articulating such issues brings the multiple facets of the genre to the fore. Its diversity is a reminder that "still life" is a construct, which, like all constructs, has a certain elasticity that allows for shifting emphases.

By the mid-seventeenth century, depictions of ordinary things were well established in Western art but remained on its periphery. Still life had been relegated to this place as early as the first century, when Pliny the Elder discussed Greek artists "famous with the brush in a minor style of painting":

> Among these was Piraeicus, to be ranked below few painters in skill; it is possible that he won distinction by his choice of subjects, inasmuch as although adopting a humble line he attained in that field the height of glory. He painted barbers' shops and cobblers' stalls, asses, viands and the like, consequently receiving a Greek name meaning "painter of sordid subjects"; in these however he gives exquisite pleasure, and indeed they fetched bigger prices than the largest works of many masters.[6]

As we shall see, Pliny's combination of praise and deprecation would come to typify later critical assessments.

The legacy of Piraeicus and other ancient painters of humble things was revived in the trecento and thenceforth informed Italian and Northern manuscript illustrations, trompe l'oeil marquetry, frescoes, and even panel paintings. But truly independent easel pictures of still life emerged only in the course of the sixteenth century; they were well established by about 1600 in Italy, the Netherlands, Germany, and Spain. The simultaneous emergence of still life throughout Europe remains a somewhat mysterious phenomenon.[7] Reverence for ancient texts, the challenge of illusionism, the growth of empirical science, and the embracing of actual experience as the stuff of art all seem to have contributed to the development of the genre. Despite the evident contagion of an exciting new idea, however, still life remained theoretically insignificant, overshadowed by history painting. Still, the modest genre quickly attracted specialists such

as Georg Flegel, Ambrosius Bosschaert, Louise Moillon, and Juan Sán-
chez Cotán. The viability of a still-life specialty bespeaks popular ap-
proval in the form of a reliable market, but economic realities failed to
inspire theoretical worth. As late as 1678, Samuel van Hoogstraeten
called still-life painters mere "foot soldiers in the army of art," but he also
noted that collectors prized their works.[8] Even the French Academy,
which placed a premium on elevated subject matter, kept a place for still
life. According to Dézallier d'Argenville, a painting of flowers and fruits
by Jean-Baptiste-Siméon Chardin hung in the Academy's antechamber,
and nearly a dozen other still lifes were displayed in the interior rooms.[9]

Such ambivalence has pervaded virtually all critical and scholarly dis-
course on still life. Francisco Pacheco considered still-life painting only
an occasional pastime of the great masters, but he pointedly named those
he considered its outstanding exponents.[10] Similarly, André Félibien
denigrated paintings of flowers and fruits along with portraits, battle
scenes, and landscapes. Yet, he admitted that some painters who chose
those lesser subjects were highly esteemed, by dint of their skill and
knowledge.[11]

The traditionally low theoretical status of still life reflects a value sys-
tem in which the abstract, the spiritual, the infinite, and the ideal are
placed above the concrete, the material, the finite, and the real. A history
painter, at the top of the traditional hierarchy, had to use the force of
imagination to depict themes from history, myth, and scripture. In con-
trast, a still-life painter could simply copy objects from life. And "mate-
rial things are heir to all sorts of ills—they break, get dirty, smell, wear out;
abstract ideas remain pristine, free from such wordly [sic] debilities."[12]
As the essays herein amply demonstrate, however, the making of a still life
is not a simple matter of working before the set-up in the studio, nor are
still lifes devoid of abstract ideas. But only as the traditional hierarchy
was dismantled did an openness to still life in all its complexity emerge.

The status of still life has risen in more recent critical and historical
writing. More often than not, historical surveys have mentioned the genre
only in passing.[13] Nevertheless, it has continually attracted specialized
scholars. Their steady trickle of catalogues and monographs has broad-
ened in the last decade into a lively stream. If its course has often been
underground, that stream has surfaced with increasing frequency in the
open landscape of art history. Its emergence has coincided with altered
perceptions of the cultural landscape as a whole—exemplified by the val-
orization of events and structures of everyday life in the historical inquiry
of Fernand Braudel, for example, and in the literary criticism and philoso-

phy of Mikhail Bakhtin.[14] The reordered priorities of art history and criticism, the new readiness to explore and validate areas outside the canon of traditional inquiry, are but one facet of that shift in perception.

This heightened status has built, however, on exhibitions and studies that formed the foundations of modern still-life scholarship. For Spanish still life, the work of Julio Cavestany, Marqués de Moret, is basic. His exhibition *Floreros y bodegones en la pintura española,* held in 1935 in Madrid, and followed by an illustrated catalogue in 1940, was one of the first scholarly investigations of European still life. Charles Sterling's monumental *La Nature Morte de l'antiquité a nos jours,* generated by an exhibition held in Paris at the Orangerie in 1952, presented two thousand years of the evolution of still life, equivalent, as Sterling said, to a history of all Western painting from the viewpoint of a single genre.[15] Sterling's overview remains unique in that ambitious effort. Ingvar Bergström's study on seventeenth-century Dutch still life, though more narrowly focused, was also seminal, raising the level of scholarly discourse for all still life with its meticulous taxonomic, historical, and iconographic analyses.[16] Michel Faré's two-volume study on French still life, which appeared in 1962, is still of fundamental importance.[17] For Flemish still life, Edith Greindl and Marie-Louise Hairs carried on the work initiated by Ralph Warner in 1928.[18] In 1964 and 1965, an exhibition of 306 Italian still lifes from the sixteenth through the twentieth centuries, originated by the Palazzo Reale in Naples, traveled to Zurich and Rotterdam.[19]

In the early 1980s, two major still-life exhibitions in Germany ushered in the period of intensified and deepened interest I noted above. The first was an exhibition simply but grandly titled *Stilleben in Europa,* held in Münster and Baden-Baden in 1979 and 1980. America, too, was encompassed, since the exhibition comprised 281 works by artists ranging from the early Dutch flower painter Ambrosius Bosschaert to Roy Lichtenstein. The 619-page catalogue emphasizes not individual entries but essays on theoretical, historical, and iconographic issues.[20] Another German exhibition, *Das Stilleben und sein Gegenstand,* organized at the Albertinum in Dresden in 1983, was the first major effort to focus on represented objects, the aim being a search for ideas through confrontation between the actual and the depicted.[21] The catalogue entries are spare, however, supplying conventional iconographic data rather than fresh interpretation. Exhibitions and surveys with nationalist emphases appeared with increasing frequency in the 1980s, and they continue to provide a convenient though limiting framework, since geographic pigeonholes are often at odds with artists' mobility and fluid national boundaries.[22] Studies of

the subtypes of Netherlandish still life—monochromatic breakfast pieces, *vanitas* images, flower paintings—advanced that well-established specialty.[23] Still-life collections were catalogued in scholarly publications, sometimes in connection with exhibitions.[24] Individual still-life specialists, including Chardin, Luis Melendez, Jan Davidsz. de Heem, William Harnett, and Georg Flegel have been featured in exhibitions and monographs.[25] The spotlight has also illuminated still lifes within the oeuvres of such nonspecialists as Picasso.[26]

The vitality of current critical discourse on still life is exemplified with special strength in two recent publications: Norman Bryson's *Looking at the Overlooked,* published in 1990, and the catalogue for the Harnett exhibition of 1992. Bryson situates his text within the tradition of still-life commentary that reaches from Félibien to Sir Joshua Reynolds, inquiring into the significance of still life for our own time. He writes, "The meaning of a picture is never inscribed on its surface as brushstrokes are: meaning arises in the collaboration between signs (visual and verbal) and interpreters."[27] His consequent emphasis on the contemporary viewer's semiotic involvement meshes with his search for a coherent sense of still life that transcends time and place. For "the least theorized of genres" (p. 8) he advances a theory that addresses issues of power, class, and gender. At the other end of the spectrum, the twenty-two essayists of the Harnett catalogue immersed themselves in a particular milieu: American life, art, and thought during the last quarter of the nineteenth century. Their viewpoints and methods are diverse, but they share an attempt to delineate the character of that era. They engage the paintings in a search for clues to "large patterns—biographical, social, and cultural—in Harnett's choice of objects."[28] Their focus, then, is more historical and contextual than theoretical.

Those volumes and this one present nuanced discussion on a level that still life has only recently begun to evoke with any frequency, discourse that acknowledges the vast range of purpose and meaning characteristic of the genre through time. Each of the six writers represented here has come to a still-life problem from a contemporary viewpoint thoroughly grounded in the historical period in question. Each pays close attention to both visual and contextual detail. The result is a group of studies that engages actively and creatively with the past, seeking understanding that both recognizes the integrity of the work and "supplements" it,[29] that raises questions and generates provocative answers for present-day beholders of objects-made-subjects.

NOTES

1. Washington 1989–90, 98, cat. no. 37.

2. That was also the title of a session I chaired at the Annual Conference of the College Art Association, Washington, D.C., in February 1991, the first CAA session to focus exclusively on still life. Three of the essays in this volume—by Falkenburg, Ballerini, and Freeman—are based on papers first presented there.

3. First published as "The Avant-Garde" in *Art News Annual* 34 (1968), 34–53; reprinted in Schapiro 1978.

4. Prown 1982, 1.

5. Vorenkamp 1933, 6–10.

6. Pliny 1984, 345, book 35, section 112. For further discussion of this passage, see Falkenburg's essay in the present volume, pp. 24–25.

7. See Spike 1983, 11–14, for a useful overview.

8. Hoogstraeten 1678, 75–76.

9. Dézallier d'Argenville 1893, 123–55.

10. Francisco Pacheco, *Arte de la pintura* (Seville, 1649), translated and discussed by Jordan 1985, 8–9. See also Jordan and Cherry 1995, 18, 187 n. 35.

11. Félibien 1685, vol. 4, no. 9, p. 133; and Félibien 1669, 16.

12. Prown 1982, 2.

13. Treatment of still life in the Pelican History of Art series for the seventeenth century, when still life flourished throughout Europe, is revealing: Blunt devotes one paragraph to still life in *Art and Architecture in France, 1500 to 1700* (1953), 164. Kubler and Soria, in *Art and Architecture in Spain and Portugal and their American Dominions, 1500 to 1800* (1959), do not discuss still life as a genre, but they include the major still-life specialists. Gerson and Ter Kuile compress still life into seven pages in *Art and Architecture in Belgium, 1600 to 1800* (1960), 158–64. Wittkower, in *Art and Architecture in Italy, 1600 to 1750* (1965), 19, mentions still life as an "adjunct to high art." Rosenberg, Slive, and Ter Kuile include a nine-page chapter on still life in *Dutch Art and Architecture, 1600 to 1800* (1966), 194–202.

14. Braudel's *Les Structures du quotidien: Le Possible et l'impossible* appeared in 1979 and was soon translated as *The Structures of Everyday Life: The Limits of the Possible,* vol. 1 of *Civilization and Capitalism, 15th–18th Century;* trans. Sîan Reynolds (New York, 1981). Bakhtin's writings were first translated into English in the 1960s. On Bakhtin's emphasis on "prosaic life" as an essential determinant of art, see Morson and Emerson 1990, 35–36.

15. Sterling 1959, 7.

16. Bergström 1956. Bergström's study had first been published in Swedish in 1947. As Bergström acknowledges (p. viii), the first comprehensive survey of Dutch still life was A.P.A. Vorenkamp's doctoral dissertation, presented at Leiden

in 1933 (Vorenkamp 1933). He also names Vroom 1945 and Luttervelt 1947 as important precedents. Bergström went on to write a useful study of Spanish still life, Bergström 1970.

17. Faré 1962. More specialized books by Faré appeared in the 1970s; see Faré 1974 and Faré 1976.

18. Warner 1928; Greindl 1956; and Hairs 1955.

19. Naples 1964.

20. Münster 1979–80.

21. Dresden 1983.

22. To cite only a sampling, Gerdts 1981; De Jongh 1982; Spike 1983; Jordan 1985; Jordan and Cherry 1995; and Taylor 1995. An international exhibition of seventeenth-century Netherlandish still-life painting is planned for the late 1990s.

23. Warner 1928, Leiden 1970, Vroom 1945, Vroom 1980, Segal's many exhibitions (including Segal 1982, Segal 1983, Segal 1988, Segal 1990), and most recently Taylor 1995.

24. For example, Weber 1989; Washington 1989–90; and Ember 1989–90.

25. Rosenberg 1979; Tufts and De Luna 1985; Segal 1991; Bolger, Simpson, and Wilmerding 1992–93; and Frankfurt am Main 1993–94.

26. See Gordon and Forge 1986; Harke 1985; and Boggs 1992.

27. Bryson 1990, 10.

28. Bolger, Simpson, and Wilmerding 1992–93, xv.

29. See the section "Dialogue and Other Cultures" in Morson and Emerson 1990, 54–56, especially 56, discussing Bakhtin's "From Notes Made in 1970–71."

Matters of Taste: Pieter Aertsen's Market Scenes, Eating Habits, and Pictorial Rhetoric in the Sixteenth Century

THE MARKET scenes and kitchen pieces by Pieter Aertsen (1508–75) occupy an important place in the history of both Netherlandish art and of still life. They are among the first large-scale paintings to devote attention to the object as subject—to food as the main theme of the picture. In his market scene in Berlin (Gemäldegalerie, Berlin-Dahlem; fig. 1; pl. I), vegetables and fruits are piled before our eyes, each food competing for our attention. Although in this respect such pictures have much in common with still-life paintings, this genre did not exist as such in the middle of the sixteenth century. Fruit had figured prominently in many paintings of an earlier date, for instance in devotional images like Quinten Massys's *Madonna and Child* (Musée du Louvre, Paris; fig. 2). The depiction of fruit, and in other paintings sustenance such as bread, butter, and wine, often has the quality of a still life, especially if objects are displayed on a table in front of Mary and her child, but these motifs are only accessory to the religious figures and lack any visual dominance.

When Aertsen's market scenes and kitchen pieces first emerged about 1550, they must have shocked the audience by their appearance as well as by their sheer size. His *Meat Stall* (Universitets Konstsamling, Uppsala; fig. 3), for example, measures more than one meter high and one and one-half meters wide. Moreover, we can observe in the display of the inanimate objects a discomforting and even aggressive quality. This impression is due to the ruthless realism with which the meat, vegetables, and fruits are depicted and to the compositional device of piling them in the immediate foreground, in a close-up of market wares and cooking ingredients. By these means, the beholder is addressed as the intended buyer and consumer of the offerings and is invited to "fall for" their attractions. The marketable and consumable quality of these foods—consumable in both

A version of this paper was presented at the Annual Conference of the College Art Association, Washington, D.C., February 1991, in the session "The Object as Subject."

a real and an aesthetic sense—is an essential feature of their character. It is, therefore, legitimate to ask to what extent these pictorial offerings relate to what people actually ate and to explore the function of the appeal to the beholder's appetite. While pursuing these matters in some detail, I will concentrate on Aertsen's market scenes in which vegetables and fruits dominate, comparing his visual offerings with historical data on food consumption. I will leave his "meat pieces," such as the one in Uppsala (fig. 3), aside because the available data on the consumption of meat are as yet less specific. In the second part of this article, I will approach the question of the marketable and consumable quality of the offered foods from the point of view of pictorial rhetoric.

There are several sources offering data about food consumption in the Netherlands during the sixteenth century. First, there are cookbooks and herbals, which give a fair impression of the kinds of foods available to upper-class people living in towns. These books are of importance, because they were written for the classes of people for whom Aertsen produced his paintings. Let us take a look at the well-known herbal by Rembert Dodoens, published in Antwerp in 1554. Among the vegetables Dodoens mentions are cabbages; spinach, sorrel, endive, chicory, lettuce, leeks, chives, and purslane; turnips, beets, onions, garlic, radishes, carrots, and parsnips; beans and peas; pumpkins, melons, and cucumbers; artichokes, and cauliflower.[1] According to Ludovico Guicciardini's *Descrittione . . . di tutti i paesi bassi* (Description of the low countries), of 1567, the Netherlands also produced a wide variety of fruit. He lists pears, apples, plums, red and black cherries, mulberries, apricots, walnuts, hazelnuts, medlars, chestnuts, and grapes.[2] Dodoens also mentions peaches, raspberries, blackberries, gooseberries, strawberries, and currants.[3] To these we might add what Guicciardini calls "noble fruits" that were imported from Spain and Portugal into the Low Countries in large quantities. Among them were almonds, olives, figs, oranges, limes, lemons, and pomegranates.[4]

The impression these enumerations give is one of abundance and variety. But did people really eat all this produce? If we rely on cookbooks, such as the *Notabel Boecxken van Cokeryen,* which appeared about 1510 in Brussels, people (that is, the well-to-do) ate mainly meat, poultry, fish, eggs, and corn. Vegetables and fruits are hardly mentioned.[5] Some historians explain this absence by referring to traditional dietetics, according to which fruits and vegetables were unwholesome if eaten uncooked or in large quantity.[6] In fact, it is known that in times of pestilence

fruits were kept off the market; plums were thought to be especially dangerous. Doctors also discouraged the consumption of melons, since several popes and emperors were said to have died from them.[7]

Historians of horticulture have studied the common consumption of vegetables and fruits in the sixteenth century using archival material on food transportation and market regulations.[8] According to these sources, only a modest variety—turnips, cabbage, carrots, parsnips, onions, garlic, leeks, and parsley—dominated the supply of vegetables on the markets. This had been so for centuries, and during the sixteenth century only lettuce was added to this basic repertoire of common vegetables. Some historians therefore suppose that vegetables other than those used for *potagie* (a common porridge made from cabbage, turnips, carrots, parsnips, onions, garlic, beans, and peas) were not widely consumed.[9]

According to sources on marketed fruits, mainly apples, pears, and nuts were widely offered in the fifteenth and sixteenth centuries. Cherries, medlars, plums, peaches, chestnuts, and grapes were also cultivated for sale, though less widely.[10] This does not imply, however, that these and other sorts of fruit were not cultivated for private use. Some townspeople in the sixteenth century still owned a parcel of land on which they grew their own crops, as had been done in previous centuries. Archives rarely provide insight into the specific kinds of fruits grown privately, but we know that peaches and mulberries were among them. Strawberries were cultivated for the market in some places but then were a luxury food; berries that grew wild were gathered by the less privileged.[11] This is what the written sources tell us about availability, but recently another kind of source has emerged, one that informs us what people actually consumed.

Recently archaeologists, especially in Germany and the Netherlands, have started to analyze food remains, such as seeds, from excavated cesspools, latrines, and layers with remains of horticultural and kitchen leavings. This paleo-ethnobotanical, or phyto-archaeological, research makes possible a more specific idea of the eating habits of people living in Netherlandish towns during the late Middle Ages and the Renaissance. Up to now, there have been very few findings from the Southern Netherlands, including Antwerp, which would especially interest us since here Aertsen produced his first market scenes and kitchen pieces. But from the North, including Amsterdam, where Aertsen worked from about 1557, we do have relevant data on vegetable and fruit consumption.

From a survey of seeds and other plant remains made by the Dutch archaeologist Van Haaster,[12] it is clear that many of the plants mentioned

by Dodoens were already consumed in the Netherlands in the fifteenth century. There are also remains of plants Dodoens omitted but which have been identified botanically. Van Haaster gives the following survey of vegetables consumed in the Netherlands in the fourteenth and fifteenth centuries: beets, peas, cucumbers, lentils, parsnips, carrots, purslane, turnips, celery, lettuce, broad beans, garden cress, orache, chicory, and white mustard.[13] Missing from this list are cabbages, pumpkins, melons, and gourds—all of which figure prominently in Aertsen's paintings. This discrepancy need not surprise us, however, because some of these vegetables, such as cabbages, were consumed before they produced seeds; thus the cesspits lack evidence. As for pumpkins, melons, and gourds, their absence from Van Haaster's list may indicate their relative rareness in the diet. The samples taken by the archaeologist Paap from several cesspits in Amsterdam yield little information on the consumption of vegetables in the sixteenth century specifically. Paap's general survey, however, ranging from the thirteenth to the nineteenth centuries, suggests that melons and pumpkins were indeed not consumed in Amsterdam before the end of the sixteenth century.[14] These findings are corroborated by a recent analysis of late medieval cesspits in 's-Hertogenbosch, a Brabantine town bordering on the Southern Netherlands.[15]

On the other hand, Guicciardini mentions that "sometimes, according to season, we have more than reasonable pumpkins, or melons," which seems to indicate that these vegetables were eaten but were not always available or of good quality.[16] *Der scaepherders kalengier* (The shepherd's demand), of 1513, mentions pumpkins and melons (*cauwoerden* and *meloenen*) among the food that shepherds and peasants (*scaepherders*) ate in summer, which implies that these vegetables were quite common among ordinary people.[17]

According to Van Haaster's list, the variety of fruit consumed in the Netherlands in the late Middle Ages was greater than one would expect on the basis of only literary sources. In addition to the varieties mentioned there, archaeologists have found the remains of grapes, medlars, walnuts, and sweet cherries, as well as a wide range of wild fruit, such as hazelnuts, elderberries, bilberries, brambles, and juniper berries.[18] Analyses of fruit remains from cesspits of the sixteenth century in Amsterdam and Kampen provide similar findings.[19] How are we to judge the selection of vegetables and fruits in Aertsen's paintings when we take these literary and archaeological data as a point of departure?

Before interpreting Aertsen's works, let us first take a short look at two paintings, contemporaneous with Aertsen's, by his nephew and follower,

Joachim Beuckelaer (1533–73). Historians and archaeologists have cited Beuckelaer's market scenes, exemplified by the paintings in the Gemäldegalerie in Kassel and the Museum voor Schone Kunsten in Ghent (figs. 4 and 5), as visual proof of the rich variety of vegetables and fruits for sale at Netherlandish markets in the sixteenth century. They treat these pictures as "realistic" scenes—though crops from different seasons are often grouped in one painting—which reveal something of the eating habits of the painter's contemporaries. If we compare the produce in Beuckelaer's paintings with the findings of archaeologists, we can indeed establish a fairly high degree of correspondence between the painted assortment and the range of food actually consumed. Apparently the paintings present a kind of visual catalogue of the riches of the fields, not unlike a collection of curiosities, in effect a *Wunderkammer,* in which variety vies with abundance.

In comparison, the assortment in Aertsen's pictures is much more limited. The *Preparation for the Market* in the Museum Boymans-van Beuningen in Rotterdam (fig. 6), for example, shows various kinds of cabbage, carrots, turnips, parsnips, lettuce, and pumpkins, as well as medlars, white and blue grapes, plums, and melons. Aertsen's *Vegetable and Fruit Market* in the Hallwylska Museum in Stockholm (fig. 7) shows even fewer vegetables: only cabbages, lettuce, carrots, parsnips, pumpkins, and cucumbers. The fruit here includes melons, white and blue grapes, apples, cherries, brambles, and several kinds of nuts—walnuts, almonds, and hazelnuts. One also sees a few pieces of white bread. The *Vegetable and Fruit Market* in Berlin (fig. 1) shows the same vegetables as the Stockholm painting plus leeks, turnips, and, extraordinarily, a cauliflower. Again, the fruit is represented by only a limited variety. Among the wares of the vendor, one also notices a few waffles, pieces of white bread, butter, and a herring.

Of course, these paintings give an impression of variety and abundance, but that impression was achieved more through compositional strategy than through botanical variation. In fact, Aertsen meticulously copied one and the same image of two heads of lettuce, two pumpkins, two melons, three intertwined parsnips, and two bunches of grapes in a whole series of paintings, including those in Berlin, Rotterdam, and Stockholm (figs. 1, 6, and 7).[20] This makes us aware that Aertsen's paintings are artificial compositions that are only somewhat directly based on his visual perception of real market offerings. His paintings do not portray actual markets or marketplaces, whether in rural or in urban areas; they show fictitious locations, which are, however, reminiscent of real market scenes. It is, therefore, impossible to deduce from them the variety, the

arrangement, or the frequency of actually marketed vegetables and fruits. His paintings can serve only as visual proof for the existence of the individual species in the sixteenth century.

Comparison with literary sources and archaeological findings does allow, however, for a general conclusion about the assortment of vegetables and fruits in Aertsen's pictures. The offerings in his paintings are clearly not representative of the full range of produce available to and consumed by townspeople in Aertsen's time. There are occasionally luxury foods, such as lemons and white bread, or expensive novelties, such as cauliflower (fig. 1), but the bulk of the vegetables belong to the most commonplace species. They do not, however, cover the whole range of these ordinary sorts since, for example, some of the basic ingredients for *potagie*—onions, garlic, beans, and peas—are absent in most of his paintings.[21]

A similar conclusion can be drawn regarding the assortment of fruits that Aertsen depicts. Apples, plums, cherries, nuts, and grapes, which Guicciardini says were grown in the Southern Netherlands, represent only a small portion of the fruits that were consumed and are ordinary species. The overall impression of the vegetables and fruits in Aertsen's market scenes is that they belong to the basic and plain comestibles of his day. Their assortment relates more to the diet of the common man than to the menu of the rich.[22] Aertsen's paintings do not, however, give a fully accurate depiction of the foods that either the common man or the rich man usually selected for consumption.

It is with the help of more strictly art-historical methods, such as iconographic and stylistic analysis, that we can refine our general impression of the foods in Aertsen's market scenes. There is an indication that the vegetables and fruits in his paintings should be viewed in connection with the peasantry that grew them. Aertsen's market vendors and their wares are iconographically related to a series of landscapes painted in Antwerp between about 1530 and 1560 by Herri met de Bles, Jan van Amstel, and Beuckelaer, as well as Aertsen himself, in which peasants are going to market with their crops.[23] One such painting, a *Landscape with Christ Carrying the Cross,* by Aertsen (formerly Kaiser Friedrich Museum, Berlin; figs. 8 and 9), can represent the group. The wares carried by the peasants are like those that comprise the bulk of the offerings in Aertsen's market scenes and kitchen pieces: carrots, turnips, parsnips, and cabbages. Occasionally one also sees peasants carrying small trays with strawberries and other fruit. As I have argued elsewhere, these folk belong to a stock repertoire of figures who exemplify preoccupation with earthly

goods and worldly affairs, as against the biblical protagonist of the scene, who represents man striving for the heavenly good of eternal life.[24] In this iconographic tradition of early Flemish landscape painting, the peasants' crops are literally and figuratively earthly goods; their connection with the material side of life is underscored by their depiction as marketable wares. The association of worldliness and rusticity is also evident in the vegetables and fruit offered for sale by Aertsen's vendors, who are the direct iconographic descendants of the peasants in this landscape tradition.

This association is sometimes emphasized in Aertsen's vegetable and fruit markets, where peasants are engaged in various forms of worldly behavior: not only the selling of the crops as such but also the "vending" to the public of the libidinous qualities inherent in the market wares, and in the vendors themselves. It is important to realize that the sixteenth-century herbalist Dodoens and other dieticians of the day attributed an aphrodisiac effect to many of the foods displayed in Aertsen's pictures.[25] This notion of aphrodisiacs has nothing to do with Panofsky's "disguised symbolism," which has served as a semantic principle for the interpretation of the vegetables and fruits in Aertsen's and Beuckelaer's paintings as erotic symbols. Art historians who recently have come to reject this concept and doubt the symbolic dimension of realistic representations of food and other objects in late medieval and Renaissance art forget that the attribution of physical effects to the consumption of food had a practical dimension. People in twentieth-century Western society may not have faith in the aphrodisiac, but in the sixteenth century such effects were thought to be very real. This opinion, rooted and vested in the respectability of a venerable tradition of medicinal knowledge, was still very much alive in the sixteenth century, not only among men of letters but probably also among the peasants and other ordinary, illiterate people who grew the crops and ate them.

In Aertsen's and Beuckelaer's paintings the aphrodisiac connotation of the vegetables and fruit is directly linked with peasantry and the "selling" of bodily pleasures that accompanies the vending of the foods. The literature and visual arts of the fifteenth and sixteenth centuries abound in mockeries of peasants proverbially associated with uncontrolled libidinous behavior.[26] Both Aertsen's and Beuckelaer's pictures have these connotations, as several iconographic investigations have shown.[27] Many paintings play with the connection that people saw between eating and drinking, sexual lust and liberty, and peasant, or boorish, behavior. Aertsen's *Kitchen Scene* in Antwerp (Museum Mayer van den Bergh; fig.

10), for example, shows an old peasant drinking wine and a kitchen maid who, while preparing the food, has grabbed his "prick," whereas a group of male and female peasants in the background uninhibitedly make similar libidinous gestures. Beuckelaer's *Market Scene* in Antwerp (Rockoxhuis, Kredietbank; fig. 11) and his *Fish Market* in Strasbourg (Musée de la Ville de Strasbourg; fig. 12) are other clear examples of the association of sexual interest, peasant behavior, and the selling and implied consumption of food. There is nothing disguised in the erotic puns in these pictures. In the *Market Scene with Ecce Homo* in the Uffizi in Florence (fig. 13), Beuckelaer even goes so far as to show a vendor who touches the lap of his female companion to express that not only her vegetables but also the "fruits" of her body are for sale.[28] Usually Aertsen is only a little more covert in such allusions than Beuckelaer, although the kissing peasant couple in the background of the *Vegetable and Fruit Market* in Berlin (fig. 1) makes explicit the erotic context of the selling—and eating—of vegetables and fruit. The cucumber balancing on top of a pair of turnips in a strange erect position in the left foreground of the Hallwylska *Market Scene* (fig. 7) might be seen as a visual pun similar to the "daggerprick" in Aertsen's Antwerp *Kitchen Scene* (fig. 10), or the finger put through the slice of salmon in Beuckelaer's *Fish Market* (fig. 12). In any case, one can conclude that the aphrodisiac connotations of the food offerings in Aertsen's paintings are closely connected with the libidinous behavior of the vendors themselves and seem to express the basic affinity between rustics and the wares they sell.

The formal presentation of the offerings in Aertsen's market scenes also has a rustic quality. This is primarily due to the rough, sometimes scarred surface of individual vegetables, especially the pumpkins and melons (fig. 14), the irregularity, not to say capriciousness, of their forms, and their sometimes oversized dimensions. The composition of the produce within the market scenes—that is, the way in which the food has been arranged by the vendors—is not only assertive but also rather disorderly and poorly balanced.

We must take care, however, not to impose a modern aesthetic upon these images. The creation of compositional patterns that give the image a weight and balance that we associate with High Renaissance art might not have been the first concern of Renaissance artists.[29] "To compose" (*componere*) was primarily understood as literally putting together individual "building blocks" into a whole. These building blocks could consist of every kind of subject and object that exists in the natural world. Art theorists of the fifteenth and sixteenth centuries, including Alberti, who

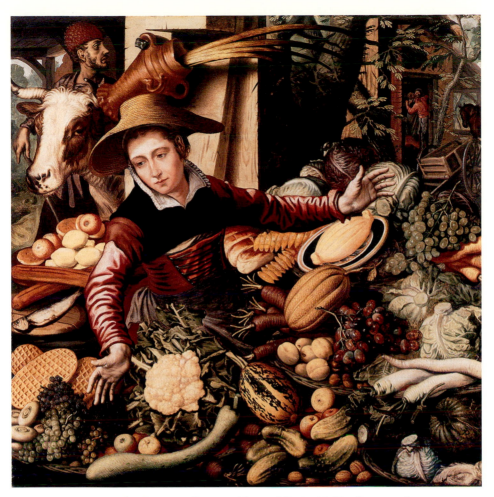

I. Pieter Aertsen, *Market Scene with Vegetables and Fruit*, 1567, oil on panel

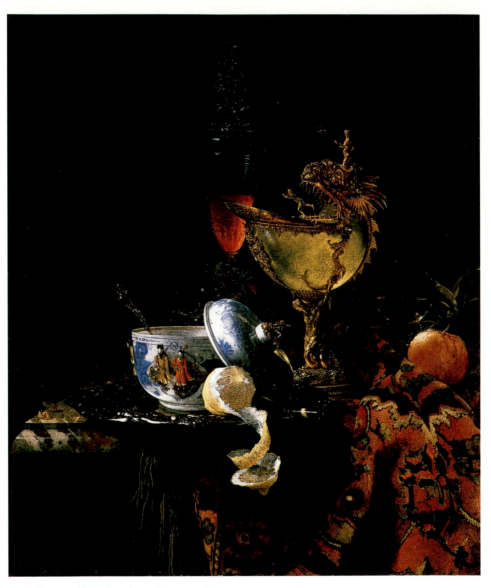

II. Willem Kalf, *Still Life with a Nautilus Cup*, 1662, oil on canvas

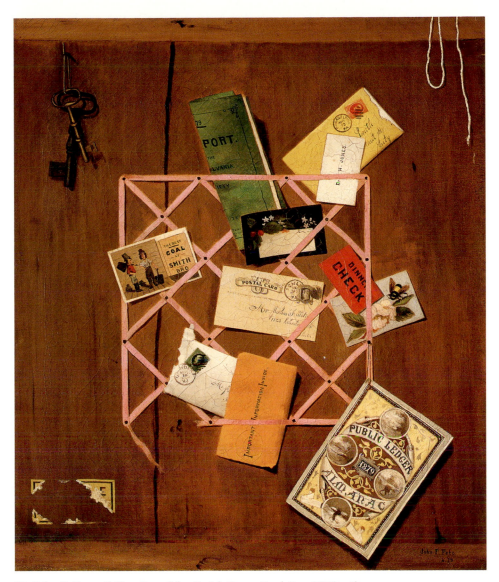

III. John F. Peto, *Office Board for Smith Bros. Coal Co.*, 1879, oil on canvas

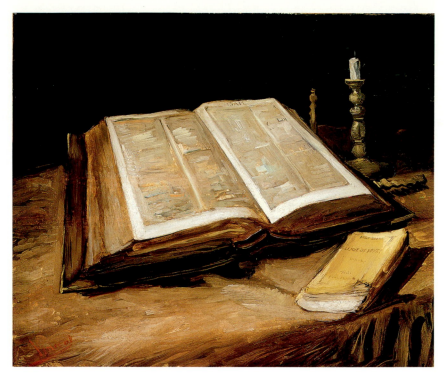

IV. Vincent van Gogh, *Still Life with Open Bible, Candle, and Book*, Nuenen, 1885, oil on canvas

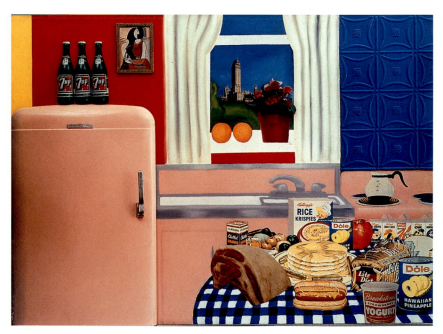

V. Tom Wesselmann, *Still Life #30*, 1963, oil and mixed media on board

was known to Netherlandish artists,[30] enumerate such individual motifs, ranging from different types of human figures to animals, buildings, and landscape elements. They combine these lists with the requirements of naturalism, richness, and variety (*verecundia, copia,* and *varietas*) in representation, thought to be central to a satisfactory composition.[31]

Aertsen's market scenes with vegetables and fruits comply with these three qualities or requirements, but when we look at other qualities that theoreticians like Alberti advocated, Aertsen's compositions show the opposite of what is recommended. Alberti says, "But I should wish this richness to be ornate [*ornata*] with a degree of variety, and also serious [*gravis*]and restrained [*moderator*] with dignity [*dignitas*] and naturalism. I certainly condemn those painters who, because they wish to seem abundant [*copiosi*] or because they wish nothing left empty, on that account pursue no composition [*compositio*]. But indeed they scatter everything around in a confused and dissolute [*dissolutus*] way."[32] When we look at Aertsen's *Vegetable and Fruit Market* in Berlin (fig. 1), we see that the image is realistic, or naturalistic, in the depiction of individual vegetables and fruit (as well as other motifs) and shows—within a limited section of the whole range of market foods—varied and abundant offerings. There is, however, no restraint, sobriety, or dignity that keeps this abundance and variety in balance. Aertsen's composition shows exactly the mistakes against which Alberti warns. In the foreground especially, there is no space whatsoever; the vegetables and fruits seem to have been scattered, lacking any order, and lie on top of one another as if they have toppled over, even partly burying the body of the vendor. Aertsen's *Preparation for the Market* (fig. 6) shows exactly the same phenomenon. But at the same time we can observe in this picture that *componere* was indeed a concern of Aertsen's. In the center a peasant holds a huge cabbage on his knee and sits on a bag, which is placed on a wheelbarrow lying on its side (fig. 14). The wheelbarrow has in turn been carefully placed on a small stone on the ground. The whole structure appears carefully thought out and is in itself an imaginative, though somewhat odd, composition showing a certain variety and abundance in invention. This artful structure of balanced building blocks strikingly contrasts with the chaotic display of food around it.

I would like to offer two interpretations of this phenomenon, each from a different, but related, point of view. The first is that we think of the arrangement of the vegetables and fruits and the wheelbarrow seat as resulting from the actions of the peasants themselves. From this point of view, the makeshift seat and the arrangement of the vegetables and fruit

21

are truly rustic compositions, totally lacking in the concept of *componere*. Thus here it is the vendors who have made the mess and come up with an odd construction. The painter has just followed peasant decorum, showing boorish behavior and crops in a rustic composition.

The other interpretation can be understood simultaneously. One may hold the artist responsible for what he paints. He might be blamed, then, for the jumble in the foreground and for a lack of proper *compositio* in the display of the market wares. But the careful construction of the wheelbarrow seat in the Rotterdam picture clearly shows that Aertsen could ingeniously apply the rules of art. I am not suggesting that this picture proves that Aertsen knew the theories of Alberti, although this cannot be ruled out. Aertsen was indeed interested in theoretical writings, as his extensive borrowings from illustrations of Sebastiano Serlio's treatise on architecture prove.[33] From this treatise Aertsen may have gained some insight into matters of taste, questions of decorum, and the rules of art. In any case, what his Rotterdam painting demonstrates is the artist's reflective attitude on these matters. In a sense, properly *componere*—that is, to compose according to rustic decorum—is the very theme of the picture.

Now, if this is true, we might ask why Aertsen preferred rustic food and boorish compositions to thematize and display his command of art. An indirect answer may be found in a biographical anecdote by a friend of Aertsen's, the historian Petrus Opmeer, which was written before 1569 but was published posthumously in 1611.[34] Opmeer relates that he once had a discussion with Pieter Aertsen about the Rotterdam painter Johannes Einout, who, "stimulated by the example of the [Praise of] Folly by his fellow citizen D. Erasmus, painted . . . a Christ fastened to the cross, in which the figures of deformed men [painted] in various colors and forms were to be seen. Thus artists might see in it the mistakes of all famous painters: and he seemed to have mocked not only artists but also art itself. Tall Pieter the painter valued this [picture] so highly that he told me it could not be valued in gold but only with the honors of a high office."[35] Although this anecdote is about an otherwise unknown contemporary of Aertsen's, I believe that it can provide a clue to Aertsen's own artistic preferences and ideas. The story suggests that Aertsen knew and valued the idea of making a pictorial counterpart of Erasmus's *Praise of Folly.* If we recognize the basic principle that underlies Erasmus's masterpiece, we may see several points of correspondence with Aertsen's market scenes.

The *Praise of Folly* belongs to a literary genre that was very popular in the sixteenth century. This genre was based on an ancient rhetorical fig-

ure, the so-called paradoxical encomium, an ironic eulogy of unworthy subjects.[36] The principle was to praise base persons and things, such as tyrants, beggars, humble plants, dust, or even illnesses, with every formal means that an orator or writer would normally use to praise the virtues of princes, towns, or useful objects. In this rhetorical tradition, the dignity of form serves to sing the ironic praises of humble and unworthy subjects in order to rouse the admiration of the audience for the technical skills of the orator or writer. At the same time, this device could be used, as it often was in the sixteenth century, to entice the audience to applaud not only the technical virtuosity of the speaker or writer but also the humble object of the praise. In this way the audience could be induced to empathize with persons and things it would normally shun. This is exactly the technique Erasmus uses to entangle his readers in the folly he praises and to make them aware of their own failings.[37]

I believe that Aertsen's market scenes with vegetables and fruits can be seen as eulogies of humble objects in their own right. This suggestion is not new: already in 1966 the literary historian Rosalie Colie drew a broad comparison between the emergence of the genre of still-life painting and the popularity of the paradoxical encomium as a literary genre in the sixteenth century.[38] Colie stated that both genres make trivial matters the subject of individual artistic creations and employ what she calls self-reference. That is, they emphasize the technical virtuosity of the writer/painter and the attractiveness of humble matters in order to have these qualities admired for their own sake. Colie's suggestion is especially enlightening in the case of Aertsen's paintings. They, too, seem to follow the principle of elevating humble folk and objects to the status of the main subject of the picture. The flaunting and thematizing of Aertsen's compositional abilities exactly fit Colie's qualification of self-reference. Even irony, a potential of self-reference, which had been exploited to an unprecedented degree in the greatest of all paradoxical encomia, the *Praise of Folly*, is inherent in Aertsen's market scenes: it is precisely the faults and the boorish quality of the composition that serve to display Aertsen's command of decorum and the rules of art.

By suggesting that the beholder is the buyer and consumer of the displayed foods, Aertsen's paintings, like Erasmus's writing, play a trick on the audience. As the viewer roams the picture with his eyes, admiring the artist's mastery in the realistic rendering of rustic crops, he is, in a certain sense, taken in by the peasants and their offerings. If the beholder feasts his eyes upon the vegetables and fruits that are offered to him, he exposes himself to the aphrodisiac effect inherent in their visual consumption. Through the very act of admiring the painted crops, the beholder

unwittingly creates a parallel between his own *pictorial* lust and the bodily interests of the peasant vendors; it is left to the beholder to ponder the implications of this parallel, as it is to the audience of Erasmus's *Folly* to reflect on their own foibles.

We can follow this trail even further and speculate that Aertsen may have been inspired not only by the example of his enigmatic fellow painter Johannes Einout but also by reading the *Praise of Folly* itself. Offering an excuse for writing his book by referring to an ancient and therefore honorable tradition, Erasmus invokes in his preface, among other examples of the genre, the *Moretum,* in Aertsen's time ascribed to Vergil, which describes a peasant's meal.[39] Here, Aertsen may have discovered the idea of devoting a paradoxical eulogy to that subject.

There is no way of knowing whether Aertsen went any deeper into the tradition of this rhetorical figure, but I must point out that the market vendor repeatedly figures in this tradition. Quintilian had already compared the eulogy of the orator to the praises of the market vendor, and Erasmus, too, played with this parallel when he had Folly address her audience: "If only you will be so good as to give me your attention—not the kind you give to godly preachers, but rather the kind you give to pitchmen, low comedians, and jokesters. . . ."[40] In his books on Gargantua and Pantagruel, which also belong to the genre of the paradoxical encomium, the sixteenth-century writer François Rabelais made extensive use of the figure of the market vendor to praise all kinds of base matters, with many scatological and sexual puns, as Mikhail Bakhtin and others have shown.[41]

Rabelais's masterpiece, containing extensive lists of crops and in which eating is a dominant theme, is interesting in our context for still another reason: the reception of Aertsen's market scenes in his own time. As Colie pointed out, Rabelais compared himself to the ancient painter Piraikos, whom Pliny called a *rhyparographus,* a painter of humble things.[42] The humanist Hadrianus Junius applied the same term to Aertsen. Junius, in *Batavia,* published in 1588, gives us virtually the only existing contemporary account of the qualities for which Aertsen's paintings were valued in his time:

We cannot pass over Pieter, nicknamed "the Tall," in silence. In my opinion one can compare him rightly with Piraikos, who is mentioned by Pliny, if he is not to be given preference over [this ancient painter]. Deliberately, as it appears, he set himself to paint humble things, and he has, according to the judgment of all, reached the highest fame in these matters of humbleness. Therefore, it is my opinion that he can be awarded—just as well as

the other [i.e., Piraikos]—the epithet rhyparographer, because of the grace that shines in all his works when he depicts, in a most tasteful way [*elegantissime*], the bodies and costuming of peasant girls, food, vegetables, slaughtered chickens, ducks, cod and other fishes, and all sorts of kitchen utensils. Besides the perfect delight [they offer] also by their endless variety, his paintings will never saturate the eyes [of the beholder].[43]

In this text we find several qualities discussed so far: the deliberate choice of humble motifs, grace engendered by the tasteful depiction of a variety of things, and an allusion to the visual consumption of the offerings by the beholder. Abundance (*copia*) is not mentioned explicitly, but the list of pictorial motifs certainly gives that impression. Overt references to the paradoxical encomium are lacking, but, as Colie suggested, the fact that Rabelais had compared himself to the ancient rhyparographer Piraikos indeed implies that Aertsen's paintings and literary paradoxical encomia could be considered comparable artistic expressions. We do not know if Aertsen thought of himself as a modern rhyparographer, or whether the audience for which he worked considered him one. Not a single name of a patron or first owner of a market scene or kitchen piece by Aertsen has been documented. There is, however, an indication that the artist and his public alike associated his pictures with the humanist culture that favored the reviving of ancient genres such as the paradoxical encomium: some of his paintings are dated to the month and day of the year with Latin calendar names, suggesting that Aertsen's pictures revive ancient Roman painting.[44]

In conclusion, it is not enough to say that with Pieter Aertsen humble objects such as vegetables and fruits were made the subject of panel paintings for the first time in the history of post-Renaissance Western art. It is important also to acknowledge the complexity of his conceptions in this novel genre. Aertsen created pictorial eulogies of his humble objects, which means that the traditional generic titles, like *Market Scene with Peasants*, fall short. Titles like *The Praise of Crops* (fig. 6), or *The Praise of Pancakes* (fig. 15), would be more appropriate. In essence, technical virtuosity, wit, and command of art—not the objects—are the real subjects of Aertsen's paintings.

NOTES

1. Dodoens 1554. See also Lindemans 1952, 165–66.
2. Guicciardini 1567, 7.

3. See Lindemans 1952, 203–6.

4. Guicciardini 1567, 7.

5. Van Winter 1982, 178; see also note 22.

6. See Sangers 1952, 37 and 47; Van Winter 1982, 178; and Van Haaster 1992, 105.

7. Vandommele 1986–87, 75.

8. Sangers 1952.

9. See Sangers 1952, 37, 74; Lindemans 1952, 169.

10. Sangers 1952, 41, 62–63, et passim.

11. Vandommele 1986–87, 72–73.

12. Van Haaster 1992.

13. Ibid., 112.

14. Paap 1983 and Paap 1984.

15. Van Haaster 1995 (forthcoming).

16. Guicciardini 1567, 8.

17. See Anonymous 1985, chap. 9.

18. Van Haaster 1992, 112–13.

19. See Paap 1983 and Paap 1984; and Vermeeren 1990.

20. The same elements are found in Aertsen's *Kitchen Maid* (Brussels, Musées Royaux des Beaux-Arts) and his *Market Scene with Christ and the Adulterous Woman* (Stockholm, Nationalmuseum).

21. Only the *Market Scene with Christ and the Adulterous Woman* in Stockholm has onions and garlic strings.

22. Concerning the eating habits of poor people in the Netherlands around 1500, see Sangers 1952, 26; Lindemans 1952, 169–71; Burema 1953, 72; and Van Winter 1986–87.

23. See Falkenburg 1988.

24. Falkenburg 1990.

25. Aphrodisiacs included cherries, apples, grapes, plums, walnuts, carrots, parsnips, turnips, leeks, onions, garlic, cabbage, and the more uncommon pumpkins, melons, cucumbers, and lettuce. See Grosjean 1974; Wuyts 1986–87; and Vandommele 1986–87, 75–77.

26. See Raupp 1986.

27. Grosjean 1974; Kavaler 1986–87; Wuyts 1986–87.

28. See Kavaler 1986–87.

29. See Stumpel 1989 and Stumpel 1990, 175–228; and Van den Akker 1991.

30. According to Denhaene 1990, 217–21, the painter Lambert Lombard organized an "Academy" in his house, where he taught his pupils the "grammar" and the "rules" of the art of the Ancients and where they discussed texts by Pliny and Vitruvius as well as modern (Italian) writers on art, including Alberti, Gauricus, Pino, Varchi, Dolce, and Vasari. See also Hubaux and Puraye 1949 for the use of the words "grammar" and "rules" by Lombard's biographer, the sixteenth-century humanist writer Lampsonius. Although Aertsen probably did

not belong to this circle, there is evidence that Lombard and Aertsen were in contact: in the British Museum in London is a very classicistic drawing by Lombard, representing Christ and the Samaritan Woman, annotated "voer langhe peire" (for tall Pieter [Aertsen]). See Denhaene 1990, 177, Drawings, A.6, fig. 230.

31. See, for example, Alberti 1972, 78–79.

32. *De pictura,* cap. II, quoted after Baxandall 1971, 136; see 136–39 for Baxandall's commentary on this passage.

33. Lunsingh Scheurleer 1947. See also note 30. "Rules of masonry, or the five manners of building, that is the Tuscan, Doric, Ionian, Corinthian, and Composite manner" (*Reglen van Metselrijen, of de vijve manieren van Edificien, te wetene, Thuscana, Dorica, Ionica, Corinthia en Composita;* Antwerp, 1549) is the title of Pieter Coecke van Aelst's Dutch translation of this treatise.

34. The following is based on and in part revises Falkenburg 1989.

35. Opmeer 1611, 470.

36. See Miller 1956; Malloch 1956; and Colie 1966.

37. See Kaiser 1963; and Watson 1979.

38. Colie 1966, especially 273–99. See also Silver 1984, 134–60, especially 141 and 149ff., where a comparison is being drawn between Quinten Massys's satirical images and Erasmus's *Praise of Folly.* Silver speaks of "visual analogues" to Erasmus's book and mentions the rhetorical figure of the encomium, but he does not conceive of Massys's pictures as paradoxical encomia in their own right.

39. See Miller 1956, 154; and Anonymous 1984, edited by Kenney. Kenney translates *Moretum* over-neatly as "The Ploughman's Lunch." The poem tells the story of a peasant preparing a meal of bread or pancakes, cheese, and a salad consisting of red onions, chives, watercress, endive, rocket, garlic, parsley, rue, and coriander. The poem also describes the garden of the peasant, where he grows crops to sell on the market. Here we find cabbage, beets, sorrel, mallows, elecampane (a very bitter root), leeks, lettuce, radishes, and pumpkins.

40. Quintilian, Book VIII, iii, 11–12, who uses the word *institor* (vendor). For the quotation, see Erasmus 1979, 10.

41. Bakhtin 1968, 160–89; see also Losse 1980, especially 33–41 and 50.

42. Colie 1966, 276; see also 64 and 70. See also Bryson 1990, especially 145–50.

43. Junius 1588, 239–40, in my translation; see also Muylle 1986–87.

44. For example, Aertsen's *Meat Stall* (fig. 3) is dated "1551.10.Martius"; and his *Kitchen Maid* (Brussels, Musées Royaux des Beaux-Arts) is dated "1559.16. Cal.Aug."

ANNE W. LOWENTHAL

Contemplating Kalf

WILLEM KALF'S *Still Life with a Nautilus Cup* (Fundación Colección Thyssen-Bornemisza, Madrid; fig. 16; pl. II) is signed and dated 1662, when the so-called Golden Age of Dutch painting and the artist himself (1619–93) had reached maturity.[1] The picture is well known, but neither the full measure of its content nor the range of its peculiar semantic structures has been taken. Certainly no single analysis can do so. The method I offer here places more than the usual emphasis on the depicted objects, identifying and evaluating their origins, functions, and thematic and formal relationships. Since these ways of creating meaning are literally shaped by the painting technique, that, too, will inform this effort to define in phenomenological and historical terms the pictorial strategies that Kalf has devised to engage the beholder.

Despite the inclusion of edibles, this is not a meal but a display, a *pronk* still life, a concentration of *objets de luxe*.[2] The setting is a rumpled carpet on the corner of a marble-topped table. Light holds us there, revealing and animating the things gathered together. Beyond, we are plunged into darkness. A nut and shells lie scattered on the very corner of the table, beside a silver platter, its highlighted rim extending over the edge. On the platter is a porcelain bowl, in which a silver spoon has been propped upright, the bowl's lid having been set aside. An agate-handled knife is tucked between the lid and a cut lemon with the peel coiling downward. Slightly back and to the right, a nautilus shell with silver-gilt mounts dominates these foreground objects as well as a large Seville orange, nestled in the folds of the carpet beside a *roemer* of white wine. At the center, rising above the nautilus is a glass covered goblet half full of red wine, flanked by two more wineglasses, a low footed one and a tall tapered flute, both holding white wine.

In addition to those colleagues whose support and aid I have acknowledged in footnotes, I would like to thank Jutta-Annette Bruhn, Lawrence O. Goedde, Rose Kerr, Alison Kettering, Sandra Knudsen, Clare Le Corbeiller, Jess McNab, Lisa Vergara, and H. Barbara Weinberg for help of various kinds in the preparation of this essay. The staffs of the Thomas J. Watson Library at the Metropolitan Museum of Art and the Frick Art Reference Library in New York and the Victoria and Albert Museum in London provided much appreciated assistance.

The organizing principle of the picture is opposition, of dark and bright, open and closed, high and low, active and reposed. As we shall see, these formal contrasts have thematic counterparts in the sweet and bitter, pagan and Christian, domestic and foreign, manmade and natural. Both the symbolic discourse and the more immediately perceptible visual one turn on the theme of polarities and preferred choices.

Identifying Kalf's objects is made difficult by his apparent preference for suggestion over description, a preference that informs the entire conception. The carpet, for example, is bunched so as to obscure its overall design. We can discern a long fringe and a guard border with regularly spaced floral ornaments, banded by a narrow guard stripe. The field is red, with a pattern of curving stems with palmettes and small flowers, which build to a medallion with striking white rays. But it has proven difficult to identify the type precisely. The stiff, kinked fringe bespeaks a woolen warp and thus a Turkish or Caucasian origin, yet the design is closer to that of Herati carpets from northeast Persia, such as the one in the Museo Bardini in Florence (fig. 17).[3] The guard border on Kalf's carpet seems exceptionally narrow, even considering that this was evidently a small rug used on a table. When we try to match it against surviving examples, or even carpets in Dutch paintings other than Kalf's, we fail to find counterparts.

Kalf is generally faithful to types of carpets brought to the Netherlands beginning about 1620, when the Dutch East India Company (V.O.C.) was established in Persia. This carpet's use as a table covering testifies to its value. In Persia carpets were spread out and sat upon, but they were not commonly used as floor coverings in the West until the eighteenth century. Such carpets were costly but not rare in the Netherlands; indeed, they were imported in considerable numbers, coming to Europe by various means. If a European trader bought carpets in a major center like Isfahan, he might then transport them by caravan to the port of Gamron, or Bender Abbas, on the Persian Gulf, where they could be stored in the V.O.C. warehouses to await shipment. Or, they could be sent through Mediterranean, Arabian, or Indian ports, or even transported overland through Turkistan, Russia, and Poland.[4]

Several of Kalf's objects resonate with exotic origins, a journey along the trade routes, and the long reach of Dutch mercantile power, which brought these riches home to *burgerlijk* tables. The nautilus shell had once lain on the shoals of the Pacific or Indian ocean. By 1605, Amboina, on the Malay Peninsula, where many nautiluses were caught, had become an important base for the V.O.C. The nautilus shells gathered there were

prized by Dutch collectors, who either kept them in their natural state or embellished them with techniques that included etching with acid, carving, engraving, and mounting in elaborate metalwork. When so treated, the shells became ceremonial drinking cups. The natural shape of the shell suited it ideally for that purpose, since the chambers of the nautilus reduced its holding capacity to that of a wineglass. The flaring, irregular lip of the natural shell was cut away, producing a straight edge that was usually lined with metal, like the lip of Kalf's cup.[5]

The covered porcelain bowl is yet another import, made in China probably in the so-called Transitional period, about 1635 to 1650.[6] The piece is of complex design, with a body and cover decorated in underglaze blue and enhanced with high-relief figures. On four sides stand pairs of the eight Taoist immortals, in unglazed porcelain that has been brightly colored and gilded; the lid is topped by a Fu-Lion.[7] Although the bowl has an imposing presence in the painting, it might have been quite small. A comparable bowl in the Rijksmuseum (Amsterdam; fig. 18) is only six and one-half inches high.[8]

Chinese porcelains had first reached Europe in the fourteenth century, but they appeared in quantity only after 1604. In that year, 100,000 porcelains from the captured Portuguese carrack *Santa Catharina* were sold at public auction in Holland for nearly 6,000,000 guilders. The Dutch coined the term *kraakporselein* for the blue-and-white wares carried by these freighters.[9] After 1602, the V.O.C. was a factor in the porcelain trade, competing with the Portuguese around the Cape of Good Hope. The *Witte Leeuw*, sunk in 1613 near St. Helena in the South Atlantic, carried thousands of pieces of blue and white.[10] Some export wares, called Chine de Commande, were made to order from Dutch models. The type Kalf depicts was probably not made exclusively for the Dutch market but was also handled as merchandise in the inter-Asian trade.[11]

Kalf's bowl is dramatized by a fall of light that emphasizes its plasticity and the eerie animation of the figures (fig. 19). It is a display piece, but it also was evidently pressed into service for fruit or condiments, to be served with a spoon. Pickled gherkins? Candied quinces? Strawberries and cream? The possibilities are considerable, and Kalf does not limit them with clues to a menu.[12]

Wine was clearly the drink, however, served in vessels of various kinds, examples of which survive. The *roemer* typifies those in common use (Rijksmuseum, Amsterdam; fig. 20),[13] but the tall covered goblet was more precious, in the *façon de Venise*. The stem section and finial are formed by glass canes twined in a two-dimensional coil resembling ser-

pents, thus the name "serpent glass" for this type, which today is rare. An example in Rosenborg Castle in Copenhagen (fig. 21) has a stem and finial of symmetrically twisted monsters with open jaws and cockscombs, like those that catch the light in the painting. The Copenhagen goblet is thought to have been made by a Venetian glassmaker in Northern Europe.[14] The virtuosity of Venetian glassmakers was renowned as early as the fourteenth century, and as Italian craftsmen moved into northern Europe, they shared their secrets. It is difficult to say with certainty whether the covered goblet that Kalf depicts was of Venetian or Netherlandish make. By the 1660s, the Dutch were adept at imitating complex Venetian techniques, but the result rarely equalled Italian models in refinement.[15] Painters could, of course, improve on their models, perhaps endowing a Netherlandish glass with all the delicacy of an Italian one.[16] Typically, however, Kalf does not linger over details. He evokes the glassblower's skill with an eruption of brilliant highlights, which seem almost detached from the form, expressive in their own right.[17]

The silver depicted was also opulent, probably of domestic manufacture, the product of a craft that had flourished in the Netherlands since the Middle Ages. The platter, which has a wide rim with an undulating contour and compartments with repoussé ornament, is a familiar type.[18] The spoon, too, is elaborate, with a heavy, scrolled handle appropriate to a serving utensil. Most surviving mid-seventeenth-century Dutch spoons are simpler, with slender stems, or handles, and small finials.[19]

Several of the objects depicted here recur, slightly modified, in other of Kalf's paintings. For example, the Chinese porcelain bowl reappears but with different blue-and-white designs.[20] Evidently, Kalf painted his models with artistic license rather than with loyalty to actual appearances. Kalf's artifice extends beyond the design of individual objects into his calculated arrangements, which, like almost all Dutch still lifes, give no hint of the apparatus—wires, props, water—that would have been necessary to sustain set-ups in the studio. In at least some cases, however, he did not even work from actual objects but instead depended on engravings or other models, conceiving his arrangements *uyt den geest* (from the imagination).[21] The illusion was itself an illusion, a product of the mind.

Another important aspect of artifice in Dutch still lifes is the conventionality of types and within them the limited repertory of depicted objects and motifs.[22] We can, for example, speak of a monochromatic breakfast piece and immediately conjure up an image of bread, wine, fish, and a knife in muted, neutral tones. A glance through Grisebach's monograph reveals the repetitiousness of Kalf's still lifes, especially those of his

late Amsterdam period. Almost invariably, they depict the corner of a table with light falling from the left. Many of the objects in the Thyssen-Bornemisza painting—orange, lemon, wineglasses, silver platter, knife, nuts, carpet—recur often in other paintings, though of course in different compositional relationships. Some of Kalf's conventions continue established Dutch practice, for instance, the knife at the edge of the table, its handle toward the viewer, and the cut lemon with a spiraling peel. From the artist's viewpoint, such conventionality obviously provided an efficient modus operandi. From the beholder's, it effectively satisfied expectations of the typical. Goedde emphasizes the function of pictorial conventions and formulas as bearers of meaning, which "can be analyzed for evidence of what contemporaries expected to see—or not to see—and what they found significant and worthy of representation out of all the multiple possibilities of existence."[23]

It follows that deviations from convention were also meaningful, charged by the element of the unexpected. Kalf surprises us with a novel motif in the *Still Life with a Nautilus Cup*. The cup itself is very similar to one in a still life by Pieter Claesz, dated 1636 (Westfälisches Landesmuseum für Kunst und Kulturgeschichte, Münster; fig. 22).[24] The foot and stem are formed by a male figure (a satyr astride a sea creature in the Claesz, a merman in the Kalf), bearing the nautilus shell in his raised arms. The mount of the shell forms the toothy jaws of a finned monster, about to close on a tiny, desperately running figure, probably Jonah.[25] On the monster's brow is Neptune, with his trident. Both these painted cups are quite like a magnificent nautilus cup made by the Utrecht silversmith Jan van Royesteyn in 1596 (Toledo Museum of Art; fig. 23).[26] Claesz might well have used this cup as his model. Kalf could have depended either on Claesz's painting or on the cup, perhaps even both, although if so he typically introduced variations.

The Jonah figure is barely visible in the Claesz, but Kalf elevates and isolates it against the dark background. The story of Jonah's three days and three nights in the whale's belly, and his subsequent release by the Lord God, is well known to readers of the Old Testament. Jonah prayed to the Lord, "For thou has cast me into the deep, in the midst of the seas; . . . When my soul fainted within me I remembered the Lord; and my prayer came in unto thee, into thine holy temple. They that observe lying vanities forsake their own mercy. But I will sacrifice unto thee with the voice of thanksgiving; I will pay that that I have vowed. Salvation is of the Lord" (Jonah 2:3–9). In the New Testament, Jesus referred to Jonah as prefiguring his own death and resurrection, remarking also on the

repentence of the wicked people of Nineveh, whom Jonah had alerted to the terrible consequences of God's wrath (Matt. 12:40). In response, those sinners "proclaimed a fast, and put on sackcloth, from the greatest of them even to the least of them" (Jonah 3:5).

Kalf's figure of Jonah runs toward the covered glass goblet that holds red wine, his outstretched hands precisely at the level of the wine (fig. 24). Is this just a fortuitous juxtaposition, or are we to make something of it? Formal emphasis suggests the latter. Compositionally, the glass wine cup is the cynosure of a movement that spirals from the lemon peel up and back into depth, through the lid of the porcelain bowl and the nautilus shell, climaxing in the sparkling highlights of the elaborate finial, which soars to the picture's upper edge. The lip of the silver-gilt mount overlaps the red wine, reinforcing their pairing. The tall covered goblet marks the painting's central vertical axis, and the wine is just above the horizontal one. Thus the pairing of Jonah and the wine gains visual, and I believe thematic, importance through formal means.[27] The splendid nautilus cup dominates a display of material wealth and, implicitly, of Dutch mercantile power and artistry, yet, ironically, it carries a message of penitence and spiritual resurrection. Red wine, a quintessential Christian symbol for the blood of Christ, is Jonah's goal. We need not strain to interpret this pairing as an ingenious reminder of repentance and salvation in the midst of temporal riches. No metaphysical poet could have devised a wittier conceit.

Such a reading requires time, alertness, and reflection, which we know to have been a characteristic way of looking in the seventeenth-century Netherlands.[28] It also requires familiarity with pictorial conventions, so that the unexpected can challenge and intrigue. Clearly it requires a receptiveness to symbolic import.[29] Of course, each of Kalf's objects had an actual life in daily use, but in a painting it could also have a symbolic one, in a system that linked the microcosm of the quotidian with the macrocosm of universals. Nicolson refers to the pervasive Dutch "habit of thinking in terms of universal analogy," which bound the daily life of man, and man himself, to the whole of creation.[30] Since symbolism could be drawn from a wide range of sources, including the Bible and emblematic literature, to name only two major ones, objects could have multiple and conflicting implications, activated and controlled by their interrelationships in a given image. This polysemy is the key to discovering in Dutch paintings what I have elsewhere called a "moral dilemma."[31] By generating implications without endorsing any one, artists could invite the beholder to weigh alternatives, creating an analogue for the choices

routinely confronted in life. There is no single valid interpretation for images so constructed, no set "meaning" for any given thing, no single message, like *vanitas* or temperance. Rather, a web of resonances engages the viewer's imagination, eliciting active participation.[32]

Kalf employs such a strategy with exceptional subtlety. For example, wine flowed freely in Dutch homes, and it was a commodity that brought shippers considerable wealth.[33] A glass of wine in a painting might inspire thoughts of well-being, inebriation, and conviviality on an immediate level, as well as of the Eucharist on a more elevated one, especially if the latter connection is reinforced by the presence of bread or another motif with Christian implications.

The nautilus cup attracts attention through stunning opulence and a translucence unexplained by natural illumination. The shell seems even to hold light and thereby to gain a spiritual power. If this cup were to be used as a drinking vessel, the red wine would provide a modest draft. By implication, Kalf conveys the idea expressed more explicitly in another surviving nautilus cup, in which the mount bears an inscription reading in translation, "Since I am a bearer of evils when I contain large drafts, I commend moderation to you."[34] In the paired nautilus cup and wine in Kalf's painting, the themes of salvation, indulgence, *vanitas*, penitence, and moderation are simultaneously in play. The tensions between readings *in bono* and *in malo* are held in equilibrium, since neither is endorsed.

Other conventions are nuanced too. Knives placed at the table's edge with the handle offered to the viewer's grasp are ubiquitous features of Dutch still lifes. Kalf's knife, just beside the lemon, implies the deliberate care with which the rough skin has been evenly pared away to expose the glistening flesh (fig. 19). Until late in the seventeenth century, table knives were individual possessions, and some of that personal character is conveyed by the considerable variety depicted in paintings.[35] This one is of cool, smooth agate, with striations that mimic the curl of the lemon peel and spiral into depth. The knife's prominence, individuality, and implicit invitation give it personalized force as a symbol of discrimination, the cutting away of the unwanted, of the bad from the good.[36] Choice is implicit.

Citrus fruits are also conventional features of Dutch still lifes, although they could be grown in the Netherlands only with difficulty.[37] The best ones were imported, spoiled quickly, and thus were fleeting luxuries. Kalf's Seville orange is topped by a flourish of leaves, a reminder that orange trees are evergreen and could thus signify immortality. Moreover,

in Jan van Eyck's Ghent altarpiece, Eve holds not an apple but a Seville orange, the fruit of the Tree of Knowledge of Good and Evil.[38]

The spread of nuts is also a still-life convention, but this alone cannot account for their inclusion here, unless we assume that Kalf mechanically followed tradition. These nuts are not visually compelling, nor were they prominent in the Dutch diet, but they do hold Christian imagery, modestly and in miniature, for the three layers of husk, shell, and nutmeat were venerable symbols of the Trinity and Christ.[39] Kalf depicts one nut in the shell, at the intersection of table's edge and background, so as to call attention to its shape; a cracked nut, the meat exposed, lies nearby. To judge from the pointed form and rough surface of the whole nut, these are almonds.[40] Dodonaeus describes two types, bitter and sweet, and debates their relative virtues. Bitter almonds, while virtually inedible, were medicinally useful. Sweet almonds were tasty in tarts and marzipan but not helpful for curing illness.[41]

None of this symbolism was recondite, for all the associations I have mentioned were alive in daily experience, were received information, or were readily accessible to the literate Dutch. Moreover, the symbolic discourse is embedded in a formal structure based on the principle of opposition and contrast. Kalf offers these dualities in a painting technique that, while uncannily illusionistic, implies rather than defines, frees rather than constrains. Innuendo surrounds the image like an aura, a formal analogue for the teasing thematic ambiguities. Like all still lifes, this one is a miniature universe with its own laws and limitations. Without representing a single animate creature, like the insects, butterflies, and amphibians that enliven many Dutch still lifes, Kalf creates a world that teems with activity, as mortals, immortals, and animals go about their business. The brightly clad Taoist figures encircling the bowl engage in animated exchange. The merman bears the nautilus shell like Atlas struggling to hold aloft the earth. The Fu-Lion menaces him, and he seems to look warily away. Jonah flees as Neptune stands guard above. This microcosm encompasses East and West, myth and scripture, mortals and immortals, ancient yet vivid creatures bound into a population that grounds the image in human experience, while conjuring up the larger universe to which it belongs.[42]

The sumptuous content and technical brilliance of Kalf's late paintings make them synonymous with *pronk* still life. That label, however, even with its implications of *vanitas,* fails to do justice to the complexity of Kalf's evocation of the temporal and the eternal in the *Still Life with a Nautilus Cup.* Through myriad pairings and oppositions, dialectical ten-

sions mirror the infinitely bifurcating moments of daily life, provoking a search for the mean that informs a virtuous life. That an intricate thematic structure can be discerned here speaks for the enrichment, not erosion, of Dutch pictorial imagery well into the seventeenth century. While the *Still Life with a Nautilus Cup* has an unusual cogency and power, its pictorial and thematic structures might well inform other still lifes by Kalf and his contemporaries. Interpretations that respond to the idiosyncrasies of the image, to the interplay of depicted objects on functional, pictorial, and symbolic levels, could unlock those structures.

Notes

1. Canvas, originally 78.5 × 66.8 cm. relined and irregularly cut to 79.4 × 67.3 cm. Signed upper left "W KALF Fecit"; dated upper right "Ao 1662." Inv. no. 203. Gaskell 1990, 74–77, no. 10. Andrade and Guerrero 1992, 509. Gaskell, 77, following Grisebach 1974, 267, lists two copies, to which should be added a third, in the New-York Historical Society, Luman Reed Collection, inv. no. 1858.15. See Foshay 1990, 179–80, pl. 41.

2. For a survey of the type, see Segal 1988, which includes the Thyssen-Bornemisza painting on p. 248, no. 55, as dated 1660. Ill. in color p. 182.

3. Inv. no. 555. My thanks to Daniel and George Anavian for help in describing and identifying the characteristics of Kalf's carpet. Grisebach 1974, 121, calls it a Herati from East Persia dating about 1600. Ydema 1991, 162, no. 470, lists it under "Persian Carpets," and 62 and 64, fig. 54, mentions it as featuring a common type of inner guard border. The carpet in the Museo Bardini (fig. 17) has been published as Northern Indian, seventeenth century; see Boralevi 1981, 8, no. 8.

4. Ydema 1991, 59–60.

5. Osborne 1975, 584–86.

6. So dated by C.J.A. Jörg of the Groninger Museum, because of the "characteristic Transitional flower motif along the rim, a simple blossom with an outstretching leaf on each side" (letter to me of 9 December 1992). My thanks to Jörg for this and other information about Kalf's porcelain bowl. For other datings of similar bowls, see note 8.

7. On the Taoist immortals, legendary personages who symbolized long life and immortality, see Ou-I-Tai 1959, 405–7. The Fu-Lion, or dog, was a symbol of prosperity, valor, and energy, according to Segal 1988, 195.

8. Legaat Westendorp, MAK 563; described by the museum as Ming dynasty, T'ien-ch'i period (1621–27). See Lunsingh Scheurleer 1985, 82, no. 68. Two other examples lack covers: Museum Het Princessehof, Leeuwarden, inv. NO 2191, Miedema 1964, 30–31, K 162, ill.; and Zeeuws Museum, Middelburg,

Lunsingh Scheurleer 1974, 51, 210, and pl. 27, as late Ming dynasty, Wan Li period (1517–1619).

9. Rinaldi 1989, 45, notes that from 1604 to 1657 more than three million porcelains were shipped to Europe. The bowl Kalf depicts may or may not be *kraakporselein,* depending on how restrictively the term is used. See pp. 185–87 for similarly shaped vessels.

10. Van der Pijl-Ketel 1982. Such wares are still prized. The cargo of twenty-eight thousand pieces of Chinese porcelain from an Asian trading junk that sank off the Vietnamese province of Vung Tau around 1690 recently fetched $7.1 million, triple the estimate, at Christie's, Amsterdam, 7–8 April 1992.

11. Letter to the author from Jörg (see note 6).

12. Rose 1989, especially 97–105. This bowl is frequently described as a sugar bowl, but sugar was then sold in small lumps—called *kandij*—which would have been served differently. Letter to the author from Jörg; see note 6.

13. Ritsema van Eck and Zijlstra-Zweens 1993, 134, no. 188.

14. Boesen 1960, no. 91. Height 58 cm. diameter 10.5 cm. No. 114 in the same catalogue is a goblet with an oblong octofoil bowl that resembles still another wine glass in the painting, the one barely visible to the left of the covered goblet, just behind the porcelain bowl.

15. Compare a covered goblet made in the Netherlands in the mid-seventeenth century illustrated in Harden et al. 1968, 172, no. 240. British Museum reg. no. 73, 12-4, 1.

16. Corning 1952, 21–22, pl. 6.

17. On Kalf's treatment of light, see Grimm 1988, 186–87, in the context of optical discoveries from Kepler (1600) to Newton (1704). See also Grimm 1984.

18. Compare Citroen 1984–85, 50, no. 35, and 61, no. 50, both illustrated.

19. Schroder 1983, 171–75, nos. 71, 73.

20. Grisebach 1974, cat. nos. 114–16, 139, and 140.

21. There are no inventories to disclose whether Kalf owned objects he depicted. The fact that he evidently did not own a house (Grisebach 1974, 25; Mai 1990, 10) suggests he was not wealthy. On Kalf's working method and objects see Grisebach 1974, 96–97, 120–29, and 162–65.

22. See Goedde 1989a, 36–37. Goedde 1989b argues for the importance of conventionality at greater length, 15–21. Sluijter 1986 approaches the interpretation of genre pictures similarly especially on pp. 3 and 8.

23. Goedde 1989b, 16.

24. Segal 1988, 238, no. 30 (color illus., p. 123).

25. Grisebach 1974, 173–74. Gaskell 1990, 77, suggests without explanation that the figure might instead represent Ulysses escaping Charybdis. Although the presence of Neptune would accord with this classical imagery, that in itself is in my view not enough to support Gaskell's identification.

26. Inv. no. 73.53; height 28.8 cm. Exhibited in Den Blaauwen 1979–80, 16, no. 7.

27. If Kalf indeed depicted the same nautilus cup without the running figure in

the still life with E. G. Bührle, Zurich (Grisebach 1974, 173, and cat. 118, fig. 136), the figure's significance in the Thyssen-Bornemisza painting would be underscored. Its apparent omission may, however, be due to the restoration reported by Grisebach.

28. See Goedde 1989a, 40–43, for a discussion of *ekphrasis* and still life.

29. For willingness to see more than a "mirror of nature" in Dutch still life, see the following range of current approaches to interpretation: De Jongh 1982; Segal 1990; Goedde 1989a; and Bryson 1990, especially the discussion of Kalf's *Still Life with a Nautilus Cup,* pp. 124–31.

30. Nicolson 1962, 19. Quoted and discussed by Goedde 1989a, 37–38.

31. Lowenthal 1988.

32. For an interpretation of Pieter Claesz's *Still Life with Oysters,* Toledo Museum of Art, as a "meditation on choice," see Lowenthal 1986.

33. Schama 1987, 193.

34. "HOSPES MALORVM CVM FERAM FONTES, TIBI COMMENDO SEDVLO MODVM 1595". Schroder 1983, 107–9, no. 33.

35. On the use of knives, see Hayward 1956, 3–4; and Gruber 1982, 22–23.

36. Segal 1983, 51, citing Valerianus among others.

37. Jan van der Groen, *Den Nederlandtsen hovenier,* 1669, does not mention oranges among commonly grown fruits. In the section on trees, however, he describes the nucleus for a large country house, including oranges and lemons, which needed winter shelter in a hothouse. Cited and discussed by Hunt 1990, 166–70.

38. Segal 1983, 37. Snyder 1976 identified Eve's fruit as "a rare citrus specie common to Portugal and the Canary Islands and known there as a *Pomo d'Adamo* or 'Adam's apple.'" Sam Segal informs me that "Seville orange" is a generic term for several varieties of bitter orange. The fruit Eve holds in the Ghent altarpiece is of this type, but Segal believes it cannot be precisely identified. Moreover, in response to Snyder's thesis, Segal points out the uncertainty that the citrus in question was called an "Adam's apple" before the late sixteenth century. My thanks to Sam Segal for sharing his expertise.

39. Segal 1983, 36, citing St. Augustine among others.

40. Hvass 1965, 19, no. 28, *Prunus amygdalus,* illustrating husk, shell, and meat. Kalf shows only the latter two.

41. Dodonaeus 1644, vol. 6, book 28, pp. 1250–52.

42. Goedde 1989a, 36–38, 40, suggests that still life be interpreted using the analogy of history paintings with human figures, an approach particularly suitable here.

Recasting Ancestry: Statuettes as Imaged by Three Inventors of Photography

The object world in general exists as a rebus, spelling and re-spelling the human name.

—Philip Fisher[1]

PLASTER casts and various statuettes are posed throughout the history of photography from the earliest experiments of Hippolyte Bayard, Jacques Mandé Daguerre, and William Henry Fox Talbot up to the work of today. The presence of these replicated figures in the twentieth century is understood as prompted by a variety of intentions, but their use at the beginnings of photography is generally considered merely an obvious practical choice, which, to some degree, it was. In Europe, the practice of taking plaster casts from Greek and Roman marbles and bronzes dates back to the sixteenth century, and well before the nineteenth century, casts from antiquity could be found in every art school and studio.[2] By the 1830s, the technological developments that had made the production and consumption of material goods possible on an unprecedented scale had also made possible a seemingly unlimited supply of statuettes. What had been primarily a pedagogical tool became a widespread commodity, an item of bourgeois home decoration. An increasing vogue for miniaturized copies of sculpture coincided, in fact, with the availability of photography and the early enthusiasm for the minute fidelity of daguerreotype reproduction.[3]

In addition to being popular, familiar, and available, marble and plaster reproductions were especially useful at the beginnings of photography because their whiteness allowed for a maximum luminosity, necessary to minimize the long exposure times, which could vary from a minute or

This essay was developed from a talk given in the session "The Object as Subject" at the Annual Conference of the College Art Association in 1991. My special thanks to Anne Lowenthal for her careful readings of several versions of my manuscript from its inception. Thanks also to those scholars who assisted me in identifying some of the statuettes and reliefs, in particular Elizabeth Bartman. In addition, this essay has benefitted from the comments and suggestions of the anonymous readers of the manuscript for Princeton University Press.

two to over an hour, depending on the site and weather conditions. It is indeed this practical aspect of their use that is stressed in the photographic literature of the time. Judging from this literature, the concerns of photography in its early stages seem mainly pragmatic: how to get the new process to work as efficiently and effectively as possible. The very strength of photography (or weakness, depending on one's opinion) was understood to be its supposed mechanical neutrality. Photography was extolled—and condemned—because it *eliminated* the vagaries of imaginative and subjective interpretation.

Nonetheless, many aspects of the choice of statuettes and plaster casts by the first photographers call into question the utilitarian and technical rationale that was given then and is still, with few exceptions, unquestioned today.[4] All categories of objects function within a ramified system of symbols and values that are integrated into their representations with varying emphases; and the very craze for statuettes, these mass reproductions of ancient and not-so-ancient sculpture, connected their users to a network of public and private discourses and attitudes.

For one, they referred to the public presences of their originals, that is, to forms of visual display that had recently been modified by the development of galleries and museums. Private galleries had been open to a public under the Enlightenment, but in the nineteenth century the European art collections that had been scattered during the French Revolution and the Napoleonic wars were assembled in different configurations according to new systems of assembly. Both the objects themselves and their audiences entered a new order within the recently founded national collections. Emphasis was less on the individual works and their aesthetic or cult values than on relationships among works as they constructed an art historical lineage—a lineage woven into the uneven fabric of national and individual identity.[5] Discussions revolved around not only the structures and modes most appropriate for the selection and display of sculpture, painting, and artifacts, but also the ways individuals of various classes and occupations might be positioned in relation to these cultural objects.

Early nineteenth-century publications particularly emphasized an ongoing mental assimilation of material historical markers. In France, the twenty-volume *Voyages pittoresques* (organized by Baron Justin Isidor Taylor in 1820 and continuing to 1874) provides a landmark series of documents. Charles Nodier's introduction to these volumes, which were intended to provide a province-by-province survey of the architectural monuments of the medieval monarchy, presents their lithographed illus-

trations as oriented primarily to associative processes: "We are not treading in the footsteps of history. We are only summoning history to conspire with our emotions and to strengthen them. . . ."[6] Nodier then elaborates that he is not referring primarily to personal emotions, but to specific associative guidelines furnished for his audience of gentleman travelers, guidelines that call upon an allegorical imagination whereby a monument will be understood as part of a larger, politicized thematic.[7]

In England, at the same time, William Hazlitt's fantasized "gallery in the mind," which located art objects in mentally constructed interior spaces alongside other material possessions, also can be situated within the broader context of nineteenth-century European discourses on associative reception of visual imagery. Hazlitt refers to the possibilities offered by such a mental gallery in rethinking a past as well as a present. It is a place where one can "con over the relics of ancient art bound up 'within the book and volume of the brain. . . .'"[8]

Sculptural reproductions, lacking the aura of original authorship and the patina of antiquity, were clearly settled within a system of consumption and exchange, but they were also strongly invested with values beyond such a system. If the "real thing" was invested with meanings within the pedagogical spaces of the new museums and publications, its copies also acquired their "symbolic capital" in private spheres as they became processed into more personal relationships. Their mass reproduction introduced them as a literal part of the furniture of the daily lives of a vast number of urban dwellers. Any single work could be barnacled with a range of associations, especially as each brought into the home contemporary references to historical and mythological narratives. Sites that could have been reserved primarily for domestic tales of aunts and uncles, grandparents and cousins, became populated by Apollos or Eves, perhaps Poseidons or Gothic kings.

Certainly, sculpture and its copies had provided mental and material furniture prior to the nineteenth century, but as industrial capitalism came to dominate the economic life of Western Europe (and the United States), the new bourgeois home became a major framework within which and through which identity and experience were deliberately and often elaborately constructed. At mid-nineteenth century the proliferation of statuettes within the homes of merchants, entrepreneurs, clerks, actors, and the like had vulgarized and trivialized their use according to elitists such as Baudelaire, who in 1845 wrote disparagingly of the phenomenon of sculpture in the drawing room and bedroom as a return to a

less civilized, fetishistic state of the art.[9] Mid-nineteenth-century photographs reflect and participate in this public and private processing of statuettes, even as this activity on their part went entirely unremarked.

Of the many possible narratives sculptural reproductions may have introduced into the intimate spaces of the bourgeoisie, one is particularly evident in early photography, beginning with the work of the inventors themselves. Again and again these first photographs staged scenarios concerning ancestry, both personal and social, a theme that integrates them into the mainstream of contemporary debates around the positioning and significance of both an individual and a collective lineage in a new era of changing sociopolitical structures. The instability of regimes oscillating between revolution and reaction after 1789 and Europe's rapid industrialization brought about major changes in family, gender, and social structures, prompting a crisis of self- and class definition. Debates over such definitions affected all areas of public life—the new museology, anthropology, architectural restoration, religion, medicine, in short cultural productions of all kinds. Independently of one another the three men best known as the inventors of photography—Bayard, Daguerre, and Talbot—repeatedly imaged variations on this pervasive theme even as they tried to guess the unpredictable reactions of chloride of silver, mercury vapors, common table salt, carbonic acid gas, potassium ferrocyanide, gallic acid, and the like.

Bayard and Daguerre are typical examples of the population shift from the provinces to Paris during the first half of the nineteenth century, a shift that dramatically added to the ranks of the petite bourgeoisie and entrepreneurial classes.[10] This flow from the provinces filled urban centers with large numbers of relocated peoples who carried few material signs of pasts or pedigrees. Deracinated from their traditional forms of self-definition such as family heritage, trade, and provincial affiliations, these new immigrants experienced dislocations that were social as well as geographical. New, smoother roadways and the first stages of a network of railways increased the speed of transportation, prompting a sense of temporal dislocation as well. The unsettled conditions of the here and the there, the then and the now, all worked toward the construction of a subjectivity that, at various levels of consciousness, brooded over questions of personal, social, and cultural positionings and lineages.

Of the three men, Bayard was the most avid collector of figurines. Born in 1801, the son of a provincial judge, he had moved to Paris around 1828 and obtained a job as a functionary at the Ministry of Finance. He began his experiments in photography sometime during 1837 or 1838. He is

said to have owned about forty miniature casts of statues and reliefs; he would include up to fifteen in a single photograph.[11] His was a typical collection in its extensive range of subjects: Greek heroes, gods and goddesses, ancient Romans, Old and New Testament figures, putti, bathers, and busts of contemporaries (fig. 25). The copies were of works from an equally extensive geographical and chronological spectrum: classical Greek, ancient Roman, and medieval French, as well as European sculptures from the sixteenth through the nineteenth centuries. Bayard's cast collection seems to have been formed neither on the basis of style nor according to the status of the sculptors whose work they reproduced. Rather, he evidently acquired these plaster figurines because they were popular and easily recognizable. They comprised a common vocabulary that could be phrased in many ways—and indeed Bayard did phrase them, arranging and rearranging his casts of characters with many variations, very likely inspired in part by his frequent attendance at the Comédie-Française and other theaters.[12] He often documented his pictures as to process, chemicals, date, and exact time. He never identified his casts, neither the characters they represented, nor the epochs or makers of their originals.

At times Bayard put himself among his arrangements in place of a statuette, picturing himself as a thing among things, an item of exchange. His is a version of a condition of "thinghood" that was coming to determine structures of modern life and concepts of a modern self to a greater degree. By the mid-1840s Marx was elaborating on the social relations of people within a capitalist economy as "the fantastic form of a relation between things,"[13] understanding human relationships as being carried out between objects existing apart from their producers. Bayard pictured himself in a state of limbo: a displaced thing among replaced things and, as the photographer/director of the scenario, the producer of his own displacement.

By means of his self-objectification Bayard also made himself a literal term in his own system of representation. In one instance he is seated parallel to Eros and Psyche, his head next to that of a pseudo-Gothic head of a king (fig. 26). It is an example of a basic triangulation that Bayard suggests again and again: pagan sexuality/Christian ancestral power/contemporary man. There are no indications that Bayard's photographs were intended to be seen as a sequential narrative, but neither do they function as single, isolated incidents. Much of the meaning of each image is dependent on the inflections it acquires in relation to Bayard's previous and subsequent work. They form a type of series that is not

linear, but rather, like much still-life painting, "the series (plural) regroup themselves around the individual work, the boundaries of the series fluctuate around each new case."[14] Seen cumulatively in this way, Bayard's tableaux set up a repetitious commentary, ironic and often humorous, on the origins and cultural heritage of man as they were debated at the time in many diverse areas.

In the sphere of artistic production, a pre-Enlightenment, neo-medieval tradition whereby Christianity was perceived as the alternative to "pagan" classicism and as the embodiment of modernity itself was very much alive in the mid-1800s.[15] During the 1840s, within the newly formed academic disciplines of anthropology and ethnography[16] the debate on human origins pitted the ascendent monogenetic religious paradigm, which assumed one original Adamic origin for all races, against the polygenetic idea of primordially diverse races of man.[17]

Simultaneous with such debates, there were more immediate, practical concerns with lineage. In France these had been given particular focus by the enactment of Napoleon's Civil Code in 1804, which abolished primogeniture and replaced it with equal distribution of inheritance among all children. It became a matter of financial concern for a father to ascertain the legitimacy of *all* his children so as to assure the legality of their eventual claims to his fortune, thus prompting what one historian has seen as a national obsession with adultery among the propertied classes.[18]

Bayard's tableaux allude to this issue of illegitimate substitution, a theme most evident in the photographs that picture a statuette of Antinous (fig. 27).[19] One such arrangement is paired here with a second version in which Bayard has put himself in the place of the miniaturized cast of Antinous that had been known in France since the turn of the century (fig. 28). It depicts the Roman emperor Hadrian's Antinous, the beautiful young boy he loved who, it is said, drowned himself in the Nile to prolong the life of the ruler.[20] Upon Antinous's death Hadrian raised him to the status of a god and had his image reproduced by famous artists. Antinous also names a Homeric impostor, the most persistent of Penelope's suitors and the first to be killed by Ulysses upon his return. While Bayard may not have had Homer in mind, he is likely to have known of Hadrian's young lover, and many viewers of these still lifes, then and now, hold both the Greek and Roman identifications in mind.

In the second photograph Bayard has moved onto his lap a large medal that is beneath Antinous in the pendant version. If its identification as representing "un enfant François" is correct,[21] then Bayard is also cra-

dling a child successor, a future generation, either from the past or in the present.

Bayard's impostures speak to the very condition of the plaster cast and miniaturized reproduction, that of im-posture: the making of a replica, a secondhand construction, a substitute, not the "real thing." Ultimately, however, it was the very existence of the "real thing"—or even the importance of a known, true original—that was in question. In this photographic pair, as in others, Antinous is not alone but part of Bayard's familiar cast of characters: his medieval king and Eros and Psyche are joined by other members of his repertoire—Three Graces, a cherub, Eve at the fountain, and the three Magi.[22] The two stories of Antinous keep company within Bayard's glyphic allusions to the differing ideas of the origins of the human race: Adamic versus polygenetic, biblical versus pagan.

In some areas of activity at the time, impostures of a sort were not only tolerated but also encouraged, seen as more "true" than a possible original. Architectural restoration was being institutionalized in the years immediately preceding Daguerre's announcement of photography in August 1839, at a joint meeting of the Academy of Science and the Academy of Fine Arts. The Société Française d'Archéologie was founded in 1834, and in 1837 the Commission des Monuments Historiques was established to protect the French architectural heritage and to document it photographically. The motivating ideal was to restore a royalist continuity that had been ruptured by the Revolution. This is not to say, however, that a concern for authenticity was always primary. The gargoyles of Viollet-le-Duc, like other of his restorations, are emblematic in the sense that they are not copies or reconstructions but "new" medieval artifacts. Le Duc's ideas of restoration—not to repair or redo, but paradoxically to create a state that never existed—set off debates that can be situated within the broader context of debates concerning the recuperation of past history and filial legitimacy.[23]

On occasion, even when photographing on a rooftop, Bayard arranged his figures amid patterned and tasselled fabrics draped and swagged among shelves and pedestals, sometimes hand-coloring them later in bright pinks and yellows. His commonplace Gothic kings, Greek heros, Eves, and Graces gesture, petrified, among these impromptu curtains and coverlets. But often there are no props. Then Bayard's figurines read like white hieroglyphs on a dark page onto which the cameraman is sporadically inscribed, an oversized intruder from another alphabet, both

fabricator of and outsider to his own scenarios of lineage, illegitimacy, and substitution.

Concurrently, although not in any collaborative way, Daguerre was setting up similar scenarios, at times using identical mass-produced statuettes. Son of a minor clerk on the royal estates at Orléans, he arrived in Paris in 1804 at the age of seventeen and was apprenticed to the stage designer Degotti and later to Pierre Prévost, a famous painter of panoramas. By 1816 he was a stage designer on his own, and in 1821 he began work on his Dioramas, enormous transparent paintings under changing lighting effects, which became immensely popular as spectacles in and of themselves. His interests in the possibility of photography started in 1823; by 1829 he had entered into partnership with the earlier experimenter Nicéphore Niépce.

Daguerre never inserted himself as a literal presence in his tableaux as did Bayard. Neither did he ever omit a clutter of props surrounding his statuettes. True to his métier, he set up scenes with objects on a shelf or table, nestled among drapes and accessories. His figurines are never other than objects, never glyphic in the sense that the viewer is prompted to read them outside of the milieu of their obvious studio compositions. Despite these differences in style and technique, however, Daguerre shares similar themes of ancestry and origins with Bayard. As a subscriber to the first volume of Baron Taylor's *Voyages pittoresques* in 1820 (and as a contributor of a lithograph), Daguerre was long familiar with an interpretive, associative approach to ancient monuments.

A daguerreotype of 1839 (fig. 29) includes a relief depicting Venus and Bacchus beside an overturned jug spilling its contents, a modern pastiche. Next to this relief is a hanging flask and adjacent to that a picture of a nineteenth-century woman, suggesting a corresponding association of wine and women. In the middle and right foreground of the photograph are two heads of amorini and two rams, the ram being one of Bacchus's metamorphoses and a common sign of the male, ardent, vital force that reassures the return of the regenerative cycle in spring. In its doubling of past/present joined with symbols of love and sensuality this picture more than hints at a continuing pagan image of sexuality and reproduction.

An earlier daguerreotype of 1837 combines Christian and pagan motifs (fig. 30). It includes a figurine of the flagellation of Christ (the same statuette that appears in many Bayard photographs), a glass and intact pitcher, common symbols of Virgin birth and female purity, and what, in this context, was perhaps intended as the hand of God. (It is the wrong hand, the left, but then Daguerre was never a theologian.) By contrast, the

central figure is most likely a copy of a Roman decorative herm representing Bacchus or his tutor Silenus, in either case, a pagan figure.[24] Also of Roman descent is the stele on the lower left showing small decorative figures within a columned portal.

Prominent in both a daguerreotype possibly by Daguerre (fig. 31) and a photograph by Bayard (fig. 32) is a bust of Charles Percier, a well-known architect and member of the French Academy of Arts and Sciences who had just died, in September 1838. Such portrait busts of contemporaries were very much in vogue, and then, as now, they were often objects of public demonstrations of political propaganda and agitation. Many incidents from the French Revolution and throughout the nineteenth century testify to their power (still strong today, as indicated by the numerous incidents of toppled and defaced statues of dictators and the like). In July 1789, just before the fall of the Bastille, when the crowds of Paris learned that the king had dismissed a popular minister, Jacques Necker, they went to the museum, seized Necker's bust, and paraded it through the streets. When the royal troops attacked the mob, their main target was not living flesh, but the marble statue, which they shattered.[25] At the center of a photograph by Charles Nègre from the 1850s is a bust of Napoleon III flanked by crowds of men tossing their hats on high in celebration. It was taken on the emperor's birthday and is the opening image of an album that depicts a workers' hospital in Vincennes established under the emperor's rule.[26]

Percier was ostensibly an incidental prop in both the daguerreotype and in Bayard's photograph, their raison d'être being a demonstration of the skills of the medium at its inception. Nonetheless, Daguerre's calculated appeal to influential political figures through his choice of subjects is well known, and scholarship is uncovering similar strategies on Bayard's part. That the recently deceased Percier was being honored by the Academy of Arts and Sciences, whose favors Daguerre, Bayard, and other early photographers were currying, can hardly be a coincidence.[27]

In any case, both images pay considerable attention to the placement of their surrogate object, posing it within alternate biblical and classical Greek and Roman heredities. In the daguerreotype, the bust of Percier is the foremost object in the picture plane. In the second plane behind him is a print showing a voluptuous, nude woman seductively placed within the huge wingspan of a very attentive black bird. It is probably a depiction of Jupiter seducing Io. In back of this image of classical seduction, and partially concealed by it, God the Father is enthroned within a pseudo-Gothic framework composed of the large, feathered wings of hovering

angels. To the right, a fragment of Renaissance armor shows Venus inscribing a shield and a bas-relief depicts the goddess Diana and a stag. Greek, Etruscan, and Roman fragments of architectural decoration make up the furthermost plane of this arrangement. Off to one side a cupid gestures toward the whole scenario like a stray prompter or a diminutive director.

In the pairing of God the Father and Jupiter's seduction of Io, references to origins are again both biblical and pagan. In this case, the various styles, especially the architectural elements, may also refer to the work of Percier. Throughout the Napoleonic era, Percier and his partner, Pierre-François-Léonard Fontaine, were the official government architects and decorators, and they became highly influential for their special brand of neoclassicism known as the "Empire" style in architecture, interior design, and furnishings. While their emphasis on archaeologically accurate earlier Greek models was pronounced, they also incorporated into their work Imperial Roman motifs, French and Italian Renaissance elements, a bit of Gothic, and many Egyptian themes as well. Whether the arrangements of eclectic fragments in this daguerreotype were intended to refer specifically to Percier or are a more general reflection of a modern, deracinated condition, they constitute—in the most literal sense—Percier's background.

Bayard's Percier, stern and frontal, is perfectly aligned with the ubiquitous medieval king, but an Eros and Psyche on an elaborate mermaid pedestal act as a divide between the two. Below and to one side an Eve, a Venus de' Medici, and a Roman copy of a Greek slave, all recopied and miniaturized, complete the cultural ancestral scenario.

William Henry Fox Talbot arrived at a similar theme of ancestry from a different perspective and visualized it in a different photographic way, never setting up little scenarios as did Bayard and Daguerre. Born in 1800 at the country home of the Earl of Ilchester, by age eleven he had been sent off to Harrow School and then on to Trinity College, Cambridge, where he was awarded the Chancellor's Medal for "the best appearance in classical learning." In 1827 he took up residence at his family estate of Lacock Abbey. Shortly thereafter he became a Fellow of the Royal Society and a Whig Member of Parliament. His interests were eclectic: mathematics (1838 Royal Medalist for researches in calculus), etymology (first translator of the Assyrian cylinder of King Tiglath Pileser), and, almost as a sideline, photography, with which he began experimenting in 1833.

In using statuary Talbot repeatedly photographed just a few pieces in isolation under varying conditions of light. Talbot's most often photo-

graphed plaster cast was a bust of Patroclus, of which he made at least eight images in 1840.[28] Two of these (figs. 33 and 34) appear as plates 5 and 17 in his book *The Pencil of Nature,* published in 1844, the first book to be illustrated with photographs.

The text to the Patroclus photograph of plate 5 is an entry typical of its era, being concerned with technical observations. It reads, in part:

> These delineations [of statues] are susceptible of an almost unlimited variety. A statue may be placed in any position with regards to the sun . . . the directness or obliquity of the illumination causing of course an immense difference to the effect. . . . The statue may then be turned round on its pedestal, which produces a second set of variations no less considerable than the first. And when to this is added the change of size which is produced on the image by bringing the Camera Obscura nearer to the statue, or removing it further off, it becomes evident how a very great number of different effects may be obtained from a single specimen of sculpture.[29]

Talbot clearly states a technical interest in his subject as an object, but such functional terms also implicate a nineteenth-century tradition that understood the effects of light and shadow as an important factor in the fabrication of meaning. For Constable the sky was "the chief organ of sentiment . . . the source of light in nature, and governs everything."[30] At the time Talbot was experimenting with photography, Ruskin was elaborating his theories on chiaroscuro and gradations of light, which would later lead him to "the intense meaning" of Turner's "shadow abstracts" and to the conclusion that "the shadow is by much a more important element than the substance."[31]

For Talbot, implications of contemporary discourse on light and its effects were always closely associated with the linguistic ramifications of words related to light and to the objects it illuminated. His *English Etymologies,* published in 1847, lists repeated fantastic and mythological connections to the etymons he relates to the word "sun." His highly imaginative researches ("a kind of alchemical activity," as one writer has put it)[32] extended to all sorts of objects as well. Every "thing" was a matter for further thought, an idea specified by the entry he supplies for "thing" in *English Etymologies.*

> So very abstract a term as a *thing* must have caused some difficulty to our early ancestors to determine what they should call it.
>
> They made choice of term derived from the verb "to *think.*"
>
> Any*thing* is any*think*—whatever it is possible to think of. . . . I think it

probable that the word *Thing* (Germ. *Ding*) may have originally meant a word: i.e. any thing *we may chance to speak of,* and that it may have been identical with the old Latin *dingua* (for *lingua*) mentioned by some writers.[33]

Talbot's photographs tend to present his "things" as objects "to be spoken of" and thought about rather than primarily as items of display or of use and habit. All signs of their physical site are absent, and in many of the Patroclus pictures the statue's very base has disappeared. Segregated from routine and distanced from the aesthetics of public display, the head, ungrounded, is free to conjure up a variety of associations. The story of Patroclus would have been familiar to Talbot. Etymologist and classics scholar that he was, Talbot would also have been aware of the translation of the hero's name as "Glory to the Father."

In itself the choice of such a bust is not unusual, since it is the kind of object one might expect to find in a connoisseur's collection.[34] That Talbot purchased the Patroclus bust early in 1839 just for his photographic experiments is also unexceptional. In the context of Talbot's lively and eclectic mind and the particular circumstances of his life, however, this choice of object to image and re-image according to different lights and camera distances seems far from arbitrary.

The Patroclus bust was acquired and photographed at a time when Talbot was well settled in his family estate and himself a father of three. This was an important, hard-won stability, since his father had died during Talbot's infancy, leaving the family in such debt that they had been ousted from their ancestral home for twenty-seven years. Anxious about his status, he changed his name from that of his father, Davenport, to Talbot upon taking possession of the estate at Lacock. Concentrating on a single, named object as it was variously effected by photography's processing of light, Talbot pictured a thing of stone, of immutable matter, as elusory and as shifting as words themselves, and as capable of unexpected metamorphoses as were his own persona and status.

Using tricks of light Talbot blurred distinctions between the animate and the inanimate, between flesh and its representation, effecting those transgressions that occur so frequently in Romantic literature, for example, in works by E.T.A. Hoffmann, Edgar Allan Poe, or Théophile Gautier. Reversing his role of decipherment as an Assyriologist, Talbot created mutable pictographs that were not to be fully equated with one soluble signification.

Many other photographs by Talbot from 1840 attest to the importance

of home, family, and possessions. He took pictures of his wife and three children (all daughters!) and of his estate. He made photographs of many of his possessions, such as porcelain and glass (fig. 35), and even of the girls' toys. Unlike the Patroclus photographs, these pictures are primarily taxonomic, classifying things into various categories, a demonstration of the camera's usefulness as a tool for inventory in case of theft, as Talbot suggests in *The Pencil of Nature*. Nonetheless, such inventories also imply a self-definition, according not to ancestry but to the possessions of an immediate present. Moreover, even considered as practical demonstrations, such photographs are related to an eighteenth-century still-life trompe l'oeil tradition of objects and figurines on shelves and mantelpieces known as "conversation pieces."[35]

Talbot's pieces of china and glassware, aligned as they are in rows, segregated from any domestic context, but placed within the context of Talbot's (often whimsical) etymological thinking, evoke a series of things isolated for mental inspection if not actual conversation. Like the bust of Patroclus and other objects photographed by Talbot these do not function as cyphers or as symbols for something other than what they are. A glass is a glass and not a potential sign of virginity, as in Daguerre's tableaux. Nor are Talbot's objects interrelated with or substituted for one another as are Bayard's figurines. Whether in isolation or as part of a taxonomic display they suggest above all their possible relationships to Talbot himself.

The syntax changes from inventor to inventor, but all three men re-image their casts of characters according to a similar, almost childlike exercise in creating miniature worlds and characters of their own, worlds and characters that function as commentaries on larger worlds beyond such control. This visual play comes from a long tradition; it is implicit in the very mythology that is referenced in these photographs.

Yet, when composed by photography, such constructs underwent a change. The labor and intentionality of the photographer always seemed smaller and more dependent than that of the creator in any other manufacture. As the title of Talbot's book indicates, photography was considered the pencil (and thus the inscription) of *nature,* not of the cameraman. Or, as the painter J. F. Millet is quoted as having said, photographs were "like casts from nature."[36] The effacement of the photographer's role as author also effaced the photograph's role as a form of representation; the picture seemed merely to transfer a reality to the space of viewing. This apparently uncritical presentation of materiality caught photography's practitioners and its viewers off guard, as it were. Former pictorial differentiations between the "real" and the represented were disrupted; the

53

found and the constructed became less distinguishable. No matter how deliberately its objects were arranged, the photograph never seemed as self-contained as a painting. Subtractive rather than additive, it was always haunted by the awareness that the picture was taken *away* from a larger scene. The specters of infinite worlds beyond the edges of the photograph mocked any notion of containment. It has been speculated that trompe l'oeil painting "so mimics and parodies the sense of the real that it casts doubt on the human subject's place in the world, and on whether the subject *has* a place in the world."[37] Photography, although often less mimetic and imitative in appearance than trompe l'oeil painting, dislocated human agency to an even greater degree, rendering the human subject even more dispensable in its creative schema.

In challenging human authorship, photography presented its own particular issues of lineage and legitimacy, unsettling previous criteria for the value of visual representation. At the most obvious level, photography undermined the value of accuracy in other mediums. No draftsman could match the all-inclusive certainty of detail provided by the camera or the subtlety of gradation in tone of the photographic print. As a pencil of nature *her*self, a nature typically constructed as female, photography presented an unexpected (and largely unsuspected) paradigm for a certainty of origins that is always lacking in any patriarchal formation of descent. Technically bound as it was to its referent, the photograph could not produce bastards. Its legitimacy as evidence was unquestioned, detracting from the testimonial value of other forms of visual imagery, encoded for the most part as masculine.

The mass-produced statuettes within the photographs recalled another parallel diminishment of male hegemony. These repeated figures were part of a fashion that transferred sculpture from traditionally male, public spaces of display to the recently feminized, private spaces of the bourgeois home. The figures' reduction in size to meet the demands of a new market also implicates realignments in gender as well as class structures.

This relation to a differently gendered world is not made overt in the still lifes of Bayard, Daguerre, and Talbot, which situate their figurines apart from any immediate domestic clues; nonetheless the rapid proliferation and domestication of such statuettes inevitably affected any contemporary viewing of them. If, as Marx was then beginning to articulate, the exchange values of commodities were such as to constitute a relation between men as a relation between things, such things were increasingly reconstituted and regendered as they passed among different hands and locations.

54

Three-dimensional representations of human beings continue to figure prominently as objects for today's photographic practices.[38] The continuation of this motif is not one that consciously builds on earlier examples—in fact, photographers are often unaware of the work of their predecessors. It is instead the activity of photographing three-dimensional human likenesses that forms an ongoing background. The fabricated human figure has, for more than 150 years of photography, held a perverse attraction for users of a medium that is characterized by its very ability to eliminate such indirect routes to representation. Statuettes often are chosen to mediate between a living subject and its direct exposure.

Unlike the earliest photographers of figurines, many of those working with this theme today are women. Their work consciously underscores a cultural dependency on an object-other that can never be fully assimilated or disregarded. Much of this work is informed by Freudian/Lacanian theory, which posits a splitting within the self as a division that is the very (gendered) condition of subjectivity. Other images are intended to function more as politicized commentaries on various social constructions according to race, gender, and class.

Susan Wides's photographs taken in wax museums over a five-year period are exemplary in their attention to the cultural processing of the human figure as an historical icon. Using dramatic filmic lighting, she enters into the museum's congealed scenarios of statesmen, actors and actresses, mass murderers, and fairy tale characters, reanimating the human effigies of pop culture. *You'll be history* (1990; fig. 36) pictures a deceptively lifelike Walt Disney (the Daguerrian entertainer of our age). To his left is a white plaster head of Abraham Lincoln, which Wides has moved, through her use of double exposure, from its nearby setting next to Dwight Eisenhower in the actual display. To the right is a half-drawn Mickey Mouse, his bright eyes destined never to be animated by the wax hand poised above them. Posed for tourism, situated between a historical figure and a fantasy of his own creation, the wax Disney lives at the outposts of public curiosity. Like many artists working today, Wides photographs figures that are the stock-in-trade of a passé middle- and lower-class tourism, models that are more a part of her parents' generation than her own. Neither emblems of "high" culture nor the pop materials of the day, these figures, hovering on the margins of a sanctioned cultural inheritance, are pulled temporarily back into contemporary life in Wides's photographs.

It is written that Greek statues were fettered to their pedestals, or their stone wings were clipped, out of a fear that they would abandon their

cities during times of crisis.[39] In the modern era it is photographs that restrain the inanimate figures of past dieties in question. Even as they struggled with a new process, the inventors of photography worked to contain the uncertainty of their ancestry within the supposed objectivity of their emerging medium. Then, as now, fetters bend and flex, wings flutter, as confines and genealogies are remapped.

NOTES

1. Fisher 1991, 232.

2. A good overview of this history is provided by Haskell and Penny 1981.

3. See Shedd 1984 and Fahlman 1991.

4. Exceptions are Buerger 1989 and Keeler 1987.

5. See Fisher 1991.

6. Nodier 1820, 5.

7. See Phillips 1983, particularly 54–57, for a discussion of Nodier's text.

8. Hazlitt 1820–21, 173.

9. Baudelaire 1846.

10. Jean-Claude Gautrand figures that approximately twenty thousand people a year moved from the provinces to Paris from the late 1820's through the 1840s. Gautrand and Frizot 1986, 16.

11. For Bayard's use of statuettes see Michel Frizot, "Bayard et son jardin," Gautrand and Frizot 1986, 77–105.

12. Bayard's closest childhood friend had become an actor at the Comédie-Française, and Bayard was a particularly avid playgoer. Like other social customs and structures, the theater underwent radical changes during the first half of the nineteenth century, particularly with the development of popular melodrama, the influence of which infiltrated even the more traditional classical theaters such as the Comédie-Française. Links between statuary and live dramatic poses were common, following a long Western tradition of easily recognizable clichés. Marvin 1989 notes the Roman use of statues in public sites as cliché indications that could be quickly understood by a contemporary public.

13. Marx 1977, 165. See Potts 1992, 45, for his use of this idea of Marx in regard to sculpture. Also Apter and Pietz 1993, particularly the section "Magic Capital" for recent debates on fetishism and Marxist materialism.

14. Bryson 1990, 10–11.

15. See Lindsay 1992 for a discussion of the specific example of Hébert's sculpture *Toujours et jamais*.

16. The beginning of the academic departmentalization of the study of man is signalled by an ordinance of December 1838, by which the French government transformed the chair of "Human Anatomy of the Museum" into the chair of

"Anatomy and Natural History of Man." The Ethnographical Society of Paris was founded the following year, 1839, the same year as the public announcement of photography and two years after the introduction of Achille Collas's *machine à réduire,* a highly popular device for reducing the scale of statues for miniature mass reproduction. For the latter, see Shedd 1984.

17. I am following the outline presented by Stocking 1974. For the related issue of the development of a Greek origin for Western civilization, see Bernal 1987.

18. On this obsession with adultery, see Mainardi 1995a and Mainardi 1995b.

19. The Antinous reproduction was part of the collection of the Jean Baptiste Giraud museum of casts from antiquity at the Place Vendôme, which opened in the early 1790s with at least 188 pieces. See Shedd 1984.

20. Bayard's exchanges with Antinous also cast a light on a series of reclining self-portraits of 1840, which he captioned with the explanation that he had drowned himself in despair over the greater public recognition accorded to Daguerre for the invention of photography.

21. Gautrand and Frizot 1986, 99. I have been working with a reproduction, the size of which does not allow for confirmation or precision in identification. I offer this interpretation as highly speculative, to be followed up at a later date.

22. The identifications are those of Frizot in Gautrand and Frizot 1986, 99.

23. A good introduction to the ideas of Viollet-le-Duc can be found in Hearn 1990.

24. The label from the Musée Rigaud in Perpignan, where this daguerreotype is located, identifies the central figure as Homer; however, the scholars I have consulted indicate it as Bacchic.

25. Fisher 1991, 12–13.

26. For an illustrated commentary on this photograph in terms of its socio-political contexts, see Rouillé and Marbot 1986, 68–69.

27. For Daguerre, see McCauley 1991, who in turn refers to Michael Marrinan, *Painting Politics for Louis-Philippe* (New Haven, 1988), 53. See also Buerger 1989. For Bayard, see Keeler 1987, who illustrates another photograph of 1839–40 by Bayard of the same bust of Percier, this time in isolation.

28. See Taylor 1988.

29. Talbot 1844, n.p.

30. Letter from Hampstead, 23 October 1821, published in Taylor 1987, 301.

31. Ruskin 1904, 105.

32. Weaver 1986, 11. The most extensive monograph on Talbot is that by Buckland 1980.

33. Talbot 1847, 13. In *The Pencil of Nature* Talbot pairs a photograph of a shelf of books with a text in which he speculates on the possibility of photographs taken with "invisible rays" that could pass through walls revealing scenes within a darkened chamber on the other side. Talbot's "darkened chamber" has been interpreted "as a reference both to the camera obscura, as an historical parent of photography, and to a wholly different region of obscurity: the mind" (Krauss

1978, 42). William Hazlitt also paginates the flexible walls of museum, house, and mind as his mental chamber of artworks become "bound up within the book and volume of the brain."

34. For the role of ancient Greece in Victorian England, see Jenkyns 1980 and Turner 1981.

35. See Weaver 1989, 14–15, for a mention of Talbot's connection with this tradition.

36. The quotation is from Van Deren Coke, *The Painter and the Photograph* (Albuquerque, 1964), 12. Coke does not give a reference.

37. Bryson 1990, 142.

38. Recent publications and exhibitions include Woodstock 1991, San Francisco 1991, and Minneapolis 1987.

39. Gross 1992, xiii.

DOREEN BOLGER

The Early Rack Paintings of John F. Peto:
"Beneath the Nose of the Whole World"

AMERICAN John F. Peto (1854–1907) turned more often than any of his contemporaries to a still-life format called rack painting—vertical compositions in which cards, letters, and other written and printed materials are suspended in a tape grid and mounted on a "wooden" support. Peto first used the format in 1879 in his *Office Board for Smith Bros. Coal Co.* (Addison Gallery of American Art, Phillips Academy, Andover; fig. 37; pl. III), at virtually the same time as his friend and artistic competitor, William M. Harnett (1848–92), completed the first of his two rack paintings, *The Artist's Letter Rack* (Metropolitan Museum of Art, New York; fig. 38).[1]

While Harnett returned to rack painting only once, in 1888, Peto used the format repeatedly throughout his career, producing some fifteen examples. His rack paintings are usually divided into two distinct phases, the first from 1879 to 1885 and the second, apparently after a nine-year hiatus, from 1894 until about 1904. Peto's early rack paintings, done in Philadelphia, are usually described as office boards, commissioned pieces that contain specific references to businesses and businessmen. His late rack paintings, done after he moved to the New Jersey shore community Island Heights, have been interpreted as more personal works. They

I began research on this topic while on leave from my curatorial position at the Amon Carter Museum and as an Ailsa Mellon Bruce Fellow at the Center for Advanced Study in the Visual Arts at the National Gallery of Art, Washington, in 1990. I owe a debt to both institutions for their generous support of my work. I am grateful to Anne W. Lowenthal for her encouragement to undertake this essay and her insightful comments throughout the course of its completion. I must also thank Andrew Walker, graduate student at the University of Pennsylvania, who assisted with research; Milan Hughston, Librarian, and Sherman Clarke, Assistant Librarian/Cataloguer, Amon Carter Museum, who facilitated innumerable research requests; and Thayer Tolles, Assistant Curator at the Metropolitan Museum of Art, and John Wilmerding, Christopher Binyon Sarofim '86 Professor, Princeton University, and Visiting Curator, Metropolitan Museum of Art, who reviewed my essay in draft form. The artist's granddaughter, Joy Peto Smiley, kindly made manuscript material available to me. Claire M. Barry, Chief Conservator, and Michael Gallagher, then Assistant Conservator, Kimbell Art Museum, helpfully advised me on technical terminology.

59

assumed such an important role in Peto's career that he chose one, *A Closet Door* (1904–06; Amon Carter Museum, Fort Worth; fig. 39), as the backdrop to his self-portrait (1904; private collection). In Peto's late rack paintings historians note his disinterest in prospective patrons (these are not regarded as commissioned works) and his creation of compositions that were highly self-reflexive, with multiple references to the artist and his family, to admired political figures such as George Washington and Abraham Lincoln, and to his sorrow over the Civil War. Only Peto's early efforts in this genre, done in Philadelphia and in Harnett's shadow, will be considered here.

The two young Philadelphia artists' sudden interest in rack painting is unexplained. While presumably used in office and home, actual examples of these devices of containment and display seem to have escaped documentation in paintings and photographs of Victorian interiors. In a rare, if not unique, tribute to the letter rack, Edgar Allan Poe featured this otherwise neglected item in his short story "The Purloined Letter" (1844). There a letter rack holds a valued and much-sought missive that an unscrupulous statesman hid "immediately beneath the nose of the whole world, by way of best preventing any portion of that world from perceiving it."[2] The story's hero recognizes the "hidden" letter in the rack and cleverly replaces it with a facsimile. Harnett and Peto achieve similar sleights of hand. The printed and written contents of their letter racks are put "beneath the nose of the whole world," yet the obviousness of such public display and their skill at creating painted facsimiles has prompted viewers to pass by their commonplace objects without a thorough consideration of their significance.

There are earlier painted examples of the rack format, notably works by such seventeenth-century Dutch and Flemish painters as Wallerant Vaillant, Cornelius Gysbrechts, and Evert Collier, but neither Harnett nor Peto had traveled abroad before 1879 (indeed Peto never crossed the Atlantic), and there are no documented instances of rack paintings by these European painters being accessible to them in Philadelphia.[3] Two still-life works of Italian origin depicting pamphlets and prints arranged on "pine" boards had been on view locally until mid-century in painter Charles Willson Peale's museum.[4] So, too, was *A Deception*, from about 1805–08 (private collection), a rack drawing formerly attributed to his son Raphaelle Peale but now given to the artist/cartographer Samuel Lewis.[5] The elder Peale informs us about how Lewis's drawing was created and displayed: "Two frames of Cards, Checks & various other papers. One of the Frames containing the *Originals*—the other *Imitations*,

mostly by the Pen, [illegible] by Samuel Lewis & by him presented to the Museum."[6] Perhaps the artistic effort was actually paired with its model in the museum so that the public could compare the two and admire Lewis's illusionistic abilities.[7] Other than Lewis's effort, the letter rack seems to have been ignored as a subject by American still-life artists for much of the nineteenth century—at least until Harnett and Peto took up the format in 1879.

These trompe l'oeil painters are part of an illusionistic tradition that extends to antiquity. The familiar story from Pliny's *Natural History* describing the competition between painters Parrhasios and Zeuxis is "a parable of realism," as Norman Bryson described it recently.[8] Harnett was seen as the modern analogue to the ancient painters. "In our school-days we used to read with admiration the story of the contest between the Athenian painters," noted one American writer in 1892, in a discussion of Harnett's work:

> [H]ow Zeuxis having depicted a bunch of grapes so cunningly that the birds pecked at them challenged Parrhasius to draw aside the curtain from his picture, and then discovered that he himself had been deceived by his rival's painted drapery.[9]

According to surviving nineteenth-century accounts, Harnett's painted objects often tricked viewers, who assumed that they were likewise real objects. The most frequently cited example is his famous game piece, *After the Hunt* (1885; Fine Arts Museums of San Francisco), which regularly befuddled patrons at Theodore Stewart's New York saloon. It hung there during the artist's lifetime, and the saloon patrons often placed wagers on whether its objects—a musical instrument, weapons, and dead animals—were real or painted.[10]

Peto's works were also deemed convincing, even though they were painted in a style that seems strangely at odds with tromp l'oeil objectives. The rich and worn textures of the folded and torn paper items Peto represented with blurred contours, thick, velvety paint surfaces, and soft, generalized lighting, were a far cry from the crisp precision with which Harnett depicted his objects.[11] Nevertheless, a contemporaneous newspaper writer described a characteristic response to the illusionism of one of Peto's racks: "[The viewer] does not think he is inspecting a painting, but believes he sees before him a genuine card rack with the actual article inserted."[12] Another journalist, cataloguing the contents of a rack painting Peto exhibited in a Philadelphia store window in March 1888, noted "THE RECORD Almanac looks as though it could be opened; one feels

inclined to lay hold of the copy of THE PHILADELPHIA RECORD; the postal card seems ready to mail and the photograph must certainly be one."[13]

While twentieth-century viewers have acknowledged the artifice achieved in Harnett's and Peto's trompe l'oeil works, they have continued to believe in the actuality of the objects depicted by both artists. Harnett and Peto indeed represented actual objects in their tabletop still lifes, often pieces drawn from their own collections.[14] Harnett was occasionally commissioned to represent the assembled possessions of his patrons.[15]

Indeed, both of Harnett's rack paintings seem to represent personal items belonging to their owners. The cards, envelopes, and printed materials, particularly those for *Mr. Hulings' Rack Picture* (Collection of Jo Ann and Julian Ganz, Jr.; fig. 40), refer directly to probable patrons and their friends and business associates. The objects Harnett chose accomplished the narrative goal of his art—"I endeavor to make the composition tell a story," as he asserted—and in these cases the story described his patrons.[16] Moreover, these works can be traced to early if not original owners who are referenced in items tucked into the racks.

While the provenance of Harnett's first rack painting, *The Artist's Letter Rack* (fig. 38), is not conclusively documented, it appears to have been owned in 1892 by C. W. Peirson, probably Clayton W. Peirson, and was perhaps even commissioned by him.[17] The blue envelope tucked into the upper right corner of the rack and covered partly by the pink tape is addressed to "C. C. Peir . . . Sons" at 3908 Story Street, Philadelphia, and the envelope opposite confirms the final syllable of the Peirson name—"son." C. C. Peirson's Sons, a firm founded by Christopher C. Peirson, listed its specialty as "hides" in the Philadelphia City Directory for 1879.[18] Other names in the rack could be those of business associates of the Peirsons, so that the picture might refer to a whole community of businessmen active in the production and sale of wool and leather. The white letter inscribed "Peter Lan[illegible] Jr. Esq." may refer to a principal in Snyder, Land & Company, wool scourers and burr extractors, actually listed in the Philadelphia City Directory. The "Snyde" inscribed below the rack may be a nickname for another of Peirson's colleagues in that same firm, or for Israel Reifsnyder, a wool dealer whose son later owned the picture. The frayed loop that hangs down from the upper edge of the canvas, once described as a string, is actually a length of wool yarn. In keeping with the celebration of commercial enterprise, a bright yellow envelope inscribed "To the lady of the house" recalls the common sales practice of soliciting an audience with the woman who ran the home and thus made domestic purchases. Many of Harnett's works were known to

have been featured in business settings, and the specific references to individuals and businesses in *The Artist's Letter Rack* make it appropriate for display in a commercial location.[19]

Whether the painting was actually commissioned by Peirson or was acquired by him after its completion, its sale would have been an inspiring example of commercial success to Peto. Moreover, the demonstrable specificity of Harnett's first rack painting helped foster the assumption that Peto's rack paintings, too, were commissions with clear references to businessmen who requested their creation.

In Harnett's dazzling second effort at rack painting, *Mr. Hulings' Rack Picture* (fig. 40), virtually every object depicted in the painting can be tied to a specific figure in the patron's circle.[20] While some of the cards and envelopes are addressed to drygoods merchant George H. Hulings at his place of business, they have been dispatched not by business associates, but by men who are known to have played important roles in his private life. Hulings's comments on the picture, recast in the third person by an interviewer in 1895, only three years after Harnett's death, confirm this notion: "It represents a home made card and letter rack made of tape in which has been placed a number of cards and letters from his friends."[21] These cards and letters can be associated directly with actual people, who in turn can be connected closely to Hulings. They contain decipherable references to men who, like Hulings, were members of the Wharton Street Methodist Episcopal church; attended the Mary Commandery, his Masonic lodge; or shared his experience of military service during the Civil War.

Scholars have long assumed that the objects depicted in Peto's seven extant early rack paintings, like those in Harnett's works, actually existed and that many referred to commissioning individuals or businesses.[22] Moreover, art historians have used the information included in these pictures to date and interpret the works. "These pictures were intended to adorn specific places of business," William H. Gerdts and Russell Burke wrote in 1971 about Peto's early rack paintings, "and as such, they are replete with cards and letters, with particular reference to the owner of the business, sometimes even including his photograph."[23] There is, however, evidence to support another interpretation, presented here. While both of Harnett's rack paintings appear to have been commissions, few, if any, of Peto's can be shown conclusively to have been requested or even subsequently purchased by the individuals they celebrate. Not one of the surviving rack paintings from Peto's early period, 1879 to 1885, can yet be traced conclusively to its original owner, let alone to the individuals

mentioned in the racks. Rather than working from actual objects provided by commissioning patrons, Peto may have selected or even fabricated imaginary objects he believed would inspire prospective purchasers to acquire the picture that contained references to them.[24] In at least one case he seems to have invented people and a business to feature in a picture conceived as a demonstration of his skill. Peto's purpose seems to have been the effective marketing of his work. This makes Peto's rack paintings a double hoax: not only are they painted in a visually deceptive style, but they also include objects that prevaricate by referring to fictitious people, firms, and documents.

Many of Peto's prospective patrons declined to purchase paintings he devised for them. The reaction to his patch painting *The Ocean County Democrat* (1889[?], New Jersey State Museum Collection, Trenton; fig. 41) suggests both the origin and the fate of his rejected rack paintings. The artist borrowed a photograph of Charles S. Haskett, editor of the *Ocean County Democrat,* and then, hopeful of a sale, returned some three months later to display his painted rendition of it in a composition that included references to Haskett. A writer for the paper recounted Peto's presentation:

> [H]e sat a square frame on the floor and began taking off wrappers until he brought to light a large oil painting which represented ye editor and his paper, also an envelope, all painted on a canvas made to represent a board on which the DEMOCRAT is tacked and the picture is stuck back of it, the whole making a piece of realistic painting of much interest as an achievement of skill in a special line of art. The work is done so deftly and with such regard for the truth of form and all the conditions of realistic art, that the most acute observer is deceived.[25]

Haskett gave *The Ocean County Democrat* a rave review, but despite the picture's personal appeal, there is no evidence that the editor purchased it upon its completion. It was relegated to a local drugstore for display.[26] Peto's rack paintings, too, may have been undertaken on speculation and met with a similar response.

Peto's early rack paintings can be divided into two groups—those heavily revised and those reworked very little or not at all. It stands to reason that paintings with few changes probably sold readily and left the studio quickly. By contrast those with extensive pentimenti evidently were not purchased by the individuals they originally celebrated. These paintings would have remained in the studio, where they were available for alteration, even transformation, as time passed. Once rejected by a pro-

spective client, they could be reworked, more than once, for other clients, with new names, addresses, and possessions simply painted beside or on top of those of the original prospect. From the practical point of view, Peto could greatly expand his options for sale, display, or personal expression with the removal or addition of a name or document. As we shall see, these paintings are often veritable palimpsests that record Peto's efforts to attract purchasers.

The available physical information enables us to study Peto's working method, exploring such issues as the actuality of the objects he depicted, the manner in which those objects were chosen, the nature of his patronage, and the expressive character of his work. Changes Peto made during the course of work on his early rack paintings can be analyzed using information gleaned from conservation treatment reports and technical examinations (including x-radiography, infrared reflectography, and infrared photography), as well as simple visual examination.

In general, pentimenti are far more common and more comprehensive in Peto's early rack paintings than in Harnett's two efforts at this format.[27] Harnett seems to have made minimal underdrawing for his rack compositions and then completed them with little alteration and a confidence that may have come, in part, from the knowledge that his works were done on commission or were readily saleable.[28] Peto, by contrast, often moved objects he painted within his compositions, eliminated them entirely, or revised them by changing dates, names, and other inscriptions. At least in some works (and possibly in all or most of them), he painted the tape grid before painting the paper items it held and, after letting the tapes dry, experimented with the placement of his papers and pamphlets within it.

A comparison of Peto's *Office Board for Smith Bros. Coal Co.* (fig. 37) with Harnett's *Artist's Letter Rack* (fig. 38) demonstrates how each artist's goals and purpose may have affected his selection and treatment of models. Peto's painting, inscribed "6.79" and thus probably completed in June 1879, may be the earliest example of the late-nineteenth-century American revival of the rack format.[29] It resembles Harnett's picture in composition and the choice of certain elements—notably the wooden support, the dangling loop of string, and the inclusion of inscribed envelopes and postcards. Peto's rack painting, however, is distinguished by the greater complexity of its tape grid, the choice of more decorative printed items, such as trade cards and pamphlets, and the addition of more substantial objects—a pair of keys hung in the upper left. The tape grid—outer tapes forming a square and each diagonal inner tape attached by

tacks equidistant from the ones above, below, or beside them—is the most complicated pattern Peto is known to have undertaken in his rack paintings. Unlike the simple X within a rectangle that Harnett used, it is a carefully devised and measured arrangement, with each side of the square divided into three equal segments by ten inner tapes, which are placed to create triangular and diamond-shaped subdivisions. The geometrical order is disturbed only by the broken tape at lower left. Something presumably has snapped the tape and dropped to the floor below.

The keys, which would seem to imply access to the subject by unlocking its secrets,[30] take on an ironic tone as we discover that most of the names featured in Peto's composition seem to be fictitious. Take, for example, the rather comical trade card tucked into the upper left quadrant of the rack: "THE BEST COAL AT SMITH BRO." In 1879 no such firm was listed in the Philadelphia city directory.[31] A postal card and at least one and possibly two envelopes are addressed to Mr. John Smith, presumably one of the proprietors of the coal firm, at 1123 Chestnut Street.[32] While no such person lived at that address, Peto himself rented a studio there. The artist seems to have invented the coal firm and its proprietor, using his own first name, middle initial, and address as convenient references. What could be more securely anonymous than the surname Smith, except perhaps Jones, which is precisely what Peto selects for the business card printed "Dr. [illegible] H. JONES," displayed in the upper right corner. If indeed the people and the business mentioned in *Office Board for Smith Bros. Coal Co.* were Peto's inventions, the painting may have been a demonstration of his skill, an attempt to attract prospective patrons. The very anonymity of commonplace names like Smith and Jones would have facilitated the viewer's imagining his or her own name in their stead.

X-radiographs show that Peto made some slight compositional adjustments as he worked on *Office Board for Smith Bros. Coal Co.*, but that he did not substantially rework the painting or alter its contents.[33] Apparently, its usefulness as a demonstration piece, or a quick sale, inhibited him from changing it. Indeed, in 1880 he exhibited a work entitled *Office Rack* at the second annual exhibition of the Philadelphia Society of Artists, held at the Pennsylvania Academy of the Fine Arts from 1 November to 6 December. *Office Rack* was offered for sale at fifty dollars and sold from the exhibition.[34] *Office Board for Smith Bros. Coal Co.* is the only extant likely candidate.[35]

Peto's success in the exhibition may have inspired him to do another rack painting dated to November 1880, *Rack Picture with Telegraph, Letter, and Postcards* (Richard York Gallery, New York; fig. 42). With a

simple tape and sparse holdings that may have been inspired by Harnett's *Artist's Letter Rack* of 1879 (fig. 38), this restrained composition contains a greatly reduced number of paper items and no readily recognizable references to patrons. It instead features an envelope addressed to "John F. Peto/Artist" as well as objects that refer to no one in particular—a blank floral greeting card that had appeared previously in *Office Board for Smith Bros. Coal Co.* (fig. 37); a printed image of a man and woman outdoors; a folded newspaper; and a partially covered postal card.[36] This rack looks relatively empty and in fact it may be so. It seems ready for an eager client to select more personalized elements for the artist to add, distinguishing it as the property of a particular individual or firm. Again, Peto may have been courting patrons by demonstrating his skill.

In contrast to the paintings just discussed, Peto's *Office Board for Christian Faser* (1881; private collection; fig. 43)[37] contains direct references to Faser, a Philadelphia cabinetmaker, paintings restorer, and frame dealer.[38] Peto's father, Thomas Hope Peto, worked as a gilder and picture frame dealer in the years following the Civil War, so it is tempting to speculate that Faser may have been known to the artist through family connections. Faser shared other interests with Peto and his father. The elder Peto had served in the Civil War, and Faser was a strong supporter of the U.S. Sanitary Commission, a civilian organization that offered aid to wounded soldiers. Faser and both Petos were Masons, albeit in different lodges.[39]

Peto joined the Masons the year he painted the Faser rack, in 1881, and the very structure of his racks may have held some added significance for him and Faser, his fellow Mason. In most cases, the tapes of Peto's early racks form an X inside a rectangle that is nearly square or, as in the Faser rack, a cluster of four such patterns. The X within a square diagrams a geometrically structured pattern that closely resembles the standard Masonic apron, itself a square with a triangular flap, its apex pointing downward from the waist (fig. 44).[40] The similarity is heightened by the fact that these aprons often were bound on all edges with dark tapes. Even the snapped segments of Peto's tapes could have Masonic meaning. The Masons frown on absolute symmetry and in their rituals include symbols or objects that break geometric order, just as the damaged tapes rupture the symmetry of Peto's racks; certainly, their imperfection is notably different from Harnett's two racks, where the tapes are intact.[41]

Faser's name and address are inscribed on the bright yellow envelope in the center of the rack and his business address and logo are imprinted on the white envelope below. Thus Faser's photographic portrait would seem

to be tucked behind the envelope addressed to him, but since Peto has slyly concealed most of the gentleman's face, his identity would remain a mystery even if we knew what Faser looked like. Of course, this compositional strategy would prove useful if Faser declined to purchase the painting and Peto needed to change the names on the envelopes; the photograph could depict almost *any* clean-shaven male. Many of the other items included are merely stock objects from Peto's familiar repertory— the blank floral greeting card; a seemingly empty envelope ironically inscribed "IMPORTANT INFORMATIO[N] INSIDE"; and the *Public Ledger Almanac,* here the issue for 1881, different in color from the one hanging in *Office Board for Smith Bros. Coal Co.* A similar trade card advertising a coal company is repeated here, but the two cartoon figures are representatives of another business concern. The name of the company is covered partly by the pink tape so that only "BE . . . SON" can be read.

Peto altered the composition of the Faser rack as he developed it. Even a simple visual examination reveals pentimenti: a blue or green rectangle, most likely an envelope, can be seen above the upper right quadrant of the rack, where the "wooden" backdrop has become slightly transparent, and the envelope with Faser's business logo has marked cracks and is so discolored that it seems likely that Peto painted it on top of another compositional element, which could easily have referred to a client other than Faser. Also, two items, the *Public Ledger Almanac* and the coal company card, were evidently added to the composition after the painted grid had dried; both of these objects are now so transparent that the pink tapes can be read clearly beneath them.

The Rack (1882; Arizona State University, Tempe; fig. 45) also demonstrates how Peto may have changed his work to make it more marketable once he was unsuccessful at convincing a potential client to purchase a painting.[42] This rack painting represents several layers of paper, printed and inscribed, colored and black-and-white, tucked into every quadrant of the rack. The surrounding wooden support is decorated with a hanging string, clippings, printed tickets or announcements, and a column of handwritten numbers. This chaotic composition includes a partially obscured envelope addressed to the painter at his Chestnut Street studio and an opened envelope inscribed "John F.," with his surname presumably covered by a hanging pamphlet. The other items are decorative printed cards—commonplace types of the period—that tell us little. Potential clues to the identity of the patron, such as the portrait photograph of a woman, the folded, handwritten note, or the envelope postmarked Boston, are concealed. The only fully legible inscription is the caption be-

neath the cartoon of two embracing children seated on a fence below an enormous sunflower: "I feel just as happy as my big sunflower."[43]

In fact Peto may not have been "as happy as [his] big sunflower," if the painting failed to attract its intended buyer. Pentimenti suggest that this was the case. X-radiographs show the photograph of an unidentified man—moustached, balding, and wearing a stiff collar—beneath two cards at the upper left and now concealed by the photographic portrait of a woman and the sunflower card.[44] His name may have been inscribed in the now obscured white rectangle at the bottom of the male portrait and on some of the envelopes that have been reworked. The fragments of an inscription beneath the "John F." are visible on the orange envelope tied to a larger envelope and inserted in the rack at the lower left, but they can no longer be read. The turquoise envelope directly below the sunflower cartoon has become slightly transparent, revealing a buff or coral envelope with a ripped open edge and a protruding letter beneath it, but the recipient's name and address are no longer visible. The brilliant yellow envelope, tucked vertically into the rack, has been covered by the now familiar floral greeting card, so that only the abbreviation "Esq." can be seen. Additional technical studies may provide more information about the identity or identities of the people originally referred to in this rack, but at least one remaining clue allows us to speculate on the profession of the gentleman represented in the now painted-over photograph. The legal publication whose banner is prominently displayed at the center of the composition may indicate that he was a lawyer.

Rack Picture for William Malcolm Bunn (1882; National Museum of American Art, Smithsonian Institution; fig. 46) was also altered extensively. Probably at some point it was intended for the Philadelphia newspaper editor whose photographic portrait, correspondence, and newspaper banner still appear prominently in the rack. Bunn was a wealthy Philadelphian who could have promoted Peto's work among journalists whose approval the artist sought—in print as writers and in cash as clients. Bunn was a leading member of the Clover Club, founded in 1882 to provide a forum for social activity and good humor among the city's businessmen. These men were not the social elite but independent individuals of achievement, often self-made men. "Humor, wit, ability are confined to no calling in the United States," explained a club publication at the turn of the century. "You can find them with all classes."[45] Bunn and his cohorts were just the sort of men whose patronage Peto would have desired.

But did Bunn purchase this rack painting and, if so, at what point in its

creation? The canvas has been studied with x-radiography and infrared photography (fig. 47), revealing a number of artist's changes, made simultaneously or in succession.[46] Peto painted out the inscription beneath Bunn's photograph, "V[er]y Truly yours/Wm Bunn." At the lower left, there are two related items—a profile caricature of a bearded man inscribed "MCFOD TO THE FORE" and an envelope addressed to Garibaldi McFod at the *Sunday Transcript,* Bunn's newspaper. These two personalized items are painted on top of more generic material that can be deciphered in the infrared photograph (fig. 47): a playing card from the suit of diamonds (probably a four or five); an envelope (now obscured by the one addressed to McFod) once marked "THE CONTENTS MAY INTEREST YOU"; and an envelope with Peto's familiar exhortation, "[IMPORTANT INFORMATION IN]SIDE", only the last four letters of which are fully legible. No copies of the *Transcript* for this period seem to exist, and no one has established the identity or significance of Garibaldi McFod.[47] The only other name featured in the rack, inscribed on the postcard in the lower center, begins "Har[p]" and is addressed to the *Sunday Transcript.*[48] Did Bunn request inclusion of the postcard or the addition of the McFod references? Or are the addition of the McFod references and the striking of Bunn's name from below the photograph the first steps in revising the composition for another purchaser?

The extent to which Peto took such alterations in a personal direction can be seen in *Old Souvenirs* (Metropolitan Museum of Art, New York; fig. 48), which received its evocative title when it first appeared on the art market in 1939.[49] X-radiographs (figs. 49 and 50) and an infrared photograph (fig. 51) of the painting show that this work was originally conceived as an office board but was refashioned by the artist to include references of personal significance to him. It thus bridges the gap between Peto's early efforts in this genre and his later, more personal works. Beneath the visible paint surface, there is an entirely different composition that was transformed, perhaps over an extended period of time, with only the taped grid remaining as a constant. The FIRE ROYAL card beneath the hanging pamphlet was originally in the upper left corner of the composition, where its ghostly image is now visible to the naked eye. It is even more legible in the infrared photograph (fig. 51). An x-radiograph of the painting (fig. 49) reveals that a document, perhaps a folded newspaper, may have been tucked into the rack where the ROYAL card and the pamphlet now appear. That x-radiograph also documents an envelope, stamped, addressed, and torn open, that had been placed in the upper right corner of the rack, an area the artist eventually left empty. Other less

legible envelopes and cards were eliminated as Peto worked.[50] Another important pentimento appears in the upper right corner of the composition near the fragmentary clipping; the infrared photograph (fig. 51) shows that Peto originally included a key hanging from a string tied to a nail but then painted it over in favor of the clipping.

The composition in *Old Souvenirs* thus seems to be the result of several painting campaigns. The newspaper date of 1881 and compositional affinities with his other known works of that time suggest that Peto began the picture in the early 1880s. The rack format—four adjoining rectangles and X's—is virtually identical to that in *Office Board for Christian Faser* (fig. 43), *The Rack* (fig. 45), and *Office Board* (1885; Metropolitan Museum of Art; fig. 52), and some familiar objects reappear. A Mr. Harper's name is inscribed on an envelope; "Har[p]" was also visible on a postal card in the Bunn rack painting. The tattered pamphlet that hangs at the lower center is repeated from *The Rack* and the envelope marked IMPORTANT INFORMATION INSIDE, now torn open, makes its appearance once again, having been employed first in *Office Board for Smith Bros. Coal Co.* (fig. 37), as was the key motif. But at least two elements may have had highly personal meaning for the artist. The large card with the words "Fire" and "Royal," so tantalizingly displayed, may allude to Peto's father, who owned a successful business that sold equipment and supplies to fire companies.[51] Peto also added a photographic portrait of his daughter Helen, born in 1893 and here perhaps seven or eight years old, over a photograph of a man whose image is most easily read in an x-radiograph of the upper center of the composition (fig. 50). The inclusion of Helen's portrait establishes that Peto must have continued to work on the painting as late as 1900.

The pentimenti evident on the canvas of *Old Souvenirs* change its interpretation as well as its date. It is not, as Johanna Drucker has asserted, "the rack motif serv[ing] purely autobiographical ends, rather than displaying the ephemera of the business or civic commissions."[52] Instead, it combines specific references, such as the envelope addressed to Mr. Harp or Harper or the newspaper of 1881, which may have been aimed at a potential patron, with self-reflexive items that are clearly later additions. Nor is the division between his two periods of work on this subject as clear as previously assumed. Even if the items depicted in his early rack paintings were selected initially to provide a narrative about a prospective patron, they could evolve into more complex visual statements, partly about the purchasers he targeted and partly about Peto himself.

Of all of the surviving rack paintings from Peto's early period, only one

example after *Office Board for Smith Bros. Coal Co.* seems to have left the artist's studio without significant reworking—*Office Board* of 1885 (fig. 52). The unaltered state of this composition has been verified by infrared photography (fig. 53).[53] *Office Board* might have quickly found its way into the hands of a satisfied patron. The picture contains correspondence addressed to the Philadelphia chiropodist Bernard M. Goldberg (died 1890), who maintained an office at 1208 Chestnut Street, close to Peto's studio.[54] He was born in Germany and had arrived in Philadelphia by the late 1870s and lived a seemingly unremarkable life.[55] In 1889, less than a year before his demise, Goldberg, like Faser and Peto, joined a Masonic lodge.[56] Goldberg worked long hours: he visited patients at home in the mornings from eight to noon as well as in the evenings after six and maintained office hours in between.

But in spite of his Masonic affiliation, Goldberg, a hard-working German immigrant, may not have been a patron who satisfied Peto's aspirations. No comprehensive study of Peto's actual or prospective patrons has yet been undertaken, and these nineteenth-century figures are so obscure that such an investigation might prove inconclusive. Nevertheless, it seems reasonable to assume that Peto sought patrons roughly analogous to those of his friend Harnett.[57] Harnett's patrons, more numerous and more prominent than Peto's, were generally well-established, middle-class or wealthy, Protestant, self-made businessmen who achieved affluence through mercantile success, often in drygoods as George H. Hulings had done, in newspapers, or in banking and finance. A number of them, notably William Bement of Philadelphia, George I. Seney of Brooklyn, and Theodore Stewart of New York, collected paintings. In many respects Harnett's patronage seems at odds with his background—he was, after all, an Irish-Catholic immigrant and a working-class craftsman turned painter. His popularity can be explained by his virtuoso illusionism, his appealing subject matter, and, in at least some cases, clever marketing techniques. *Mr. Hulings' Rack Picture* is perhaps the most dramatic example of the discordance between Harnett and his patrons: here he celebrates a secret organization (the Masons) and a religion (Methodism), both unsympathetic to his religious beliefs and national background.

Yet Peto, whose origins corresponded more neatly with those of Harnett's supporters, was unable to attract men of Hulings's ilk. From the point of view of social commonalities, Peto, American-born, middle-class, a Methodist, a Mason, and the son of a successful merchant who had served in the Civil War, would seem to have been an ideal choice for men like William Malcolm Bunn (who may have rejected Peto's rack painting)

and particularly for Hulings (who chose Harnett instead). Ironically, Peto seems to have been ignored by the very men who shared his background.[58]

Unless additional documentation is discovered, we have few clues that explain *why* his work was so frequently rejected. Here, as with so many questions about this artist's obscure career, we can only proffer some speculations by contrasting his failure with Harnett's success. Peto exhibited his *Office Rack* in 1880, probably about a month after Harnett left for Europe, perhaps as a solicitation for patronage in a market recently vacated by a more successful competitor. Peto endured his struggle for recognition in Philadelphia during the early 1880s, while Harnett was abroad. Throughout this period, Harnett's absence notwithstanding, Peto seems to have experienced considerable difficulty in selling his rack paintings, although for some time he continued to strive for sales. When Harnett returned to America in 1886, he immediately recaptured the attention of prospective patrons with such ambitious trompe l'oeil compositions as *After the Hunt* (1885; Fine Arts Museums of San Francisco) and *The Old Violin* (1886; National Gallery of Art, Washington). Harnett's second rack painting (fig. 40) soon followed upon these notable successes. Meanwhile, Peto, home-trained and a less convincing master of trompe l'oeil painting, simply could not compete. In 1889 he moved from Philadelphia, outside the artistic mainstream, and abandoned the rack format until 1894, two years after Harnett's death. At this time he resumed his exploration of the subject without the benefit (or problems) of patronage, seemingly content to paint largely for his own expression and satisfaction.

Peto's early rack paintings hint at some of the larger issues that appear more forcefully in his later efforts in the genre. The very process by which we imagine that these compositions—and the actual models for them—were created is replete with reminders of mutability and the passage of time. In most of Peto's racks, material appears to have been painted on the canvas (and removed or changed) over an extended period, much as one would have used an actual rack hanging in the home or office.

The wooden supports, the racks, and the paper items in Peto's early rack paintings seem old and evince changes wrought by time. A broken tape often hanging forlornly from a tack, implies the absence or removal of some item as well as wear and the passage of time. The familiar envelope marked IMPORTANT INFORMATION INSIDE is often torn open and left empty, its significant contents lost. Its inscription can be read as an unheeded plea for recognition. Even the written and printed items that are relatively new—letters and cards that recently have been received

or a folded newspaper that might contain up-to-date news—are shown creased and tattered. On the "wooden" support of every early rack painting Peto represents the remains of a card that was glued or tacked on and then pulled off, apparently recently since the area beneath it remains cleaner than the surrounding wood. While the inclusion of the names of specific patrons has led scholars to view these works as celebrations of professional and personal achievements, the decrepit appearance of Peto's racks seems to carry a more complex message. The rack paintings are *vanitas* still lifes that remind the viewer that eventually even the achievement of worldly success—by the subject or the artist—is reduced to tattered remains. And as Frankenstein put it forty years ago, "Peto's concern with used-up, discarded, and rejected things parallels his own life."[59]

These expressive features, which underscore inconstancy and deterioration, are also analogues for Peto's working process and even for the condition of his works as they have aged and pentimenti have become more evident. Modern technology has given us the tools to look beneath the surface of Peto's paintings and to consider more fully the many aesthetic and practical decisions he made as he experimented with this still-life format. It reveals the expressive character of his work and demonstrates that Peto's working method, with its changes over time, is consistent with the themes that absorbed him.

NOTES

1. Relatively little documentary evidence, such as diaries or correspondence, has survived for either artist. Harnett and Peto did not exhibit as widely as many of their contemporaries, and when they did, cosmopolitan art critics rarely noticed their work. In fact, neither artist received scholarly attention until the late 1930s. Because Harnett's signature was added falsely to many of Peto's paintings, the oeuvre of the two artists was confused until Frankenstein published his work on Harnett and related American still-life painters in 1953 (Frankenstein 1969). As a result of the dearth of information on these painters and the early confusion about their work, issues of biography and connoisseurship have preoccupied art historians, museum professionals, and conservators. Only in recent years have Harnett and Peto been the focus of more interpretive studies investigating the possible significance of their subject matter and the effects of patronage and criticism on their careers. See Wilmerding 1983 and Bolger, Simpson, and Wilmerding 1992–93.

Both Harnett and Peto, however, have been presented in surveys of American

still-life painting and in monographs. See Gerdts and Burke 1971, 133–44; and Gerdts 1981, 152–63, 177–86.

2. Poe 1983, 680–98, 694–95 (quoted). This literary use of the letter rack was first noted in Dolphin 1969, 88.

3. Gerdts 1981, 179, notes that the Charles Graff collection, Philadelphia, included a work by Vaillant, but that it was not a rack subject. A survey of the annual exhibitions of the Pennsylvania Academy of the Fine Arts from 1869 to 1880 (the shows were suspended from 1870 to 1876) indicates that many still-life paintings were shown, but judging by their titles, these were more conventional fruit, flower, and game pieces. None were specifically identified as racks, nor did selections from the Academy's permanent collection of American and European paintings, which were often noted in these catalogues, include rack pictures.

Gerdts 1986, 23 n. 3, provides a helpful bibliography for reference on rack painting and other trompe l'oeil subjects throughout the history of art.

4. The paintings could well have remained in the city, even after the dispersal of the museum in 1854. The entry Peale made in Peale Memoranda, on 3 January 1818, reads "Two paintings (Still Life) representing, Pamphlets, Prints &c. on Pine boards. painted on canvas, upwards of a hundred years old from Italy. pres. by Capn. Benj. Betholomew." This description is far from precise, but it seems likely that the still life was either a rack painting or what is sometimes called a "patch picture"—an arrangement of paper items hung on a vertical ground without the benefit of a tape grid for support. For a discussion of other American examples of the patch format, see Wilmerding 1983, 171–78.

5. The reattribution of the American rack drawing was made convincingly by Gerdts 1986, 4–23; on p. 9 Gerdts ties its ownership to the Peale family on the basis of an old label, now confirmed by the note in Peale's Memoranda.

Related trompe l'oeil compositions taken up by members of the Peale family's artistic circle include Raphaelle Peale's *Venus Rising from the Sea—A Deception* (1822; Nelson-Atkins Museum of Art, Kansas City); and Charles Willson Peale's *Staircase Group: Raphaelle and Titian Ramsay Peale* (1795; Philadelphia Museum of Art).

6. Peale Memoranda, 19 November 1808.

7. Lewis may have made a similar juxtaposition at the 1811 exhibition of the Society of Artists at the Pennsylvania Academy of the Fine Arts, where no. 375, *A Deception and original* was among his five submissions (Gerdts 1986, 13). Years later Harnett planned to execute a trompe l'oeil painting of an ivory crucifix he had purchased abroad and then present the painting and the model to St. Patrick's cathedral in New York for churchgoers to compare the two (Harnett Collection 1893, 14, no. 110).

8. See Bryson 1990, 30–32.

9. Cogswell 1892, 305–6. Cogswell was discussing Harnett's *Old Models* (1892; Museum of Fine Arts, Boston).

10. For a discussion of the phenomenological implications of trompe l'oeil painting in the nineteenth century, see Paul Staiti, "Illusionism, Trompe l'Oeil, and the Perils of Viewership," in Bolger, Simpson, and Wilmerding 1992–93, 31–48.

11. For a thoughtful discussion of the very different styles of these painters, see Goodrich 1949, 57–59. An early account of Harnett's life and work was actually entitled "Painted Like Real Things: The Man Whose Pictures are a Wonder and a Puzzle," interview in *New York News,* 1889 or 1890, quoted in Frankenstein 1969, 29, 54–56.

12. This review describes a now unlocated rack, which featured letters, a post-card, an engraving of Abraham Lincoln, and a copy of the Lerado, Ohio, *Commercial Gazette* (A.C.G., Lerado, Ohio, "Realism in Art," undated clipping, Peto Family Papers).

13. "Realism in Art," another undated clipping (inscribed 27 March 1888), Peto Family Papers.

14. Both artists collected objects avidly. Harnett's collection, which included antique books and decorative arts, sheet music, musical instruments, and other ephemera, as well as a few of his paintings, was dispersed after his death. For a partly illustrated list of the contents, see Harnett Collection 1893. Harnett made convenient alterations and adjustments in his actual models, most notably in the inscriptions on the spines of books, where he often changed authors or titles. Many of Peto's objects, largely worn and cherished but more commonplace pieces with less commercial value, remained in the possession of his family. Frankenstein discovered this collection in Island Heights, New Jersey, and used it as evidence as he sorted out the then-confused careers of Harnett and Peto (Frankenstein 1969, 13–17). Today some of these objects are still in the same house, which is maintained as a bed and breakfast by the artist's granddaughter, Joy Peto Smiley.

15. Among the works wherein Harnett featured the possessions of his patrons are *Ease* (1887; Amon Carter Museum, Fort Worth), which includes the possessions of Holyoke, Massachusetts, newspaperman and envelope manufacturer James T. Abbe; *Still Life with Bric-a-Brac* (1878; Fogg Art Museum, Harvard University, Cambridge), which depicts objects belonging to Philadelphia dry-goods merchant William Folwell; and *Still Life for Nathan Folwell* (1878; private collection), which represents objects that most likely were owned by his brother and business associate. For illustrations, see Bolger, Simpson, and Wilmerding 1992–93, 36, 80, and 200.

16. Quoted in the interview in *New York News,* 1889 or 1890, reprinted in Frankenstein 1969, 55.

17. In the catalogue for the first exhibition of the picture (Philadelphia 1892), which was held shortly after the artist's death, *The Artist's Letter Rack* was included, but its owner was not clearly indicated. The lenders were listed separately from the works they lent, but "C. W. Pierson" (a slight and rather common mis-

spelling) is included in the list. Peirson is the only lender whose name can be associated with the people featured in this rack painting, and he is not known to have owned another work by the artist.

Frankenstein assumed that the painting was commissioned by Israel Reifsnyder, whose son Howard sold the painting at auction in 1929, but since Mr. Reifsnyder did not own the picture in 1892, this seems rather unlikely. Frankenstein also suggested that the "Snyde" in the simulated inscription to the lower left of the rack might be Mr. Reifsnyder's nickname and mistakenly went on to discuss other items as references to Reifsnyder's partner, Caleb D. Peirce, or his son Clifford C. Peirce (Frankenstein 1969, 52–53). For a full discussion of this picture and its provenance, see Burke 1980, 50–53.

18. Peirson 1893, 1120. Among the family members working for the firm in 1893 were Christopher's sons D. Frank Peirson and William T. Peirson. Two other sons worked in related industries: John W. Peirson for North Star Tannage Co. and Walter Peirson for Mitchell & Peirson, a glazed kid manufacturer.

19. Among Harnett's works that are known to have been displayed at the business locations of their owners are *Ease* (1887, Amon Carter Museum, Fort Worth), which hung in its owner's factory office (see note 15), and *Still Life with the Toledo Blade* (1886, Toledo Museum of Art), which was displayed in the drugstore of Isaac Newton Reed in Toledo (Frankenstein 1969, 7).

20. For a full discussion of this picture, see Bolger 1990.

21. Hulings 1895.

22. For descriptions of some of Peto's lost (or altered) works, see Frankenstein 1969, 102–4. X-radiographs reveal that *The Poor Man's Store* (1885; Museum of Fine Arts, Boston) was painted over a rack painting (Wilmerding 1983, 99 n. 19). Other rack pictures may be similarly concealed under other works by the artist, obliterated rather than merely transformed.

23. Gerdts and Burke 1971, 144. See also Frankenstein 1969, 107–8; and Drucker 1992, 44–45.

24. Frankenstein acknowledged that Peto may have painted the lost work *Our Office Board*, which contained references to William M. Singerly, "in the hope of selling it to Singerly, but [he] was unable to do so," since this work was apparently not sold to Singerly but purchased by I. S. Isaacs and later included in an auction of his belongings in 1889 (Frankenstein 1969, 104).

25. "Fine Painting," undated clipping, Peto Family Papers.

26. Ibid.

27. These patterns are consistent for both artists throughout their careers. As Frankenstein noted of Peto's later career, "He repeatedly reemployed his old canvases without scraping them down; X ray has revealed as many as three separate pictures on one support" (Frankenstein 1969, 106).

28. For discussions of Harnett's working process and its analysis through technical study, see Jennifer Milam, "The Artist's Working Methods," in Bolger, Simpson, and Wilmerding 1992–93, 168–75. Milam makes extensive use of

infrared reflectograms. For an earlier analysis of Harnett's work through x-radiography, see Sheldon Keck, Comparison of Technical Information on Harnett and Peto; typescript 1949; "Report to Mr. Alfred Frankenstein on Technical Examination of Paintings by Harnett and Peto," typescript, n.d.; and radiographs of Harnett and Peto paintings taken in the 1940s, Paintings Conservation Department, Brooklyn Museum. I am most grateful to Kenneth Moser, Chief Conservator, for making these materials available to me.

29. It is not known whether Harnett or Peto took up rack painting first. A case for Peto's precedence can be made, but it is by no means conclusive. Harnett's *Artist's Letter Rack* is dated 1879 and includes a postcard marked August 26, which Frankenstein assumed dated the picture to August 1879, two months later than Peto's effort. However, since there is no year stamped on the postcard and that particular card was issued as early as 1875, the date of the postcard does not definitively establish the date of Harnett's picture. The two artists worked closely in these years—theirs was a visual dialogue, as John Wilmerding's recent work on Harnett has shown—and so the issue of precedence is less interesting than the complexities of their ongoing interaction (see John Wilmerding, "Notes of Change: Harnett's Paintings of the Late 1870s," in Bolger, Simpson, and Wilmerding 1992–93, 148–59). Peto kept a photograph of Harnett's *Artist's Letter Rack* until his death, implying a degree of appreciation of his efforts. For discussions of this dating issue, see Frankenstein 1969, 51; Burke 1980, 50, 52; and Wilmerding 1983, 209.

30. The *clavis interpretandi* was commonly used in many seventeenth-century Dutch paintings. Jan Steen, to mention one example, used the hanging key as a small detail in the backgrounds of such paintings as *Merry Company* (Kunsthistorisches Museum, Vienna), *The Harpsichord Lesson* (Wallace Collection, London), and *The Marriage at Cana* (Staatliche Kunstsammlungen, Dresden). While we do not know whether Peto had access to reproductions of these or similar works, many American artists admired and emulated the Dutch Old Masters. New York painter Francis W. Edmonds borrowed just this device in his *What Can a Young Lassie Do wi' an Auld Man* (ca. 1851, unlocated). See Clark 1988, 30, for an illustration.

31. A survey of Philadelphia City Directories of the period reveals a Joseph D. Smith & Bro. at 922 Oxford Street, with its purpose variously listed as coal (1875 and 1876) and lime (1877, 1881, and 1886), but this does not seem to be the firm depicted here, since both the address and the full name of the firm are different.

32. The artist's father-in-law was John Farrell Smith (1837–1918), so it is possible that his is the name that appears on the envelope, but it is more probable that this is simply a coincidence. It does not seem likely that Peto knew Smith in 1879, when he painted *Office Board for Smith Bros. Coal Co.* Moreover, technical examinations did not reveal any pentimenti on the envelope that might suggest that Peto added the "John F. Smith" inscription to the envelope later, after meeting him. Peto met his wife, Christine Pearl Smith, in Lerado, Ohio, in the mid- to

late 1880s, and the two married in June 1887. Peto was apparently there working on his *Stag Saloon Commission* (now unlocated), although this major work has been dated variously. See Wilmerding 1983, 16–17, 33 n. 4, 158, 154 (illustration); Frankenstein 1969, 103.

33. Sandra L. Weber, Williamstown Regional Art Conservation Laboratory, letter to Susan Faxon, Addison Gallery of American Art, Andover, Massachusetts, June 1993.

34. Philadelphia 1880, no. 146. While Peto was not a member of the society, his friend Harnett was. "Philadelphia Society of Artists," clipping, n.d., Peto Family Papers, mentions the sale of still-life paintings by Peto, Morsten Ream, R. M. Pratt, and William Mason Brown. In May 1881 Peto exhibited a work entitled *Card Rack*, priced at thirty-five dollars, at a show connected with the St. Louis Exposition (Frankenstein 1969, 102).

35. Peto displayed paintings regularly at the Pennsylvania Academy while he resided in Philadelphia, but he also put his works on view in the sort of commercial and business locations favored by his friend Harnett. For a discussion of Harnett's exhibition practices and critical reception, see William H. Gerdts, "The Artist's Public Face," in Bolger, Simpson, and Wilmerding 1992–93, 87–99.

36. There is one minor pentimento in this composition. The printed card tucked beneath the newspaper was originally placed in the lower left quadrant, where it is now visible beneath a slightly translucent layer of brown pigment.

37. For catalogue information on this painting, see Wilmerding, Powell, and Ayres 1981, 106, 156; and New York 1993, no. 6. Faser was born in Pennsylvania in 1844.

38. For biographical information on Faser, see his obituary, *Philadelphia Public Ledger*, 15 December 1923, 3; U.S. Census of 1880, Philadelphia, Pennsylvania, v. 66, e.d. 211, sh. 8, ln. 4; and U.S. Census of 1900, Philadelphia, Pennsylvania, v. 185, e.d. 805, sh. 11, ln. 69.

39. Faser became an approved member of the Orient Lodge No. 289 / R.A. Chapter 169, on 5 May 1869. Thomas H. Peto was a member of the Birmingham Lodge No. 8 ([Obituary or Death Notice] undated clipping [ca. 8 March 1896], Peto Family Papers). John F. Peto was a member of Meridian Sun Lodge #156 (initiated as an Apprentice on 5 July 1881; crafted on 6 December 1881; and raised to Master Mason on 6 December 1881), but he was suspended for nonpayment of dues in 1891. See Meridian Sun Lodge 1913, 84.

40. On the Masonic apron, see Lexington 1980. In the eighteenth and early nineteenth century, aprons were often produced individually by local merchant tailors, but by the late nineteenth century aprons conformed to standardized regulations and were manufactured by regalia makers (p. 39).

41. A few acknowledged Masonic symbols appear in other of Peto's rack paintings. The crossed keys hang in *Office Rack for the Smith Bros. Coal Co.* and appeared in *Old Souvenirs* until they were painted out. In his later racks the Star of David is "carved" into the "wooden" support of *Lincoln and the Star of David*

(1904; private collection), as is a trapezoid in *Old Time Letter Rack* (1894; Museum of Fine Arts, Boston). See Wilmerding 1983, 195, 196, for illustrations.

42. The date of this painting has been published variously as 1880 and 1882. The picture can be dated conclusively to June 1882 on the basis of a careful conservation treatment report, which includes a photograph of the reverse of the unlined canvas, which is inscribed "John F. Peto/ Artist/ Phila/ 6.82" (Balboa Art Conservation Center, San Diego, California, 1987–88, Curatorial File, Nelson Fine Arts Center & Matthews Center, Tempe, Arizona). The signature at lower left has suffered some abrasion and is not entirely legible.

43. The *sun*flower caption is particularly intriguing when we recall that Peto was a member of the Meridian *Sun* Lodge (see note 39).

44. The painting was x-rayed by Harriet Dolphin in August 1969. For an extended discussion of this and other technical means used in her analysis of the painting, see Dolphin 1969, 93–107.

45. Deacon 1897, 7; and Clover-Club 1913, n.p.

46. Cleo Mullins recorded a detailed technical examination of this painting, dated 15 January 1974, Conservation Department, National Museum of American Art, Smithsonian Institution. I am grateful to Ann Creager and Fern Blechner of the Conservation Department for their assistance with this material.

47. The fullest discussion of the elusive McFod appears in Frankenstein 1969, 104. It seems likely that the name "Garibaldi" was chosen to convey some meaning. It should be noted that the most famous Garibaldi—the Italian patriot and soldier Giuseppe Garibaldi—died in 1882, the year that Peto painted this rack. Garibaldi was a popular hero for Italians everywhere and a name that would have been strongly associated with this ethnic group. "McFod" also carries an ethnic connotation. The "Mc" so often used as a prefix for Irish names has been combined with "Fod"; fodder is not only a coarse food for livestock, but also an appellation for readily available people of little value. This combination of Italian/Irish references might hint at a nativist contempt for two immigrant ethnic groups arriving in Philadelphia in great numbers during the late nineteenth century.

48. Mr. Harp [illegible] cannot be identified with certainty. In 1881 there was a John C. Harper, editor, at the business address 713 Chestnut Street, with a residence at 1945 Mervine. That same year the *Evening News* was located at 713 Chestnut Street, so presumably Harper worked for this rival paper. Joseph Harper, printer (no business address given), also lived at 1945 Mervine. The name Harper appears on an envelope in *Old Souvenirs* (fig. 48), probably begun about 1881, and a second envelope is inscribed to Mr. John [illegible]. This device—giving parts of a name in various locations within the same composition—supports the notion that Peto was naming John Harper in *Old Souvenirs*. It seems likely that the same individual was specified in *Rack Picture for William Malcolm Bunn*.

49. New York 1939, no. 8. This is one of the Peto works that appeared on the art market with a false Harnett signature (Burke 1980, 170–71).

50. Other pentimenti can be read in the infrared photograph (fig. 51). Along the left vertical tape, shadowy cards or envelopes are tucked above the pamphlet marked REPORT and below and to the left of the folded BULLETIN. Another card is tucked behind the torn envelope marked IMPORTANT INFORMATION INSID[E].

51. [Obituary or Death Notice,] undated clipping [ca. 8 March 1896], Peto Family Papers.

52. Drucker 1992, 45, 47, provides an extended discussion of *Old Souvenirs* but dates the painting about 1881. For an earlier discussion of the date and models depicted in this painting, see Burke 1980, 170–71.

53. I am grateful to Thayer Tolles, Assistant Curator, American Paintings and Sculpture, Metropolitan Museum of Art, for arranging for this technical investigation.

54. Bernard M. Goldberg, Will, Book 146, 386, Inventory Book 10, 225, Philadelphia, Pennsylvania; Death Announcement, Philadelphia *Public Ledger,* 3 January 1890, 4; Philadelphia City Directories, 1881–87.

55. Goldberg is not listed in the Philadelphia Directories until 1881, but his wife Sallie (born ca. 1858) and his son Harold (born ca. 1879) were both born in Pennsylvania, suggesting that Goldberg must have arrived in Philadelphia by the late 1870s (U.S. Census of 1880, Philadelphia, Pennsylvania, v. 71, e.d. 403, sh. 11, ln. 49). The census of 1880 records Goldberg as living with his father-in-law John L. Kucker, a brassfounder, at 1508 North 10th Street, his home until 1883, and while Kucker disappears from city directories after that year, Goldberg continues with a residential listing until 1886. His business address, the same since 1881, disappeared a year later.

56. Goldberg joined Fernwood Lodge No. 543, being initiated on 6 April 1889; crafted on 21 May 1889; and raised on 18 June 1889.

57. For a discussion of Harnett's patrons, see Doreen Bolger, "The Patrons of the Artist: Emblems of Commerce and Culture," in Bolger, Simpson, and Wilmerding 1992–93, 72–85.

58. Peto's family attended both Presbyterian and Baptist services; he himself was a devout Methodist. As already noted, Peto's father worked in business, first as a gilder and dealer in picture frames, then as a supplier for fire companies, aspiring in a modest way to the success later achieved by his son's prospective patrons. ([Obituary or Death Notice] clipping, n.d. [ca. 8 March 1896]; and Jno. Elliott, Chairman, Pew Committee, First Presbyterian Church, Southwark, Philadelphia, receipt made out to Thos. H. Peto, 8 May 1868, Peto Family Papers; Wilmerding 1983, 12–13. Both father and son also were Masons (see note 39).

59. Frankenstein 1969, 107.

Emblems for a Modern Age: Vincent van Gogh's Still Lifes and the Nineteenth-Century Vignette Tradition

RAISED with the Bible and the writings of generations of Protestant moralists—ranging from John Bunyan and Jacob Cats to nineteenth-century preachers like J.J.L. ten Kate, P. A. de Genestet and Charles Haddon Spurgeon—Vincent van Gogh was thoroughly familiar with the parables and tropes that had been the common stock of edificatory literature since the end of the sixteenth century. Indeed, many of his best-known works were inspired by this metaphorical tradition, which had found concise visual formulation in the so-called *sinnepoppen,* or moralizing emblems, produced in quantity during the sixteenth and seventeenth centuries in Holland, England, and Germany.[1] Vincent's familiarity with this visual tradition is obvious, for example, in his numerous paintings of sowers, which are informed by any of the numerous derivations of such sixteenth-century emblems as Nicolas Reusner's "Spes proxima messis" (Hope is the forthcoming harvest) or Nicolaus Taurellus's "Tandem putrefacta resurgent" (In the end that which has rotted will rise again).[2] As was common, these emblems, in turn, had been inspired by biblical texts.[3]

Vincent's familiarity with the emblematic tradition was not exceptional. As Tsukasa Kodera and others have pointed out, a revival of interest in Renaissance and Baroque emblemata took place in Protestant circles during the mid-nineteenth century. This revival was marked by the reissuing of the complete works of Jacob Cats in Holland (1862) and the

An early version of this paper was read in June Hargrove's session, "Continuity and Rupture: Iconography and Allegory in Nineteenth-Century European Art," at the Annual Conference of the College Art Association, 1991. A sabbatical leave from Seton Hall University, spent as a Jane and Morgan Whitney Fellow, Metropolitan Museum of Art, New York, made its completion possible. I am grateful to Anne Lowenthal for her insightful comments, which have enhanced its form and content. Thanks are due as well to William S. Heckscher and Laura Coyle for their interest and advice.

publication in England of selected moralizing emblems of Cats, Robert Farley, Francis Quarles, and others.[4]

Like his paintings of sowers, Van Gogh's early *Still Life with Open Bible, Candle, and Book,* of 1885 (Rijksmuseum Vincent van Gogh, Amsterdam; fig. 54; pl. IV), appears at first glance to partake of this well-worn emblematic tradition.[5] Snuffed-out candles and books are traditional death and *vanitas* motifs that appear in numerous emblems, like the one from the sixteenth century illustrated here (fig. 55), as well as in the painted *vanitas* still lifes they informed, throughout the seventeenth and eighteenth centuries. I shall argue, however, that Vincent's image draws more directly on what might be called "modern emblems," namely, the *en-têtes* and *culs-de-lampe,* or head- and tailpieces, found in nineteenth-century novels and poetry collections.

A case can be made, I believe, for considering these Romantic devices as the somewhat rebellious nineteenth-century offspring of Renaissance-Baroque emblems. Not only did the latter often provide formal and iconographic precedents, like the emblem from Mathias Holtzwart for an *en-tête* in Victor Hugo's *Le Livre des mères: Les enfants* (figs. 56 and 57); but also, like emblems, Romantic head- and tailpieces are closely related to texts, in their physical placement on the printed page as well as in meaning. The two types of image function similarly, summarizing verbal texts in visual form, whereby the nature of each kind of text determines the character of the word-image relationship.

The traditional emblem, first formulated by the Italian Andrea Alciati during the sixteenth century (fig. 58), consists of three distinct parts: motto, picture (*impresa*), and epigram. The motto, which functions as the emblem's "title," is a concise dictum, such as "Amicitia etiam post mortem durans" (Friendship lasting even after death). Closely linked to the motto, the picture does not illustrate but rather complements it, and the relation between the two is often not clear at first glance. Indeed, the tantalizing connection between motto and picture was considered one of the pleasing qualities of the Renaissance emblem. The puzzle is resolved in the third part of the emblem, the epigram, which consists of a moralizing verse or short prose passage that elucidates their relationship.[6] The picture generally represents a single figure, a simple action, or one or more inanimate objects. Objects are especially common in seventeenth-century Dutch *sinnepoppen,* such as those by Cats, Otho Vaenius (Otto van Veen), and Roemer Visscher. Dutch emblems further distinguish themselves from their Italian prototypes by exhibiting a more easily grasped relationship between picture and motto, so that the implied moral lessons are often clearly stated. For example, to the seventeenth-

century viewer familiar with the contemporary "tulipomania," the connection between picture and motto in Roemer Visscher's emblem "Een dwaes en zijn gelt zijn haest ghescheijden" (A fool and his money are soon parted) offered little difficulty (fig. 59).[7]

A typical nineteenth-century head- or tailpiece is an extreme reduction of a complex narrative, frequently in the form of an image of one or more simple objects.[8] For example, a raised pitchfork (fig. 60), seen in complete isolation and randomly truncated, concludes the dramatic chapter in Victor Hugo's *Notre Dame de Paris* that recounts the assault on the cathedral by the rabble, after Quasimodo's murder of the young student Jehan.[9] Much like an emblem, this simple reductive image summarizes a verbal text in visual form. But unlike emblems, which relate to static moralizing texts, the tailpiece condenses a dynamic narrative. The pitchfork in *Notre Dame de Paris* sums up a chapter's story and evokes its mood, but it does not illustrate, in the sense of helping to visualize, the text.[10] In this respect, the tailpiece differs from the text vignette (fig. 61), which provides a visual narrative that runs parallel to the verbal one. Thus, while in head- and tailpieces the narrative is condensed in a reductive and generalized image, often a single object or figure, in the text vignettes it is "enlarged" with a particularized image that elucidates the story.[11] Because of their generalizing nature, head- and tailpieces are fungible, and they were often used by printers for different chapters in one book, or even in different books.[12] Text illustrations, by contrast, are too specific to serve more than one function.

Like emblems, Romantic head- and tailpieces often bear a complex relationship to the texts they accompany. The *en-tête* that introduces chapter 4 of *Notre Dame de Paris,* entitled "Grès et cristal" (Stoneware and crystal), illustrates the multiple levels on which such pictures operate (fig. 62). On the one hand, the image provides a typically reductive summary of the narrative of the chapter: Quasimodo has hidden Esmeralda in the towers of the cathedral. So that she can call him, he has given her a whistle. Keenly aware of Esmeralda's love for the handsome but indifferent Phoebus, he places on Esmeralda's windowsill two vases of flowers. One vase is made of beautiful crystal, but the flowers it holds are withered because it contains no water; the other is a coarse stoneware mug filled with water, so that the flowers are fresh and colorful. When Esmeralda wakes in the morning, she clutches the faded flowers to her breast, a devastating sign to Quasimodo that all his kindness to Esmeralda has not won her love.

The three objects depicted in the *en-tête* not only sum up the narrative of the chapter but also form objectified representations, or "devices," of

the three principal characters: Phoebus, beautiful in stature but fickle and fragile in his love, is represented by the crystal vase; Esmeralda by the whistle; and Quasimodo by the stoneware mug. The placement of the whistle, moreover, between the two vessels but closer to the crystal one, suggests the emotional relationships among the three characters. The headpiece also contains a general moral lesson, namely, that one should not judge by outside appearance but rather by what is within. This meaning is conveyed by the title of the chapter, "Grès et cristal," written immediately beneath the headpiece, which verbally affirms the contrasting materials of the two vessels.

The layered reading invited by nineteenth-century head- and tailpieces like the one just discussed may serve as a model for the interpretation of many of Van Gogh's works, notably his still lifes. Before we test this model, however, a few words might be said about the visual resemblance between Vincent's still lifes and nineteenth-century head- and tailpieces. With their simple arrangements of isolated objects seen against neutral backgrounds, Van Gogh's still lifes often show a striking similarity to such vignettes. The oval *Still Life with Three Books* (Rijksmuseum Vincent van Gogh, Amsterdam; fig. 63), from the artist's Parisian period, in which the books virtually float against a background of painted crosshatchings, suggests the Romantic tailpiece both in subject matter and treatment (fig. 64). Such a similarity is clearly not fortuitous. Vincent's consuming interest in nineteenth-century book and magazine illustrations is amply documented in his letters to Theo. His collection of wood engravings from *The Graphic* and other contemporary illustrated magazines, now in the Rijksmuseum Vincent van Gogh, further attests to his special interest in this form of popular imagery.[13] While much has been written about the impact of nineteenth-century popular illustration on Vincent's art,[14] most of the literature focuses on narrative illustration and its relation to Vincent's figurative works, not on the special importance of head- and tailpieces for his still lifes.

With the above in mind, let us turn again to the *Still Life with Open Bible, Candle, and Book* (fig. 54). As indicated before, this early still life may be related to the emblematic tradition and, in that context, it must obviously be read as a *vanitas* image. Indeed, we know that the work was painted some months after the death of Van Gogh's father, on 27 March 1885, and it can be seen as a pictorial meditation on that event. The painting may also, however, be read on other levels, much like the head- and tailpieces we have just analyzed. Similar to a Romantic tailpiece, Van Gogh's still life terminates, that is, comes at the end of, and sums up a narrative—one that was developed at length in his letters to Theo, start-

ing as far back as his stay in Etten in 1881 and intensifying during the first months of his stay in Nuenen, from December 1883 on. It is the narrative of the ongoing conflict between Vincent and his father, caused by their mutual inability to bridge the gap between two generations and two divergent philosophies of life. One of the more explicit references to this conflict is found in a passage in a letter written from Nuenen [354]:

Father believes in his own righteousness, whereas you and I and other human creatures are imbued with the feeling that we consist of errors and efforts of the lost souls. I commiserate with people like Father . . . because the good within them is wrongly applied, so that it acts like evil—because the *light* within them spreads darkness, obscurity around them.[15]

Another equally telling passage is found in an earlier letter [195], written at Etten:

But father and mother are getting old, and they have prejudices and old-fashioned ideas which neither you nor I can share anymore. When father sees me with a French book by Michelet or Victor Hugo, he thinks of thieves and murderers or of immorality.

The *Still Life with Open Bible, Candle, and Book* sums up this epistolary narrative of the conflict between Vincent and his father in the two contrasting volumes set side by side, the Bible alluding to the older man's dogmatic Protestant outlook, and the novel—Zola's *La Joie de vivre*—his blanket condemnation of modern ideas. At the same time, these objects also function as visual characterizations—we have earlier called them "devices"—of the two protagonists in the interpersonal narrative.[16] The large bible can be seen as the objectified portrait of Vincent's father, not only because it was his personal property but also because with its imposing size and solid rigidity it conveys what Vincent saw as his father's "self-righteousness" and ideological inflexibility.[17] It is significant as well that the bible, though its facing pages are painted in light tones of broken white, yellow, and light blue, is surrounded by blacks, dark browns, and greys, alluding to Van Gogh's remark that the "light within" his father spread darkness. By the same token, the citron-yellow paperbound French novel, with its flimsy, dog-eared, well-thumbed cover, seems to represent Vincent himself, the "lost soul" consisting of "errors and efforts" of his letters.[18] As in the headpiece of "Grès et cristal," the placement of the objects in relation to one another appears meaningful. The bible occupies a dominating position in the center of the table, while the novel is marginally, even precariously, placed on the edge.

Beyond the personal, textbound significance of the still life, which one

can understand only by reading Vincent's letters to Theo, the painting also has a generic meaning that can be grasped by anyone who understands the significance of the two objects.[19] The Bible and Zola's *La Joie de vivre* juxtapose two moral philosophies, one traditional, the other modern, one based on Christian dogma, the other on conscience and the empirical and personal search for truth. Pauline, the heroine of Zola's novel, is the modern, female antipode to Christ. Much as Christ raised Lazarus from physical death, she raises Lazare from mental rigor mortis. Her positivist philosophy of altruism and self-sacrifice is not imposed by a paternalist religion like Christianity,[20] but is based instead on the reasoned principle that thinking of others causes one to forget one's own ennui and helps one attain a true joy of life.[21]

The multilayered signification that I propose for Vincent's still lifes, modeled on the reading of nineteenth-century vignettes, may throw new light on some problems of interpretation, or at least relativize some old conflicts. The famous debate between Martin Heidegger and Meyer Schapiro over the ownership—and by extension, the interpretation—of Van Gogh's still lifes of old shoes (fig. 65), so eloquently and wittily treated in Jacques Derrida's essay *Restitutions*,[22] may be resolved if we consider these still lifes as painted *culs-de-lampe*, which sum up the numerous narratives of Van Gogh's memorable walks found in his letters to Theo.[23] François Gauzi, one of Van Gogh's fellow students at the Cormon studio, noted a direct relationship between the shoe still lifes, dated for the most part in 1887, and Vincent's walks around the Paris fortifications, which resulted in a series of astonishing drawings made during the summer of that same year.[24] Gauzi wrote the following:

> Just then [during Gauzi's visit to Vincent's studio] he was finishing a still life which he showed to me. He had purchased at the flea market a pair of old, worn-out shoes, shoes of a street peddler which nonetheless were clean and freshly polished. They were sturdy footwear lacking in fantasy. He put on these shoes one rainy afternoon and took a walk along the fortifications. Covered with mud, they appeared more interesting. A study is not necessarily a painting; army boots or roses might have served just as well.
>
> Vincent copied his pair of shoes faithfully. This idea, which was hardly revolutionary, appeared bizarre to some of us, his studio comrades, who could not imagine a plate of apples hanging in a dining room as a companion piece for a pair of hobnailed boots.[25]

Considered more broadly, the shoe still lifes may sum up Vincent's physical as well as spiritual wandering, and, more generically still, they can

stand for the entire concept of a walk, or way, of life. Nineteenth-century illustrated books abound in head- and tailpieces with shoes, which invariably invite a reading in the multilayered fashion suggested for Van Gogh's shoes. For example, a headpiece in Alphonse Daudet's *Sapho* (fig. 66), showing two pairs of shoes, "condenses" the narrative of the budding love affair between Fanny Legrand and Jean Gaussin and their shared life in Jean's garret in the Latin Quarter. At the same time, the two pairs of shoes are the obvious objectified images of Jean and Fanny, a young student from the provinces and an urban *cocotte*. Read apart from the text, in a more generic fashion, the image evokes and perhaps comments on a bohemian way of life marked by carefree and careless promiscuity.

The shoe as a metaphor of both walk and way of life was an important topos in nineteenth-century literature and even common parlance. The painter Jean-François Millet sent autograph collectors a sheet of paper with his signature and a pen sketch of a pair of *sabots,* referring both to his status as a peasant painter and to his simple way of life in Barbizon, away from the urban sophistication of Paris. Van Gogh was well aware of Millet's practice, which was duly noted by Sensier, complete with illustration (fig. 67), in his biography of the artist, which Vincent read several times. In a letter from Nuenen [400], he paraphrased with delight Millet's saying that the indifference of the public to his work would be difficult to bear if he felt the need for gentlemen's shoes, but as long as he was content with a pair of *sabots,* he would manage. A few weeks later, characterizing his own isolation from the fashionable art world in Paris, Van Gogh wrote that he was "banished because of his wooden shoes" [408]. Seen in this context, the still life of *A Pair of Wooden Shoes* (Rijksmuseum Vincent van Gogh, Amsterdam; fig. 68), painted in Arles towards the end of 1888, is at once autobiographical, as it speaks of his simple lifestyle far away from Paris in small-town Arles, and generic, as it signifies country and peasant life, in its full nineteenth-century significance of an existence of labor and poverty, oscillating between resignation and revolt.[26]

Beyond providing a general model for the reading of Van Gogh's still lifes, specific head- and tailpieces often are directly relevant to them with regard to both form and content. Van Gogh's paintings of birds' nests, such as the one in the Rijksmuseum Kröller-Müller in Otterlo (fig. 69), have generally been interpreted as nostalgic images of the home he "never really found," but they lack the coziness and warmth that such an interpretation requires.[27] Indeed, Vincent's nests are isolated from their natural surroundings and displaced into a neutral, manmade environment, quite unlike the "living" nests in the popular paintings and watercolors of

William Hunt, an acknowledged specialist in the genre (Yale Center for British Art, New Haven; fig. 70).[28] Vincent comments on this displacement in a letter to Theo [428]:

> Well, the birds' nests were also purposely painted against a black background, because I want it to be obvious in these studies that the objects do not appear in their natural surroundings, but against a conventional background. A *living* nest in nature is quite different—one hardly sees the nest itself, one sees the birds.
>
> But when one wants to paint nests from one's *collection of nests*, one cannot express strongly enough the fact that the background and the surroundings are quite different, therefore I simply painted the background black.

Vincent's nests show an interesting similarity with a vignette in Michelet's *L'Oiseau* (fig. 71), a book he admired "passionately."[29] The image serves as an *en-tête* to a chapter that specifically deals with birds' nests. Michelet tells us at the outset that he is writing opposite a collection of nest specimens, a position that invites him to see the nest as a created object rather than a "bird's house." To Michelet the nest "owes everything to art, to skill, to calculation." Made with the bird's beak, and above all his body, which is used to felt the materials and to give the nest its ultimate shape, the nest is the bird's "very person, his form, and his immediate effort—I would say his suffering."[30] When we apply Michelet's words to Van Gogh's still lifes, their meaning changes radically from the one traditionally assigned to them. The nests then simultaneously signify works of art and the artist himself, his creative effort, and the total involvement and supreme suffering that creativity necessitates. Once again, the birds' nests summarize an important leitmotif in the letters, expressed as early as the Nuenen period when, in a letter to Theo [400], Vincent wrote, "But I always think of what Millet said, 'Je ne veux point supprimer la souffrance, car souvent c'est elle qui fait s'exprimer le plus énergiquement les artistes'" (I would never do away with suffering, for it often is what makes artists express themselves most energetically). And, quoting Millet again, he wrote in the same letter, "Dans l'art il faut y mettre sa peau" (In art, one must invest one's hide).

Like many head- and tailpieces in Romantic book illustration, Vincent's still lifes may be seen as manifestations of a characteristically nineteenth-century tendency toward what Karl Marx called *Verdinglichung*, a term usually translated as "reification." Defined as the act, or result of, transforming human properties, relations, and actions, into properties, relations, and actions of human artifacts,[31] the term is com-

monly used in the social sciences but has not found much use in cultural studies. Nonetheless, it is a useful term that may define a modern form of literary, or visual, rhetoric that distinguishes itself from traditional symbols or metaphors in that its primary agent is association, and the primary focus of its application a manmade object as opposed to a natural one.

The tendency toward reification may be seen in literature throughout the nineteenth century. It is prominent in some of Van Gogh's favorite works, such as the tales of Hans Christian Anderson, whose moral lessons are often spun around simple objects—a pair of red shoes, a darning needle, an old street lantern; and in Thomas Carlyle's *Sartor Resartus,* in which human properties and actions are "reified" in the form of clothes.[32] But no doubt the most striking symptom of this tendency toward reification is a fetishistic interest (in a Marxist, not a Freudian sense) in personal relics. To nineteenth-century viewers, inanimate objects like Napoleon's hat or George Washington's chair, though simple and insignificant in themselves, were imbued with the stature, achievement, and historic significance of the person to whom they once belonged. At the same time, they served as poignant reminders that their owners had departed forever, as, enshrined in historic houses and museums, these relics had lost their original purpose and remained unused and untouched.

Vincent's letters give ample evidence of his preoccupation with the immanence of the individual in objects owned or used. In an early letter to Theo from Amsterdam [118], for example, he writes about his father's recent visit:

> After I had seen Father off at the station and had watched the train go out of sight, even the smoke of it, I came home to my room and saw father's chair standing near the little table on which the books and copybooks of the day before were still lying; . . . I cried like a child.

Another, self-referential, example may be found in a letter from Drenthe [328], written in a little garret of a cheap rooming house:

> through one single glass pane, the light falls on an empty color box, on a bundle of wornout brushes, in short it is so curiously melancholy that fortunately it also has a comical aspect, enough not to make one weep over it but to take it gaily. For all that, it is very disproportionate to my plans, very disproportionate to the seriousness of my work—so here is an end of the gaiety.

The preoccupation with the immanence of an individual in the object he or she owns or has owned underlies several of Van Gogh's still lifes, notably his two well-known chair paintings, *Vincent's Chair* (Tate Gallery,

London; fig. 72) and *Gauguin's Chair* (Rijksmuseum Vincent van Gogh, Amsterdam; fig. 73). While Vincent's white deal kitchen chair, placed on a tile floor flooded by daylight, suggests the upright, unvarnished, and solid personality of a Dutch country boy, Gauguin's elaborate armchair, set in a gaslit, carpeted room, implies an urbane personality, at once colorful and exotic, mysterious and sinister, imaginative and sensuous, polished and sleek. Like the chairs themselves, the objects they carry—a pipe and tobacco, and two books beside a blue enamel candleholder—belonged to or were used by Van Gogh and Gauguin, respectively,[33] and they enhance and refine the characterizations. The books and the lighted candle on Gauguin's chair may suggest the artist's imagination, a faculty Van Gogh envied and associated with the night.[34]

The pipe on Vincent's chair refers to the artist's smoking habits, often discussed in his letters, particularly those from Arles [for example, 520, 543]. Smoking, to Vincent, was one of the little pleasures of life that, unlike women and alcohol, he could enjoy without guilt. Pipe-smoking related him to his father, whose pipe and pouch appear in *Still Life with Satin Flowers* (fig. 74), a pen sketch that he enclosed in a letter to Theo written immediately after his father's death [398]. It also connected him with a long line of modern artists and writers, from Charles Baudelaire and Gustave Courbet to Stéphane Mallarmé and Joris Huysmans, who were convinced that their pipes enhanced their creative faculties. This idea was perhaps most powerfully expressed by Baudelaire, in his poem *La Pipe,* incidentally a prime example of reification in literature:

> I am the pipe of an old author
> Who smokes a lot, as one could guess,
> Because the color of my face
> Is Abyssinian or Kaffir.
>
> When his remorse begins to burn,
> I fume like anybody's cottage
> Where someone's wife prepares a pottage
> Against her workingman's return.
>
> I cradle and entwine his soul
> Within a drifting blue-grey cloud
> That rises from my fiery bowl;
>
> A powerful comfort spreads about
> His tired heart and begins to cure
> His spirit's sad discomfiture.[35]

More ambitious than the two chair still lifes, Van Gogh's paintings of his bedroom in the "yellow house" in Arles (first version, Rijksmuseum Vincent van Gogh, Amsterdam; fig. 75) constitute his most complex objectified self-images.[36] They are, in effect, interiors as still lifes, in which the objects and their overall arrangement imply the artist's character, lifestyle, and ambitions.[37] The room so powerfully evokes the artist's presence that it was chosen as the setting for the Van Gogh diorama in the Palace of Living Art of the Movieland Wax Museum in Buena Park, California; a figure of the artist was placed on the chair by the bed (fig. 76).[38]

Bedrooms and studies, and the furniture they contained, were perhaps the most important objects in the nineteenth-century personality cult. Historic houses and history museums highlighted such rooms, which were intended to provide intimate glimpses into their owner's life and character as well as concrete reminders of their passing, especially if the bedroom had also served as death chamber. Goethe's bedroom in his house in Weimar may serve as a case in point. Generations of pilgrims have come to see this room, both *Schlaff-* and *Sterbezimmer,* whose simple modesty was inversely proportioned to the greatness of its occupant. Postcards of the bedroom were, and still are, sold as souvenirs (fig. 77), possibly to be tacked to a wall in lieu of a portrait.

And this brings us back to our point of departure: the relationship between Van Gogh's still lifes and the nineteenth-century vignette tradition. Just as bedrooms and studies, or ateliers, were featured spaces in historic houses and history museums, so these same rooms are common if not stereotyped subjects of vignettes illustrating nineteenth-century biographies as well as obituary articles and biographical essays in newspapers and magazines. One, S. Luke Fildes's *The Empty Chair* (fig. 78), shows the study of Charles Dickens with the author's empty chair. It appeared in the Christmas issue of *The Graphic* upon the author's death in 1870 and is known to have been admired by Vincent [252].[39] Another one is an image of Turner's bedroom (fig. 79), in *The Life of J.M.W. Turner, R.A.* by Walter Thornbury (1877).[40] Politicians, painters, scholars, inventors, all found their characterization in images of the bedroom and the study, both eminently private spaces, one providing a glimpse of its occupant's intimate personal life, the other of his or her solitary creative, intellectual life.

In conclusion, our interpretation of Vincent van Gogh's still lifes may be enhanced by placing them in the context of the Romantic vignette tradition. Not only is it possible to consider them as *culs-de-lampe* to the ongoing epistolary narrative that Vincent sent to his brother Theo, but

through their similarity with commonly occurring types of nineteenth-century vignettes, they also evoke specific literary traditions, such as biography, history, natural history, and even individual works. Finally, Vincent's strategy of making reference to contemporary literary texts by modeling his still lifes after the vignettes that accompany them may be seen as a form of updating the tactics of his seventeenth-century forebears, whose own still lifes often incorporated motifs that bore complex relationships to emblematic texts and images.

NOTES

1. The emblematic tradition originated in Italy with Andrea Alciati's *Emblematum liber* of 1531. Emblems became particularly popular in the Netherlands, where between the sixteenth and the eighteenth centuries some 250 different emblem books saw the light, the bulk of which (168) were published before 1600. See De Jongh 1967, 8–11.

2. For a discussion of these emblems, see Henkel and Schöne 1967, 1095–96.

3. Judy Sund (1988) relates the sower image in the art of Van Gogh primarily to the parable of the sower, told in the Gospels of Mark and Matthew. But that parable, often associated with the Calvinist doctrine of predestination, may have been less than appealing to the artist. Instead, I would argue that the twin notions of hope and rebirth were essential to Van Gogh's sower images, especially that of 1888 (Rijksmuseum Vincent van Gogh, Amsterdam), as they had been for the sower images of his role model, Jean-François Millet (see Sensier 1881, 88). These ideas are more closely related to other biblical texts, such as 1 Cor. 15:35–44, in which the idea of sowing is related to rebirth and resurrection, or Psalm 126:5–6, "They that sow in tears shall reap in joy. He that goeth forth and weepeth, bearing precious seed, shall doubtless come again with rejoicing, bringing his sheaves with him." Such texts also seem to have inspired Reusner and Taurellus as well as Dutch moralists like Jacob Cats, who in *Ouderdom en buyten leven* is repeatedly led to reflections on the hope and joy that accompany planting and sowing.

4. See Kodera 1990, 17; and Höltgen 1986, 141–96.

5. See Werness 1980 and Sund 1992, 109.

6. See Heckscher 1985, 112–13.

7. For more on the difference between Italian Renaissance and Dutch Baroque emblems, see especially Alpers 1983, 230–31.

8. In the case of a headpiece, it sometimes complements the title, much as the *impresa* of an emblem complements the motto.

9. Wood engraving after a drawing by E. de Beaumont, made for the original illustrated edition of Victor Hugo's *Notre Dame de Paris,* published by Perrotin in 1844. This edition, on which well-known illustrators collaborated, was reissued

in numerous reprints, more or less costly, depending on the quality of paper and binding. I have used an undated Albin Michel edition.

10. On the problem of text illustration, see Schapiro 1973.

11. For the term "enlarge" in this context, see ibid., 11.

12. As several authors including De Jongh (1976) and Alpers (1983, 231) have pointed out, this was the case with seventeenth-century emblems as well.

13. For a list of books and periodicals read by Vincent, see Pabst-Van Uitert 1987, 68–84, 89–90.

14. See especially Pickvance 1974. See also Van Tilborgh 1987.

15. Van Gogh 1991. Throughout the text, letter numbers in brackets refer to this source.

16. On this identification of the two books with the persons to whom they belonged, see also Hulsker 1980, 206, and Roskill 1979, 162–63.

17. Acquired in 1988 by the Rijksmuseum Vincent van Gogh, Amsterdam, the bible that belonged to Vincent's father is a nineteenth-century reprint of the Statenbijbel of 1714, the official Dutch translation first published in 1637. On the history of the bible, see Van Tilborgh 1988. Van Tilborgh points out that the binding is broken so that the bible automatically falls open to the Book of Isaiah, verse 53, the one indicated in Vincent's still life by the inscription ISAIE LIII.

18. The choice of these colors was quite deliberate, as we know from a description of the painting in letter 429: "I send you a still life of an open—so a broken white—Bible bound in leather, against a black background, with a yellow-brown foreground, with a touch of citron yellow."

19. On the two meanings of Van Gogh's paintings, specific and generic or, in other words, private and public, see Roskill 1979.

20. Christianity exemplifies paternalism, since Christ's suffering was imposed by his Father. This is made clear in Isa. 53:6–7: "and the Lord hath laid on him the iniquity of us all. He was oppressed, and he was afflicted, yet he opened not his mouth: he is brought as a lamb to the slaughter. . . ."

21. In interpreting this still life, most authors have focused on the two verbal elements, "EMILE ZOLA/LA JOIE DE VIVRE," which appears on the title page of the novel, and "ISAIE LIII," written on the right page of the Bible. While some scholars have interpreted the text of Isaiah (see note 20) and the words "joy of life" as signifying two contrasting philosophies (Graetz, Nordenfalk), one based on the notions of sin and guilt, the other joyous and guilt-free, others (Lövgren, Pollock) have seen them as related forms of belief. For a summary of the various interpretations of this work, see Kodera 1990, 43–46 and 113 nn. 137 and 138. Kodera (1990, 44) offers an interpretation that is close to my own, by citing a letter to Willemien [W 1] in which Van Gogh contrasts the modern novel, "truth . . . life as it is," with the Bible, which he feels is dead. My interpretation, which is much indebted to the analysis of Zola's *La Joie de vivre* by Nils-Olof Frantzen (1958), differs substantially from the most recent reading of the painting by Judy Sund (1992, 113), who sees a little of Van Gogh in all of the characters of

Zola's book: "Van Gogh probably identified to some extent with each of Zola's protagonists"

22. Derrida 1987, 257–382.

23. These walks are often described as therapeutic, even visionary experiences. His one-week walk in September 1880 from Cuesmes to Courrières, the birthplace of Jules Breton, in spite of utter fatigue and sore feet, made his "energy revive" and caused him to say to himself, "In spite of everything I shall rise again" [136]. A walk in Antwerp, where he "trudged through quite a number of streets and back streets . . . in the pouring rain" was "most satisfactory" [437].

24. For a fascinating discussion of these drawings, see Thompson 1987.

25. Quoted from Welsh-Ovcharov 1974, 34.

26. The link between wooden shoes and workers' revolts is most clearly seen in the twentieth-century term "sabotage," but the association is made as early as the 1830s by Carlyle (1927, 167), who in *Sartor Resartus* (first published in 1833–34) speaks of the "clouted shoes" that the German peasants "bore aloft with them as ensign in their *Bauernkrieg*."

27. See Graetz 1963, 39: "Indeed, deep in his heart, he [Vincent] always looked for a nest—a home, and never really found one."

28. For an insightful discussion of the contrasting affective values of the "live" nest and the "object" nest, see Bachelard 1964, 90–104.

29. See Welsh-Ovcharov 1974, 18.

30. Michelet 1981, 248.

31. For this definition and an excellent summary of the use of the term, see the article on "reification" in Bottomore 1983.

32. Though Carlyle himself still speaks of "symbols," his rhetorical use of old clothes is clearly one of association. This is obvious in a passage that describes his visit to the old clothes market in London (Carlyle 1927, 181): "What still dignity dwells in a suit of cast clothes! How meekly it bears its honors! No haughty looks, no scornful gesture: silent and serene it confronts the world. . . . The Hat still carries the physiognomy of its head. . . . The Coat-arm is stretched out, but not to strike; the Breeches in modest simplicity, depend at ease, and now at last have a graceful flow; the waistcoat hides no evil passion, no riotous desire; hunger or thirst now dwells not in it. . . ." On Van Gogh's interest in Anderson, see Sund 1992, 30 and 259 nn. 73 and 74; on his engagement with the writings of Carlyle, see Pollock 1980, chapter 3.

33. It is noteworthy that nearly all these objects recur in the *Still Life on a Drawing Table* of January 1889 (Rijksmuseum Vincent van Gogh, Amsterdam), painted shortly after Vincent had been released from the Arles hospital, where he had recuperated from the dramatic ear incident that had caused Gauguin's departure from Arles. The candleholder from Gauguin's chair and the pipe and tobacco from Vincent's own chair appear on opposite ends of the drawing board, separated by a white ceramic plate with onions (a motif likewise found in *Vincent's Chair*). The painting furthermore contains a book, not one of the novels that

appear in *Gauguin's Chair*, but F. V. Raspail's *Annuaire de la santé,* which relates the painting directly to Vincent's recuperation. The artist seems to have read this book avidly in search of cures against insomnia [570] and feverishness [576]. The *Still Life on a Drawing Table* may be seen as a reified self-portrait showing the artist at a particular moment in time and under specific circumstances, analogous in many ways to the contemporary *Self-portrait with Bandaged Ear* (private collection), in which the pipe is equally important.

34. It is significant, for example, that Vincent's *The Poet* (Musée d'Orsay, Paris), "a man who dreams great dreams," [520] is painted against a night sky. An interesting parallel may be drawn between *The Poet* and *The Peasant* (private collection), on the one hand, and *Gauguin's Chair* and *Vincent's Chair* on the other. In both pairs of paintings there is a juxtaposition of nocturnal and daytime settings for the evident purpose of characterizing two opposing ways of life that are directly related to contrasting personalities.

35. Baudelaire 1991, 131.

36. For a discussion of the work, which exists in three versions, with differently colored floors, see Amsterdam 1990, 172–76. Earlier discussions of the work (by Brettell, Hulsker, and others) are cited in a footnote at the end of the entry.

37. On the importance of the room and its furnishings as an image of its inhabitant(s), see Baudrillard 1968, 21ff.

38. A fascination with these paintings as the intimate characterization of the unique self can also be seen in the work of Roy Lichtenstein, who in *Bedroom at Arles* of 1992 (private collection) deliberately "depersonalizes" Van Gogh's painting, not only by repainting it in his customary style of "dots and stripes," but also by replacing the handmade rush-bottom chairs with modern mass-produced tubular chairs and Vincent's painting smocks with white uniform shirts.

39. The parallel between Van Gogh's two paintings of chairs and Fildes's wood engraving *The Empty Chair* was first drawn by Van Uitert 1976, 94. A more extensive discussion may be found in Bailey 1990, 143–47.

40. See Van Uitert 1976, 94.

Tom Wesselmann: Still-Life Painting and American Culture, circa 1962

IN THE early 1960s, the United States witnessed a sudden outpouring of figurative art, which included several currents of still-life painting. This emerging manifestation, dubbed Pop Art, was identified as an important phenomenon around 1962. It presented iconography and issues wholly different from those posed by Abstract Expressionism, which had dominated American critical and popular attention for a decade. Still life, as a subject, possessed a context in traditional art that provided a conceptual and formal underpinning on which the new painting could firmly stand, and, along with it, an opportunity to develop a productive and energetic tension between the foregoing tradition and its new American sociological slant.

Art in America throughout its history had developed within two axes of unresolved polarity, a fact of which American artists had usually been sharply and self-consciously aware: the old versus the new, and the European versus the American. Pop artists of the 1960s used the venerable tradition of the still-life genre as a foil to emphasize the aggressively new and idiosyncratically American character of their images. In addition, another axis (often carried as an anxiety-producing psychological element within the artist) was continually projected by the uncertain or unproven status of American art: the axis between "just as good as any" versus "acceptable for provincials but not world-class." Post–World War II painters took a hint from the United States' position as an ascendant economic and political power, declared themselves immune to the kind of inferiority complex that had haunted the generation of Jackson Pollock, and presented their new art with unapologetic braggadocio. When an interviewer asked Andy Warhol a question implying a negative evaluation of his paintings because they were made using techniques more closely associated with mass manufacture of industrial products than with

This paper was first presented at the Annual Conference of the College Art Association, Washington, D.C., February 1991, in the session "The Object as Subject."

traditional fine-art objects, he responded with his self-celebrating and dismissive (but not ironic) remark, "I'd love to be a machine."[1]

Objects chosen for still-life painting in the early 1960s show the artists' readings of their burgeoning American material culture and, by implication, the values and processes bringing it about. The subject matter they emphasized consists of ideal and typical contemporary items of popular use, including especially foodstuffs and household items. The subject matter of Pop Art still life points to the post–World War II flourishing of late industrial capitalism in the United States, with its enormous proliferation of goods for individual use; the resulting development of hyperactive buying of such goods as a major modality of American behavior; and, further, a conceptualizing of consumerism and a conscious preoccupation with it in the American sociocultural community. Consumerism, in this context, becomes confused with political behavior, as buyer-user is equated with the citizen in the body politic. Also, the activity of buying and using goods is conceived broadly as a determinant of psychological states, so that behavior as a consumer is understood by Americans to govern emotional satisfaction and to influence sexual success within the culture's gender norms.

It is interesting and relevant that the pattern of art patronage that emerged around Pop Art and artists by the late 1960s reflects this same sociocultural characteristic. Paintings whose aesthetics, subjects, and general spirit were deliberately based outside established norms of the fine arts, paintings that celebrated a world characterized by the unrefined, ephemeral, cheap, and common, were accepted as art and avidly purchased by a large group of American collectors newly in possession of large amounts of money and bent on becoming conspicuous consumers of luxury goods. This phenomenon lies outside the scope of the iconology/iconography of the artworks themselves, but it is a strongly related manifestation of parallel values.

Issues concerning still life in its new American form were abundantly treated in art of the Pop movement, by the dominant personalities such as Jasper Johns and Andy Warhol as well as the secondary ones like Tom Wesselmann and Roy Lichtenstein. Many works that became defining icons of Pop Art are still-life images.

Early in the movement, in 1960, Jasper Johns made the sculpture *Painted Bronze*, depicting two Ballantine ale cans, one "full" (unopened) and the other "empty" (the top pierced by a beer opener) (Kunstmuseum, Basel; fig. 80). Johns replicated the actual size of the original ale cans and set them side by side in an arrangement without artistic composition and without hierarchy. Andy Warhol provided many paintings that came to

epitomize Pop Art still-life attitudes and content, such as *Green Coca-Cola Bottles* of 1962 and *100 Cans,* also of 1962 (Albright-Knox Art Gallery, Buffalo, N.Y.; fig. 81). Johns had painted the labels on his Ballantine cans exactly but with a somewhat painterly quality. That, along with a slight textural play in the sculptural surface, gives a hint of imperfection and craftsmanly warmth, taking the edge off the cans' manufactured appearance and establishing a slight aura of mystery, nostalgia, and humanity. Warhol by 1962 expunged traditional artistic beauties almost entirely, eschewing all hints of an author's painterly hand or the judgments of human aesthetic intelligence. He makes explicit in his rendering his use of mechanical methods that run counter to the traditional values of uniqueness, high technical quality, and refined aesthetics. This latter trend is strong in Wesselmann's work, where he uses several manners of rendering that are all aesthetically foreign to painterly traditions and close to those of advertising and mass printing.

Warhol, in his works of 1962, like Johns in *Painted Bronze,* employed antihierarchical compositional arrangements. The cans or bottles are oriented forward, of equal size, and equally spaced in rows and grids, strongly suggesting production lines or supermarket shelves. Wesselmann employs compositional schemes showing elaborate judgments in design, so that his images are structurally more like traditional still lifes. Such compositions make an uneasy, ironic match with his manner of painting.

Many American artists worked with these issues between 1961 and 1963. Roy Lichtenstein painted *RotoBroil* in 1961 (Collection of Mr. and Mrs. Leonard Asher, Los Angeles; fig. 82), an artwork devoted to American labor-saving kitchen appliances. Here an electrical deep-fryer stands alone and dominant on the huge surface of the canvas, radically flattened, face-forward, and close up. Its trade name is made conspicuously visible, along with its imprinted temperature tables for frying and cooking. The RotoBroil is presented with its frying basket raised and overflowing with fried chicken legs, in a style Lichtenstein took directly from cheap daily newspaper illustrations advertising such products.

Tom Wesselmann's Pop Art still-life paintings remain closer to the great European tradition within which they operate. Wesselmann's images combine edible things, the vessels that contain them, and objects from the interiors within which they are characteristically found; sometimes, also, they include the human characters who have to do with the objects or foods. They are usually depicted within a traditional (though rudimentary) pictorial space. Wesselmann's *Still Life #30,* of 1963, is a typical example of his work (Museum of Modern Art, New York; fig. 83; pl. V).

The title exemplifies Wesselmann's practice of giving his works numbers

rather than individual names during these years, stressing both the generic nature of his paintings and the categorical nature of his participation in the European artistic tradition. The tactic of numbering paintings was used by the major Abstract Expressionists (notably Jackson Pollock and Clyfford Still) in an effort to prevent specific readings of subject matter in their paintings and to stress their nontopical, universalist nature and arcane metaphysical content. In Wesselmann's usage, the implication is shifted, so that numbers for names suggest seriality, a productionist notion with hints of the egalitarian attitude appropriate to the mass-production aspect of Wesselmann's depicted subject.

Still Life #30 is a large painting on canvas, measuring 123 by 168 cm, enhanced with applied paper components and attached three-dimensional elements that are real objects from the world of actual use, including a refrigerator door and three 7-Up bottles standing on top of it. In his technique and formal organization, Wesselmann bypasses Abstract Expressionism to associate himself strongly with the earlier, more rigorous, and most highly respected tradition of European early modernism. His use of collage and attached objects stems directly from Picasso's Synthetic Cubism of 1912, and his compositional organization is based specifically on Cubism's immediate derivations, early twentieth-century pure geometric abstraction, especially De Stijl. Wesselmann's debt specifically to Mondrian is humorously and pointedly acknowledged in his closely related *Still Life #20* of 1962 (Albright-Knox Art Gallery, Buffalo, N.Y.; fig. 84), which prominently features a reproduction of a Mondrian painting, set with other elements in an aggressively geometric compositional balance.

In *Still Life #30,* Wesselmann specifies his setting as a kitchen interior. He includes a refrigerator and an electric range flanking a kitchen sink, the three primary pieces of large equipment for the storage, cooking, and cleaning of food. The 1950s had been a decade in which Americans filled their homes with appliances, the refrigerator being the most popular. Of the American homes wired for electricity, 98 percent had been equipped with refrigerators by 1959.[2] Wesselmann's refrigerator bears the American manufacturer's name (Westinghouse), and it is identifiable by its design as from the mid-1950s. The buttons on the stove front and the sink's faucets and taps are also mid-1950s in style. The coils on the electric range are clearly depicted. On one of them stands a coffee pot made of glass and plastic, of 1950s design.

The refrigerator, sink cabinet, and range are all bright pink, indicating thoughtful, if vulgar, coordinated interior decoration. Above is a neatly curtained window, establishing coziness. On one side is a pressed-tin wall

covering that evokes an earlier decade, while on the other is a bad repro-
duction of a Cubist painting by the famous Pablo Picasso, revealing this
home's appreciation of high culture.

Wesselmann's characterization identifies the kitchen as belonging to a
middle-class, mid-1950s home, typically located in the suburbs, which by
1960 thickly surrounded all major American cities. If we look out
Wesselmann's window, we look across a wide green lawn toward a nearby
city. New single-family homes were built at a rate of almost a million and
a half per year between 1950 and 1960, so that by the end of the decade
25 percent of existing homes had been newly built within the prior ten
years.[3] The American population was 150.7 million in 1950 and 180
million in 1960, representing the largest numerical increase in any single
decade to that time. Of the population growth that occurred, 83 percent
was in the suburbs, so that by 1960, sixty million Americans, one-third of
the population, experienced life in that new modality of family life and
social interaction.[4]

The suburbs had been made accessible to the working middle-class by
the now ubiquitous automobile and paid for by the postwar economic
boom and the new enthusiasm for buying on credit. By 1960, eighty per-
cent of families owned an automobile, with fifteen percent owning more
than one.[5] In the 1950s, the amount Americans owed in private individ-
ual debt more than doubled: in 1950 they owed $73 billion, and in 1960,
$196 billion. The American Express card had been introduced in 1955,
followed by a host of credit cards issued by major merchants.[6]

Through the 1950s, the massive and continuous flow of these internal
currents in city planning and consumerism was felt not only as changing
American life but also as defining it. Concurrently, the status and activity
of the United States in relation to the external world were demanding a
well-defined concept of America, as the World War II alliance against
Nazism and Fascism dissipated and re-formed around the cold war
threat, world communism. In 1950, Senator Joe McCarthy of Wisconsin
launched the intense and wide-reaching anticommunist crusade that he
would pursue until 1954.[7] In 1950, under the name of the United Nations
Police Action, the United States went to war in Korea. President Truman
said, "Our homes, our nation, and all the things we believe in are in great
danger."[8]

Tom Wesselmann, born in 1931 in Cincinnati, Ohio, was drafted into
the U.S. Army in 1951 and sent to Fort Riley, near Manhattan, Kansas,
although he apparently did not serve in combat in Korea. An armistice
was negotiated in 1953, after 34,000 American casualties. For the young

men of the Korean war generation, Wesselmann's painting has something to do with an American lifestyle and ideology they talked about defending.

Through the 1950s, the modern home, especially the kitchen, came to be seen as a major sociological locus for Americans: Wesselmann's kitchen, for example, is no longer a mere food service area but a place in which Picasso may be viewed. It became the cynosure of the culture, a center of family life, a site especially for the use of consumer products, and an important outlet for American scientific and industrial research and development. For example, a book published in 1962, extolling the wonders of modern American life and making predictions on the basis of the values and preoccupations ascendant in the early 1960s, praises the development by General Electric of a major new kitchen appliance, a combination oven and freezer, which is intended to save time in household work. The caption under the picture (fig. 85) showing it in operation says,

> Push a button, get a meal! Among tomorrow's "wife savers" is this working model of a combination oven and food freezer. Meals are prepared in advance and stored in the individual freezing compartments. . . . At dinner time, the housewife pushes the appropriate buttons; in less than half an hour, the full meal emerges at the rear end of the appliance, hot and ready to serve.[9]

Even texts whose theme is not modernism in cooking but rather the joys of primitivism extol such inventions. In the cookbook *Barbecues and Picnics,* of 1963, the technique section "Kabobing for swordsmen" in the chapter "Over-the-Coals-Kabobs" instructs, "Lucky the chef who boasts motorized skewers. For hand turning, use kabob frame or support on bricks."[10] The last bit of advice seems directed at the hapless chef, lacking motorized skewers, who is too dumb or too alienated from his kabobs to know how to turn them over.

The modern kitchen as symbol of American life was so powerful that it was used in international cultural representation. In 1959, the U.S. and the U.S.S.R. arranged an exchange of cultural exhibitions. The Soviet promotional show, set up in New York, featured scientific and technical developments (especially those relating to the successful Soviet space program) and Soviet culture. The United States sent to Moscow a model American home, accompanied by Vice President Richard Nixon. Displays in it included a large selection of household consumer products, and Pepsi Cola was served. The experience of the American kitchen was evidently so

intense that Soviet Premier Nikita Khrushchev was inspired there to en-
gage Mr. Nixon in acrimonious debate over the relative merits of the
communist and the capitalist systems. The two were photographed in the
midst of the confrontation, and the incident went down in cold war his-
tory as the "Kitchen Debate."[11]

In Wesselmann's postwar kitchen, the conglomeration of foodstuffs is
arranged on a table covered with a modest blue-checked tablecloth. All
the items are identifiable as readily available medium-priced brands that
could be obtained at a suburban supermarket; indeed, many of them are
national brands that could be bought at any supermarket across America.
Already by 1953, there were in the United States 17,000 supermarkets,
with "supermarket" defined as a grocery store with annual sales in excess
of $375,000. These supermarkets, 4 percent of the grocery stores in
America, handled 44 percent of the nation's grocery sales.[12]

Wesselmann's arrangement of foods includes two types, packaged and
unpackaged. Most of his items are processed packaged foods, marked with
trademarks, labels, and wrappings that identify their various producers-
sellers. Wesselmann has rendered his painted and collaged depictions ex-
tremely accurately, with sharply focused, complete, and legible labels.
Each of the packages is dateable; some, by now, are obsolete. The promi-
nent inclusion of specific brand-name packaging in works for a fine arts
context is striking and a peculiarity of the 1960s, although there are a few
precedents for this in early twentieth-century European art. Picasso's
Glass and Bottle of Suze, of 1912 (Washington University Gallery of Art,
St. Louis), includes an actual bottle label printed "Suze Aperitif à la Gen-
tiane." A few occurrences in American art of the early modern movement
are based on European Cubism but are more thoroughgoing and celebra-
tory in their use of brand-name labeling, an indication of their American
character. The paintings of Stuart Davis, especially his *Untitled* depicting
a bottle of Odol, of 1924 (Collection of Mrs. Stuart Davis), and his *Lucky
Strike*, of 1921 (Museum of Modern Art, New York), are often mentioned
in this context. Wesselmann says he began to incorporate brand labels in
1962, after having avoided such labels in earlier still-life paintings "in
order to preserve a more classical composition."[13]

The viewer may look among Wesselmann's still-life items for visual
elements that seem "more classical," in order to alleviate the impact of
the brand-labeled objects, which Wesselmann characterized as "very de-
manding elements."[14] The apple, for example, is an age-old component
of still-life painting. Wesselmann presents it bare and unpackaged, ren-
dered so as to show its natural volume, its rich color variations, and the

shine on its taut skin. It is carefully given identifiable characteristics that even specify its particular breed, a Red Delicious. Its shape is perfect and its condition ideal. In fact, it corresponds exactly to the definition published by the government in its compendium for the grading and sizing of fruits and vegetables in the codes regulating the produce industry, the Perishable Agricultural Commodities Act, applicable to fruits and vegetables that cross state lines. The code sets out, through pictures, diagrams, and elaborate verbal specifications, the standards for various grades of apples. There are also charts establishing government classifications of apples by size categories and, for most fruits, diagrams and pictures specifying permissible standard shapes, all of which stress regularity and symmetry; figure 86 is an example.[15] By all appearances, Wesselmann's apple meets the requirements for the very best.

The industry's conceptualization of apples is based on ideal types but not with the suggestion of Eden or reference to the State of Nature, or even in the spirit of the backyard victory gardens of World War II. The issue is rather the virtues of commerce and industry. The code stresses standardization, regularity, and predictability because they are characteristics of mechanized production, and the classification of items into sizes facilitates the process of packing in standard-measure crates for the long-distance distribution required in profitable mass marketing.

Wesselmann's apple is additionally linked to the world of commerce by the style in which it is rendered, that of common printed fruit pictures used in the 1950s in crate labels and supermarket produce-department decorations, idealizing depictions intended to suggest that the fruit being sold is eternally perfect. Furthermore, Wesselmann has not even bothered to paint his own version of this familiar illustration style; he has glued an actual cut-out printed fruit picture onto the surface of his painting.

For many of Wesselmann's other foodstuffs, we see not the food itself but only the package, which, we have faith, contains the food. Inside are the highly processed, artificially structured, textured, and flavored versions of the original natural product, with added ingredients. A perfect example, known to every American, is Kellogg's breakfast cereals, represented in the painting by a large box of Rice Krispies and a package of ten assorted different cereals in small separate boxes.

In the box of Rice Krispies, the familiar commercial packaging features on its front a small still-life painting, an ideal picture of that cereal unpackaged and prepared for eating, along with the manufacturer's name in its high-recognition signature typeface and the cereal's name (in its brand-product alternative spelling) in its own different typeface. Also on the

package is the face of a comic cartoon mascot for this particular product, one of three elfin characters invented by the Kellogg Company as personifications of the noises the company asserts can be heard emanating from its specially formed rice flakes when they are exposed to milk: "Snap, Crackle, and Pop." In animated cartoon form, the three elves were familiar as actors in Rice Krispies television commercials. By 1960, ninety percent of American homes had television sets, the most effective medium for commercial advertising in the history of the world.[16] The three elves' encouragement to listen for the utterance of their names by your morning meal invites active audience participation, not just in the eating of Rice Krispies but also in the Kellogg Company's whole realm of literature and psychology. Wesselmann's faithful depiction lets on to this elaborate and ramified commercial iconography, indicator of the enormous machinery of the American postwar packaged food industry.

Wesselmann's second product from Kellogg exemplifies several additional aspects of American food production, packaging, marketing, and distribution. Called a Variety Pak, this is a transparently wrapped large package that carries within it ten subpackages, each containing one serving. They offer several Kellogg cereals, each articulated as precisely and supported as elaborately as Rice Krispies, each distinguished by the offer of a different sensory experience or nutritional benefit to its eater. In the Variety Pak, all cereals compete visually and informationally, through their packages, for the consumer's attention and choice. Together the set of ten is intended to convey the message of the luxury of plenitude and diversity plus the excitement of changing experience: in their variety the ten tempt the eater not only to have breakfast cereal but also to have a different cereal than he did the morning before. In a family setting the Variety Pak both stimulates and gratifies each member of the social group in expressing his or her individuality in terms of the cereal he eats, having been offered by the manufacturer a dimension in which to enact personal freedom. Finally, therefore, breakfast has become a microcosm of the nation, as each person, reaching for the cereal he wants, paradigmatically reenacts the highest and most sacred right of a citizen of a democracy, casting a vote for the candidate of his choice.

This item stresses convenience as well as individuality and choice. What cannot be shown by Wesselmann in the painting but may be remembered by those who as children in the late 1950s consumed such cereals is that in some Variety Paks each little box was lined with waterproof paper and scored on the back with lines for cutting. If the eater followed directions carefully, he could cut the box and fold back the flaps,

so that the box itself became a small eating bowl. He could pour milk into the cereal inside, eat, and throw the box away. This is an example of highly lauded American ingenuity devoted to convenience eating and to relieving housewives of such laborious household tasks as dishwashing.

The Kellogg's Variety Pak reflects many trends in eating styles that emerged in the late 1950s, including speed, extreme informality, and the reduction of utensils and dishes. In post-war society, informality reigned, most married couples had small children, servants were a thing of the past, and husbands did not yet think of helping wives with housework. The designation "genius" could be given to a person who invented cereal boxes that converted into disposable bowls. General Electric even invented a kitchen appliance, extolled in 1962, with which a housewife could, in her own home and at the touch of a button, stamp out plates and cups from liquid plastic, feed her family on them, and throw them away.[17]

The trend toward informality spurred a vogue for eating outdoors, especially among families in suburbia, where single-family homes came with enough land for a backyard, an outdoor fireplace, a terrace (called by its more fashionable though architecturally erroneous Spanish name, *patio*), and perhaps later in the decade a swimming pool. *Better Homes and Gardens* magazine's cookbook for the outdoors illustrates instructions for sandwiches made from a canned processed ham spread with a picture of picnicking children captioned, "The hobos meet for lunch! . . . The kids vote it always more fun—no worries about crumbs or forks or fancy manners. Finger food is easy to eat."[18] Hobos (American slang probably derived from "homeless boys" or "homeless bums") meant migrant workers in the 1920s, and in the poverty-stricken depression years had come to mean destitute vagrants. The editors evidently found it an endearing term for messy suburban children, who are seen as "voters," ratifying the abandonment of refined mealtime behavior.

The designing of food packages for disposability, and for accessibility without the use of a separate tool, flourished in this period. In Wesselmann's still life, the carton of Florida chilled orange juice shows a design popular in the early 1960s but already obsolete by the 1970s. This is a wax-permeated carton that, instead of terminating in the later-popular house-top folds that break open into a spout, had a flat, attached top with a round opening, reclosable with a little trap-door lid on a paper hinge. It was disposable, of course. There were at least two other designs for drink cartons in production in the 1960s, now extinct; many packages were designed that were never commercially adopted. All addressed the

quest for presenting small portions of food that could be easily unpacked by hand and eaten as soon as exposed, with minimal preparation (cleaning, cutting, mixing, cooking, serving) in the American kitchen now so elaborately equipped to prepare it.

The packages are all descendants of one great ancestor, the metal "tin" can. In continuous, universal, heavy use from the nineteenth century to this day, cans were the packaged-food industry's first great victory over the natural cycle of uneven seasonal abundance, spoilage, and the limitations of distant growing locations. Food preparation by steaming inside a sealed container was known in the early nineteenth century in France. In 1825, a patent was taken out for "a tin case" in New England. Other packages and other processes followed, such as dehydrating, condensing, freezing, and freeze-drying. Much research was devoted to these, leading to consumer products such as the landmark TV dinner, a packaged frozen complete meal, which appeared on the market in 1954.[19] The can and canning themselves continued to be developed and improved, but Andy Warhol spotlighted a sensational news story about women dying from improperly canned tuna in *Tunafish Disaster* of 1963 (Andy Warhol Foundation for the Visual Arts, Inc., New York; fig. 87), a canvas in which he interspersed photos of the dead women with images of a can labeled "A&P Chunk Light Tuna," the house brand of a large national supermarket chain.

The "tin" can was made of heavy metal and required a separate can opener; the invention of the electric opener alleviated the effort. Since 1960, when Jasper Johns depicted the Ballantine Ale can, drink cans have been redesigned with the new "pop-top" so that they can be easily opened by hand.

Packaged, widely available convenience foods projected into the cuisine of the 1960s the quintessentially American trait of coupling goodness and complexity with immediacy and ease of attainment. In the cookbook *Best Buffets,* of 1963, a menu for "A Traditional New England Supper" needs almost no recipes, because almost none of the dishes requires mixing or cooking. In the introduction, praise of modern convenience is mixed with a heartbreaking historicist nostalgia:

Old fashioned favorites with no fuss! Polish up the family heirlooms and get set for an easy New England supper! . . . These wonderful foods of the colonists . . . are at your fingertips, on canned and packaged food shelves or in the freezer cases. So how about inviting folks over for a real New England supper? Fun for the guests and easy for you! . . . The beans bake all day in a brick oven; they come to you in cans or glass bean pots. Serve

them with hot brown bread—from a can; with corn relish, piccalilli, spiced crab apples—all from jars. Round out the meal with . . . a country kitchen dessert, Indian Pudding. Cooks of yesteryear baked this corn-meal-and-molasses dessert for hours; yours comes glassed, heated in minutes. Or have mince pie (from a frozen package) or mix-made cake with Apple Snow Frosting.[20]

On Wesselmann's table is packaged yogurt, a non-American food that was not popular in all parts of the United States in 1962 but that would flourish on the American mass market over the next quarter century. Wesselmann faithfully shows that the Breakstone Company offers strawberry yogurt; the Middle Eastern dairy food has been adapted to American tastes by the addition of fruit preserves, so that it becomes a dessert resembling the popular strawberry ice cream sundae.

The drive for elaboration in purchasable packaged foods resulted in the increase of unusual, imported, and foreign items. The appeal of the "exciting" and "different" aspects of exotic foods was balanced by the comfort attained through domesticating modifications made by manufacturers and distributors. In cuisine, this phenomenon parallels the Americanization of immigrants' surnames at Ellis Island and its corollary, the popularity of packaged tours to foreign countries for provincial American suburbanites. American supermarkets and home magazines offered a smorgasbord of decontextualized culinary possibilities, a veritable Disneyland of simulacra of foreign cultural experience.

Another exotic food appears on Wesselmann's table twice: pineapple, imported from the other side of America's far-flung commercial source pool. As the United States generated its abundant domestic consumer products environment, pineapple became a popular ingredient for the type of cuisine enjoyed by fashionable young suburbanites socializing at home. In 1963, the cookbook *So Good Meals* offered American cooks one hundred recipes; twelve of them require canned pineapple. In every case, the recipe specifies exactly which canned pineapple product to buy. For example, Pineapple and Cucumber Salad takes "two no. 2 cans dietetic-pack pineapple tidbits." In other recipes, pineapple rings are grilled with hotdogs in "Hilo Franks" or transform hamburgers into "Aloha Burgers"; the term "luau" was sufficiently well known to be used without further explanation.[21] In easy recipes that produced exciting dishes for informal eating, pineapple offered the 1960s a touch of orientalist exoticism.

Wesselmann's pineapple comes in its sturdy can wrapped with a bright

label showing the brand name and displaying the fruit cut into rings, an interesting decorative shape, one of the many choices available. The brand name is that of the Dole family, who became wealthy growing and exporting pineapple from the U.S. territory of Hawaii. With his choice of canned Dole pineapple for his suburban middle-class table, Wesselmann presents a detail from everyday life that reflects major and dominant political, military, and economic developments in modern American history. The Dole family, especially in the figure of Sanford Ballard Dole, exemplifies the combination of commercial entrepreneurship, territorial expansion, and cultural imperialism of this period. Dole was the son of missionaries who had gone to Hawaii to Christianize the natives. In 1887, Dole helped lead a revolution for constitutional changes under the longstanding royal government of Hawaii. When the next revolution overthrew the Hawaiian royal house (1893), he initially opposed it but later accepted an appointment as president. He led the movement petitioning for annexation to the United States, but President Grover Cleveland demanded the restoration of the legitimate Hawaiian queen. In response, Dole delivered a famous paper challenging Cleveland's right to interfere.[22] Annexation of Hawaii as a U.S. territory was subsequently accomplished under the McKinley administration in 1900; Sanford Ballard Dole became the territorial governor.

Hawaii had been valuable for more than fruit, providing an important early American military base in the Pacific. For Wesselmann's period and cultural milieu, Hawaii was fated to figure large in the mythology that accompanied the emerging national political reality. The bombing of the American military base at Pearl Harbor had turned the tide of domestic political opinion in 1941, prompting the entry of the United States into World War II and generating the course of events that led to America's post-war global political ascendancy and economic prosperity. Hawaii was promoted to statehood four years before Wesselmann painted *Still Life #30*.

The last packaged food on Wesselmann's table is bread, traditional component of still-life paintings and an even older signifier of sustenance itself, carrying a weight of cultural symbolism that even embraces the Last Supper of Christ. Bread signifies abundance and well-being; the most familiar text in Protestant Christian worship, the Lord's Prayer, says "Give us this day our daily bread" to express the hope of humankind's nourishment by God Almighty. In Wesselmann's painting, bread certainly connotes abundance, especially set within the multiplicity of food items on his table. Wesselmann's bread, however, is of a specifically American type,

eaten by almost no other cultural group; its development could in itself be the subject of a long sociological study. The bread is not broken but cut, presliced at the factory so that the eater does not have to bother; every slice is perfectly and precisely even, matching the homogeneous texture inside and the pristine, blank color. So noteworthy was the mass-market introduction of prepared and packaged bread within American culture that it generated an idiom of praise for any outstanding innovation, "the greatest thing since sliced bread."

This bread, however, has an additional virtue beyond its ancient value as the Staff of Life. This is Lite Diet brand, revealing through its name that it is also beneficial against obesity. It is a characteristic, peculiarly American malady (more prevalent in the wealthy post-war years) to indulge in unchecked intake of sweet or starchy foods, while at the same time hoping to reverse the natural effects of such indulgence—plump body contours. Abstinence, or even moderation, of unleashed appetite is nowhere suggested by Lite Diet; the delectable bread slices cascade invitingly out of the see-through package, and we expect the experience will be as gratifying as eating normal bread, but we trust that the calorie count is regulated within the product so as to prevent weight gain.[23]

The unpackaged foods in Wesselmann's still life seem at first to hark back to the natural, unaltered forms that had populated earlier still-life painting. Wesselmann has included, besides his apple, two oranges in the window, a tray of other fruit, a beef roast, and two popular American cooked dishes—a stack of pancakes surrounded by little sausage links and a hotdog on its bun.

The hotdog with mustard, placed front and center, is again a reminder of the popularity of eating outside the dining room. The frankfurter, with its German name shortened and anglicized as frank, became, with the hamburger, ubiquitous and the most American of foods. In 1950, the American citizenry ate 750 million pounds of frankfurters; in 1960, that quantity had grown to 1.05 billion pounds.[24] In 1954, Ray Kroc began a chain of standardized quick-service hamburger restaurants called McDonald's, destined to represent worldwide both American cuisine and the quintessence of American business entrepreneurship before the end of the century.[25]

Wesselmann's hotdog and stack of pancakes are both presented in their cooked, served, ready-to-be-eaten form; this is an ideal state. It is also a state that lasts, in reality, only a fleeting moment. The butter pat on the pancakes is melting from still-radiant heat, but it has not yet soaked in and disappeared. The syrup has been poured and has only begun to run down the sides. The hotdog shines with the moist, plump look of just-

cooked meat. Such images project an urgency, but also, since these are ideal, archetypal forms, they project a kind of permanence, an immortality not subject to the effacement of temporal existence. This combination of ideality and temporality belongs to a specific style of visual rendering, not from the realm of fine arts but from advertising: the air-brushed renderings of perfectly prepared foods at their climax of ready-to-eat-right-this-very-moment goodness found in the pages of homemaking magazines, which arrived by mail in huge numbers at the houses in the American suburbs, showing women what irresistible dishes could result from the mixes and powders in the supermarket boxes.

The compelling immediacy of the hotdog and the pancakes sets up a curious conflict: both foods are in a state of intense readiness, but one is rather exclusively breakfast and the other lunch. Their juxtaposition generates an unsettling discord. Contemplating Wesselmann's painting as a feast, the viewer becomes increasingly aware that although there are many foods on the table, they are not coordinated. This is not a meal, and it is not even a balanced diet. This visual rendering—in which each element is ideal, each demands attention with its aggressively sharp detail, and all are revealed in a broad undifferentiated glare—results in an ensemble in which each of the components is equally attractive to the viewer but distinct from the others. Each item retains a hermetic identity despite the tight compositional design in which all are caught. They jam together disjunctively, alien to one another and without reciprocity or mutual acknowledgment, each competing for the viewer's visual and psychological consideration, so that his attention jumps, unsatisfied, from food to food.

This is the message of Wesselmann's painting beyond the iconography of its parts. If we were to view American foods in their natural setting, that is, if we were to go shopping in one of the great American supermarkets of 1955 or 1965 or even the present day, we would experience continual visual bombardment from countless equally aggressive individual items, as we pushed our carts up and down straight aisles between rigorous grids of packaged displays. In Wesselmann's painting, the groceries have been selected and brought home to the kitchen and the table, but, although the artist has designed a combination of elements less geometric and better integrated and composed than a supermarket display, he has not allowed the components to lose any of the character necessarily stamped on them by the process of American manufacture, distribution, advertising, and sale. That aspect of each of their personae, and of their national character collectively, never melts, never falters, never quiets, never fails to self-promote. In the end, then, a larger issue emerges after the picture's subject matter has been excavated: the discordant

association of these objects is an analogue to the competitive demands from disjunctive elements that pervade American society itself.

NOTES

1. Swenson 1963, 26.

2. Vatter 1963, 175.

3. Department of Commerce 1975, 639.

4. Oakley 1986, 111–12.

5. Rae 1965, 192.

6. Oakley 1986, 231.

7. Reeves 1982, 224. It is important to note that prior to 1950, McCarthy had not been active or even ideologically involved with anticommunism; he chose the issue as an effective one with which to gain support in a reelection campaign. Earlier he had been known in Congress for his energetic lobbying efforts on behalf of the soft drink and real estate industries.

8. Donovan 1982, 319.

9. Barach 1962, 29.

10. Better Homes *Barbecues* 1963, 25.

11. Nixon 1962, 255–58.

12. *Fortune* 1955, 147.

13. Glenn 1974, n.p.

14. Ibid.

15. Kotschevar 1961, 17, 36–47.

16. Department of Commerce 1975, 796.

17. Barach 1962, 30.

18. Better Homes *Barbecues* 1963, 61.

19. Barach 1962, 53–59; Kotschevar 1961, 163; *Fortune* 1955, 142–43.

20. Better Homes *Buffets* 1963, 29.

21. Better Homes *Meals* 1963, 49; Better Homes *Buffets* 1963, 58.

22. *Columbia Encyclopedia,* 1975 ed., s.v. "Dole, Sanford Ballard."

23. The reason for eating diet foods is of course to maintain a form of the human body, especially the female body, considered ideal, which is to say sexually attractive. The popularity of diets and diet consumer products, and its relationship to the American post-war canon of ideal/sexy female beauty, are beyond the scope of this essay. Wesselmann's interest in the question of sex appeal, its character in American visual imagery, and its parallelism to manufactured consumer products and consumerism are richly suggested in his *Great American Nude* paintings of the 1960s, which I hope to discuss in a subsequent essay.

24. Time-Life 1970, 123.

25. Boas and Chain 1976, 19–28.

Notes on the Contributors

ANNE W. LOWENTHAL received a Ph.D. in art history from Columbia University in 1975, with a dissertation published as *Joachim Wtewael and Dutch Mannerism* (Doornspijk: Davaco Publishers, 1986). She first pursued her interest in objects on the curatorial staff of the Department of Western European Arts at the Metropolitan Museum of Art, New York. A Chester Dale Fellow at the National Gallery of Art, Washington, 1971– 72, she was also an Ailsa Mellon Bruce Visiting Senior Fellow at the Center for Advanced Studies in the Visual Arts in 1985. She has received grants from the Samuel H. Kress Foundation, the American Council of Learned Societies, the National Endowment for the Humanities, and the National Coalition of Independent Scholars. Her publicaitons include many interpretive studies of seventeenth-century Dutch art.

REINDERT L. FALKENBURG is Vice Director of the Rijksbureau voor Kunsthistorische Documentatie (Netherlands Institute for Art History) in The Hague. He received a Ph.D. *cum laude* from the University of Amsterdam in 1985. His dissertation, published in English as *Joachim Patinir: Landscape as an Image of the Pilgrimage of Life* (Philadelphia: J. Benjamins, 1988), was honored by the Association of DutchArt Historians with the Carel van Mander Award, for the best art-historical publication on Netherlandish art in 1985. He is also the author of *The Fruit of Devotion: Mysticism and the Imagery of Love in Flemish Paintings of the Virgin and Child* (Amsterdam/Philadelphia: J. Benjamins, 1994). He was a research fellow of the Royal Netherlands Academy of Arts and Sciences (1987–91) and of the Netherlands Institute for Advanced Study, Wassenaar (1986–87).

JULIA BALLERINI received a Ph.D. from the City University of New York in 1987, with a dissertation on mid-nineteenth-century French photographs of Egypt. In 1988–89 she was the recipient of Princeton University's Gould Fellowship and in 1995–96 received a fellowship from the American Council of Learned Societies. She has curated three photography exhibitions, most recently *Beyond the Label* (University of Hartford), which received a grant from the Connecticut State Council for the Arts. Among her publications are essays in the anthologies *The Body Imaged*

(Cambridge University Press, 1993) and *Home and Its Dislocations in Nineteenth-Century France* (Albany, N.Y.: SUNY Press, 1993).

DOREEN BOLGER is Director of the Museum of Art of the Rhode Island School of Design in Providence, Rhode Island. She was previously the Curator of Paintings and Sculpture at the Amon Carter Museum, Fort Worth, Texas, and Curator of American Paintings and Sculpture at the Metropolitan Museum of Art in New York. She received a Ph.D. from the City University of New York in 1983; her doctoral dissertation was a catalogue of the Metropolitan Museum's late-nineteenth-century American paintings. Dr. Bolger was an Ailsa Mellon Bruce Visiting Senior Fellow at the Center for Advanced Study in the Visual Arts, National Gallery of Art, in 1990. Her many publications include several articles in the *American Art Journal* and an essay in the catalogue *William M. Harnett* (1992), which she also co-edited.

PETRA TEN-DOESSCHATE CHU is Professor and Head of the Department of Art and Music, Seton Hall University, in South Orange, New Jersey. She completed her doctoral work in art history at Columbia University in 1972; her dissertation was published as *French Realism and the Dutch Masters* (Utrecht: Haentjens Dekker & Gumbert, 1974). She edited *Courbet in Perspective* (Englewood Cliffs: Prentice Hall, 1977) and was editor and translator for *The Letters of Gustave Courbet* (Chicago: University of Chicago Press, 1992). With Gabriel Weisberg, she edited *The Popularization of Images: Visual Culture under the July Monarchy* (Princeton, N.J.: Princeton University Press, 1993). Dr. Chu was awarded a Guggenheim Fellowship in 1986–87 and was a member of the Institute for Advanced Study, Princeton University, in 1990. In 1994–95 she was a Jane and Morgan Whitney Fellow, Metropolitan Museum of Art.

NAN FREEMAN received a Ph.D. in history, theory, and criticism of art from the Department of Architecture at the Massachusetts Institute of Technology in 1979, with a dissertation on Jasper Johns. Her articles on contemporary art and artists have appeared in various journals and exhibition catalogues. She was awarded Fulbright fellowships in 1988 and 1989 for work in Istanbul, where she wrote a monograph on the contemporary painter Mehmet Güleryüz. In 1990 and 1991 she served as Curator of the Collections at the Fitchburg Art Museum. From 1991 through 1994, she was Lecturer on Visual and Enviromental Studies at Harvard University. Dr. Freeman now teaches at the School of the Boston Museum of Fine Arts, where she is also director of the Post-Baccalaureat Program.

Bibliography

Alberti 1972 Leon Battista Alberti, On Painting and On Sculpture. The Latin Texts of De Pictura and De Statua. Ed. with trans., intro., and notes by Cecil Grayson. London, 1972.

Alpers 1983 Alpers, Svetlana. *The Art of Describing: Dutch Art in the Seventeenth Century.* Chicago, 1983.

Amsterdam 1990 *Vincent van Gogh: Schilderijen.* Exhibition catalogue. Amsterdam, Rijksmuseum Vincent van Gogh, 1990.

Andrade and Guerrero 1992 Andrade, José Manuel Pita, and Maria del Mar Borobia Guerrero. *Old Masters, Thyssen-Bornemisza Museum.* Barcelona: Fundación Colección Thyssen-Bornemisza, 1992.

Anonymous 1984 *The Ploughman's Lunch. "Moretum," a Poem ascribed to Virgil.* . . . Ed. Edward John Kenney. Bristol [Eng.], 1984.

Anonymous 1985 *Der schaepherders kalengier. Een Vlaams volksboek, naar het unieke exemplaar van de Antwerpse druk door Willem Vorsterman van 1513.* Ed. Willy Louis Braekman. Bruges, 1985.

Apter and Pietz 1993 Apter, Emily, and William Pietz, eds. *Fetishism as Cultural Discourse.* Ithaca, N.Y., and London, 1993.

Bachelard 1964 Bachelard, Gaston. *The Poetics of Space.* New York, 1964.

Bailey 1990 Bailey, Martin. *Young Vincent: The Story of Van Gogh's Years in England.* London, 1990.

Bakhtin 1968 Bakhtin, Mikhail Mikhailovich. *Rabelais and His World.* Trans. H. Iswolsky. Cambridge, Mass., and London, 1968.

Barach 1962 Barach, Arnold B., and the Kiplinger Washington Editors. *1975 and the Changes to Come.* New York, 1962.

Baudelaire 1979 Baudelaire, Charles. "The Salon of 1846, XVI: Why Sculpture is Tiresome." In *Art in Paris 1845–1862: Salons and Other Exhibitions Reviewed by Charles Baudelaire.* Trans. and ed. Jonathan Mayne, pp. 111–13. London and New York, 1979.

Baudelaire 1991 Baudelaire, Charles. *The Flowers of Evil and Paris Spleen.* Trans. William H. Crosby. Brockport, N.Y., 1991.

Baudrillard 1968 Baudrillard, Jean. *Le Système des objets.* Paris, 1968.

Baxandall 1971 Baxandall, Michael *Giotto and the Orators: Humanist Observers of Painting in Italy and the Discovery of Pictorial Composition 1350–1450.* Oxford, 1971.

Bergström 1956 Bergström, Ingvar. *Dutch Still-life Painting in the Seventeenth Century.* Trans. Christina Hedström and Gerald Taylor. New York, 1956.

Bergström 1970 Bergström, Ingvar. *Maestros espanoles de bodegones y floreros del siglo XVII.* Madrid, 1970.

Bernal 1987 Bernal, Martin. "The Fabrication of Ancient Greece 1785–1985." In *Black Athena: The Afroasiatic Roots of Classical Civilization.* Vol. 1. New Brunswick, N.J., 1987.

Better Homes *Barbecues* 1963 Editors of *Better Homes and Gardens. Barbecues and Picnics.* N.p., 1963.

Better Homes *Buffets* 1963 Editors of *Better Homes and Gardens. Best Buffets.* N.p., 1963.

Better Homes *Meals* 1963 Editors of *Better Homes and Gardens. So-Good Meals.* N.p., 1963.

Blunt 1953 Blunt, Anthony. *Art and Architecture in France, 1500 to 1700.* The Pelican History of Art. Baltimore, 1953.

Boas and Chain 1976 Boas, Max, and Steve Chain. *Big Mac: The Unauthorized Story of McDonald's.* New York, 1976.

Boesen 1960 Boesen, Gudmund. *Venetianske glas på Rosenborg.* Exhibition catalogue. Copenhagen, Rosenborg Castle, 1960.

Boggs 1992 Boggs, Jean Sutherland. *Picasso and Things: The Still Lifes of Picasso.* Exhibition catalogue. Cleveland Museum of Art; Philadelphia Museum of Art; and Paris, Galeries Nationales du Grand Palais, 1992.

Bolger 1990 Bolger, Doreen. "'Cards and Letters from His Friends': *Mr. Hulings' Rack Picture* by William Michael Harnett." *American Art Journal* 22, no. 2 (1990), 4–32.

Bolger, Simpson, and Wilmerding 1992–93 Bolger, Doreen, Marc Simpson, and John Wilmerding, eds. *William M. Harnett.* Exhibition catalogue. New York, Metropolitan Museum of Art; and three other museums, 1992–93.

Boralevi 1981 Boralevi, Alberto. "I Tappeti Orientali del Museo Bardini a Firenze." *HALI,* Supplemento italiano (September 1981), 2–15.

Bottomore 1983 Bottomore, Tom. *A Dictionary of Marxist Thought.* Cambridge, Mass., 1983.

Braudel 1981 Braudel, Fernand. *The Structures of Everyday Life: The Limits of the Possible.* Vol. 1 of *Civilization and Capitalism, 15th–18th Century.* Trans. Sîan Reynolds. New York, 1981.

Bryson 1990 Bryson, Norman. *Looking at the Overlooked: Four Essays on Still Life Painting.* Cambridge, Mass., 1990.

Buckland 1980 Buckland, Gail. *Fox Talbot and the Invention of Photography.* Boston, 1980.

Buerger 1989 Buerger, Janet E. *French Daguerreotypes.* Chicago, 1989.

Burema 1953 Burema, Lambertus. "De voeding in Nederland van de middeleeuwen tot de twintigste eeuw." Ph.D. diss., University of Amsterdam. Assen, 1953.

Burke 1980 Burke, Doreen Bolger. *American Paintings in the Metropolitan Museum of Art. Volume III: A Catalogue of Works by Artists Born Between 1846 and 1864.* Ed. Kathleen Luhrs. New York, 1980.

Carlyle 1927 Carlyle, Thomas. *Sartor Resartus.* 1838; reprint, New York, 1927.

Citroen 1984–85 Citroen, K. A., et al. *Meesterwerken in zilver: Amsterdams zilver 1520–1820*. Exhibition catalogue. Amsterdam, Museum Willet-Holthuysen, 1984–85.

Clark 1988 Clark, H. Nichols B. *Francis W. Edmonds: American Master in the Dutch Tradition*. Exhibition catalogue. Fort Worth, Amon Carter Museum, 1988.

Clover-Club 1913 *Thirty-first Anniversary of the Clover Club, Jan. 17, 1913*. Philadelphia, 1913.

Cogswell 1892 Cogswell, Louisa Trumbull. "Art in Boston." *Arcadia* 1 (December 1892), 305–6.

Colie 1966 Colie, Rosalie Littell. *Paradoxia Epidemica: The Renaissance Tradition of Paradox*. Princeton, 1966.

Corning 1952 *Glass Vessels in Dutch Painting of the 17th Century*. Exhibition catalogue. Corning, N.Y., Corning Museum of Glass, 1952.

Deacon 1897 Deacon, Mary R. *The Clover Club of Philadelphia*. Philadelphia, 1897.

De Jongh 1967 Jongh, E. de. *Zinne- en minnebeelden in de schilderkunst van de zeventiende eeuw*. N.p., 1967.

De Jongh 1976 Jongh, E. de. "Pearls of Virtue and Pearls of Vice." *Simiolus* 8 (1974–76), 69–97.

De Jongh 1982 Jongh, E. de, et al. *Still-Life in the Age of Rembrandt*. Exhibition catalogue. Auckland City Art Gallery, 1982.

Den Blaauwen 1979–80 Den Blaauwen, A. L., ed. *Nederlands zilver / Dutch Silver 1580–1830*. Trans. Patricia Wardle. Exhibition catalogue. Amsterdam, Rijksmuseum; Toledo Museum of Art; and Boston, Museum of Fine Arts, 1979–80.

Denhaene 1990 Denhaene, Godelieve. *Lambert Lombard: Renaissance en humanisme te Luik*. Antwerp, 1990.

Department of Commerce 1975 U.S. Department of Commerce, Bureau of the Census. *Historical Statistics of the United States: Colonial Times to 1970*. Bicentennial ed. Washington, D.C., 1975.

Derrida 1987 Derrida, Jacques. *The Truth in Painting*. Trans. Geoff Bennington and Ian McLeod. Chicago and London, 1987.

Dézallier d'Argenville 1893 Dézallier d'Argenville, Antoine-Nicolas. *Description de l'Académie Royale de Peinture et de Sculpture par son secrétaire Nicolas Guérin et par Antoine Nicolas Dezallier d'Argenville le fils*. Paris, 1893.

Dodoens 1554 Dodoens, Rembert. *Cruijdeboeck*. Antwerp, 1554.

Dodonaeus 1644 Dodonaeus, Rembertus [Rembert Dodoens]. *Herbarius oft cruydtboeck*. Antwerp, 1644.

Dolphin 1969 Dolphin, Harriet S. "'The Rack' by John Frederick Peto." Master's thesis, Arizona State University, 1969.

Donovan 1982 Donovan, Robert J. *Tumultuous Years: The Presidency of Harry S. Truman 1949–1953*. New York, 1982.

Dresden 1983 *Das Stilleben und sein Gegenstand.* Exhibition catalogue. Dresden, Albertinum, 1983.

Drucker 1992 Drucker, Johanna. "Harnett, Haberle, and Peto: Visuality and Artifice among the Proto-Modern Americans." *Art Bulletin* 74 (March 1992), 37–50.

Ember 1989–90 Ember, Ildikó. *Delights for the Senses: Dutch and Flemish Still-life Paintings from Budapest.* Trans. András Szántó. Exhibition catalogue. Wausau, Wis., Leigh Yawkey Woodson Art Museum; and other museums, 1989–90.

Erasmus 1979 Erasmus, Desiderius. *The Praise of Folly.* 1509; reprint with trans., intro., and comm. by Clarence H. Miller, New Haven and London, 1979.

Fahlman 1991 Fahlman, Betsy. "A Plaster of Paris Antiquity: Nineteenth-Century Cast Collections." *Southeastern College Art Conference Review* 12 (1991), 1–9.

Falkenburg 1988 Falkenburg, Reindert Leonard. "Iconographical Connections between Antwerp Landscapes, Market Scenes, and Kitchen Pieces, 1500–1580." *Oud Holland* 102 (1988), 114–26.

Falkenburg 1989 Falkenburg, Reindert Leonard. "'Alter Einoutus': Over de aard en herkomst van Pieter Aertsens stilleven-conceptie." *Nederlands Kunsthistorisch Jaarboek* 40 (1989), 41–66.

Falkenburg 1990 Falkenburg, Reindert Leonard. "Antithetical Iconography in Early Netherlandish Landscape Painting." In *Bruegel and Netherlandish Landscape Painting from the National Gallery Prague,* pp. 25–36. Exhibition catalogue. Tokyo, The National Museum of Western Art; and Kyoto, The National Museum of Modern Art, 1990.

Faré 1962 Faré, Michel. *La Nature Morte en France, son histoire et son évolution du XVIIe au XXe siècle.* 2 vols. Geneva, 1962.

Faré 1974 Faré, Michel. *Le Grand Siècle de la nature morte en France. Le XVIIe siècle.* Fribourg, 1974.

Faré 1976 Faré, Michel. *La Vie silencieuse en France. La nature morte au XVIIIe siècle.* Fribourg, 1976.

Félibien 1669 Félibien [André]. *Conferences de l'Academie Royale de Peinture et de Sculpture pendant l'année 1667.* Paris, 1669.

Félibien 1685 Félibien [André]. *Entretiens sur les vies et sur les ouvrages des plus excellens peintres anciens et modernes.* Paris, 1685; reprint, London, 1705.

Fisher 1991 Fisher, Philip. *Making and Effacing Art: Modern American Art in a Culture of Museums.* New York and Oxford, 1991.

Fortune 1955 Editors of *Fortune. The Changing American Market.* Garden City, N.Y., 1955.

Foshay 1990 Foshay, Ella M. *Mr. Luman Reed's Picture Gallery: A Pioneer Collection of American Art.* Intro. by Wayne Craven, catalogue by Timothy Anglin Burgard. New York, 1990.

Frankenstein 1969 Frankenstein, Alfred. *After the Hunt: William Harnett and Other American Still Life Painters, 1870–1900.* Berkeley and Los Angeles, 1953; rev. ed., 1969.

Frankfurt am Main 1993–94 *Georg Flegel, 1566–1638: Stilleben.* Exhibition catalogue. Historischen Museum, Frankfurt am Main, 1993–94.

Frantzen 1958 Frantzen, Nils-Olof. *Zola et* La Joie de vivre. *La Genèse du roman, les personnages, les idées.* Stockholm, 1958.

Gaskell 1990 Gaskell, Ivan. *Seventeenth-century Dutch and Flemish Painting: The Thyssen-Bornemisza Collection.* London, 1990.

Gautrand and Frizot 1986 Gautrand, Jean-Claude, and Michel Frizot. *Hippolyte Bayard: Naissance de l'image photographique.* Paris, 1986.

Gerdts 1981 Gerdts, William H. *Painters of the Humble Truth: Masterpieces of American Still Life 1801–1939.* Exhibition catalogue. Tulsa, Philbrook Art Center, 1981.

Gerdts 1986 Gerdts, William H. "*A Deception* Unmasked: An Artist Uncovered." *American Art Journal* 18, no. 2 (1986), 4–23.

Gerdts and Burke 1971 Gerdts, William H., and Russell Burke. *American Still-Life Painting.* New York, Washington, and London, 1971.

Gerson and Ter Kuile 1960 Gerson, H., and E. H. ter Kuile. *Art and Architecture in Belgium, 1600 to 1800.* The Pelican History of Art. Baltimore, 1960.

Glenn 1974 Glenn, Constance, et al. *Tom Wesselmann: The Early Years, Collages 1959–1962.* Exhibition catalogue. Art Galleries, California State University, Long Beach, 1974.

Goedde 1989a Goedde, Lawrence O. "A Little World Made Cunningly: Dutch Still Life and *Ekphrasis.*" In *Still Lifes of the Golden Age, Northern European Paintings from the Heinz Family Collection,* pp. 35–44. Exhibition catalogue. Washington, National Gallery of Art; and Boston, Museum of Fine Arts, 1989.

Goedde 1989b Goedde, Lawrence Otto. *Tempest and Shipwreck in Dutch and Flemish Art: Convention, Rhetoric, and Interpretation.* University Park, Penn., 1989.

Goodrich 1949 Goodrich, Lloyd. "Harnett and Peto: A Note on Style." *Art Bulletin* 31 (March 1949), 57–59.

Gordon and Forge 1986 Gordon, Robert, and Andrew Forge. *The Last Flowers of Manet.* Trans. Richard Howard. New York, 1986.

Graetz 1963 Graetz, H. R. *The Symbolic Language of Vincent van Gogh.* New York, London, and Toronto, 1963.

Greindl 1956 Greindl, Edith. *Les Peintres flamands de nature morte au XVIIe siècle.* Brussels, 1956.

Grimm 1984 Grimm, Claus. "Glas, Licht und Optik." In *Glück und Glas: Zur Kulturgeschichte des Spessartglases,* pp. 310–19. Exhibition catalogue. Munich, Haus der Bayerischen Geschichte, 1984.

Grimm 1988 Grimm, Claus. *Stilleben: Die niederländischen und deutschen Meister.* Stuttgart, 1988.

Grisebach 1974 Grisebach, Lucius. *Willem Kalf (1619–1693).* Berlin, 1974.

Grosjean 1974 Grosjean, Ardis. "Toward an Interpretation of Pieter Aertsen's Profane Iconography." *Konsthistorisk Tidskrift* 43 (1974), 121–43.

Gross 1992 Gross, Kenneth. *The Dream of the Moving Statue.* Ithaca, N.Y., and London, 1992.

Gruber 1982 Gruber, Alain Charles. *L'Argenterie de maison du XVIe au XIXe siècle.* Fribourg, 1982.

Guicciardini 1567 Guicciardini, Ludovico. *Descrittione . . . di tutti i paesi bassi.* Antwerp, 1567.

Hairs 1955 Hairs, Marie-Louise. *Les Peintres flamands de fleurs au XVIIe siècle.* Paris and Brussels, 1955.

Harden et al. 1968 Harden, D. B. et al. *Masterpieces of Glass.* Exhibition catalogue. London, British Museum, 1968.

Harke 1985 Harke, Peter J. *Stilleben von Paula Modersohn-Becker.* [Lilienthal bei Bremen,] 1985.

Harnett Collection 1893 *The Wm. Michael Harnett Collection: His Own Reserved Paintings, Models and Studio Furnishings.* Sale catalogue. Philadelphia, Stan. V. Henkels at Thos. Birch's Sons, Auctioneers, 1893.

Haskell and Penny 1981 Haskell, Francis, and Nicholas Penny. *Taste and the Antique: The Lure of Classical Sculpture 1500–1900.* New Haven, 1981.

Hayward 1956 Hayward, J. F. *English Cutlery Sixteenth to Eighteenth Century.* London, 1956.

Hazlitt 1820–21 Hazlitt, William. Essay XVII of *Table Talk.* London, 1820–21; reprint, pp. 168–74, London, 1959.

Hearn 1990 Hearn, M. F., ed. *The Architectural Theory of Viollet-le-Duc: Readings and Commentary.* Cambridge, Mass., 1990.

Heckscher 1985 Heckscher, William S. *Art and Literature: Studies in Relationship.* Ed. Egon Verheyen. Durham, N.C., and Baden-Baden, 1985.

Henkel and Schöne 1967 Henkel, Arthur, and Albrecht Schöne. *Emblemata. Handbuch zur Sinnebildkunst des XVI. und XVII. Jahrhunderts.* Stuttgart, 1967.

Höltgen 1986 Höltgen, Karl Josef. *Aspects of the Emblem: Studies in the English Emblem Tradition and the European Context.* Kassel, 1986.

Hoogstraeten 1678 Hoogstraeten, Samuel van. *Inleyding tot de hooge school der schilderkonst: Anders de zichtbaere werelt.* Rotterdam, 1678; reprint, Doornspijk, 1969.

Hubaux and Puraye 1949 Hubaux, J., and J. Puraye. "Dominique Lampson: Lamberti Lombardi . . . vita. Traduction et notes." *Belgisch tijdschrift voor archeologie en kunstgeschiedenis* 18 (1949), 53–77.

Hulings 1895 "Harnett: How George Hulings Lost His Fiddle." *The Evening Item* (Philadelphia), 11 June 1895, 1.

Hulsker 1980 Hulsker, Jan. *The Complete Van Gogh: Paintings, Drawings, Sketches.* New York, 1980.

Hunt 1990 Hunt, John Dixon, ed. *The Dutch Garden in the Seventeenth Century.* Dumbarton Oaks Colloquium on the History of Landscape Architecture, XII. Washington, 1990.

Hvass 1965 Hvass, Else. *Nuttige planten in kleur.* Amsterdam, 1965.

Jenkyns 1980 Jenkyns, Richard. *The Victorians and Ancient Greece.* Cambridge, Mass., 1980.

Jordan 1985 Jordan, William B. *Spanish Still Life in the Golden Age, 1600–1650.* Exhibition catalogue. Fort Worth, Kimbell Art Museum; and the Toledo Museum of Art, 1985.

Jordan and Cherry 1995 Jordan, William B., and Peter Cherry. *Spanish Still Life from Velázquez to Goya.* Exhibition catalogue. London, National Gallery of Art, 1995.

Junius 1588 Junius, Hadrianus. *Batavia: in qua praeter gentis et insulae antiquitatem originem.* Leiden, 1588.

Kaiser 1963 Kaiser, Walter. *Praisers of Folly: Erasmus, Rabelais, Shakespeare.* Cambridge, Mass., 1963.

Kavaler 1986–87 Kavaler, Ethan Matt. "Erotische elementen in de markttaferelen van Beuckelaer, Aertsen en hun tijdgenoten." In *Joachim Beuckelaer: Het markt- en keukenstuk in de Nederlanden, 1550–1650,* pp. 18–26. Exhibition catalogue. Ghent, Museum voor Schone Kunsten, 1986–87.

Keeler 1987 Keeler, Nancy. "Hippolyte Bayard aux origines de la photographie et de la ville moderne." *La Recherche photographique* 2 (1987), 6–17.

Kodera 1990 Kodera, Tsukasa. *Vincent van Gogh: Christianity versus Nature.* Amsterdam and Philadelphia, 1990.

Kotschevar 1961 Kotschevar, Lendal. *Quantity Food Purchasing.* New York, 1961.

Krauss 1978 Krauss, Rosalind. "Tracing Nadar." *October* 5 (1978), 29–47.

Kubler and Soria 1959 Kubler, George, and Martin Soria. *Art and Architecture in Spain and Portugal and their American Dominions, 1500 to 1800.* The Pelican History of Art. Baltimore, 1959.

Leiden 1970 *Ijdelheid der ijdelheden: Hollandse vanitas-voorstellingen uit de zeventiende eeuw.* Exhibition catalogue. Leiden, Museum De Lakenhal, 1970.

Lexington 1980 *Bespandled, Painted, and Embroidered: Decorated Masonic Aprons in America, 1790–1850.* Exhibition catalogue. Lexington, Mass., Scottish Rite Masonic Museum of Our National Heritage, 1980.

Lindemans 1952 Lindemans, Paul. *Geschiedenis van de landbouw in België.* Vol. 2. Antwerp, 1952.

Lindsay 1992 Lindsay, Suzanne Glover. "Some Evangelical Roots for Hébert's *Toujours et jamais.*" *Art Bulletin* 74 (1992), 619–22.

Losse 1980 Losse, Deborah N. *Rhetoric at Play: Rabelais and Satirical Eulogy.* Bern, Frankfurt, and Las Vegas, 1980.

Lowenthal 1986 Lowenthal, Anne W. "The Debate on Symbol and Meaning in Dutch Art: Response to Peter Hecht." *Simiolus* 16 (1986), 188–90.

Lowenthal 1988 Lowenthal, Anne W. "Lot and His Daughters as Moral Dilemma." In *The Age of Rembrandt: Studies in Seventeenth-Century Dutch Painting,* pp. 13–27. Papers in Art History from the Pennsylvania State University, Vol. 3. Ed. Roland E. Fleischer and Susan Scott Munshower. University Park, Penn., 1988.

Lunsingh Scheurleer 1947 Lunsingh Scheurleer, Theodoor Herman. "Pieter Aertsen en Joachim Beuckelaer en hun ontleeningen aan Serlio's architectuurprenten." *Oud Holland* 62 (1947), 123–34.

Lunsingh-Scheurleer 1974 Lunsingh-Scheurleer, D. F. *Chinese Export Porcelain: Chine de Commande.* New York, Toronto, and London, 1974.

Lunsingh Scheurleer 1985 Lunsingh Scheurleer, Pauline, ed. *Asiatic Art in the Rijksmuseum, Amsterdam.* Trans. Patricia Wardle. Amsterdam: Meulenhoff/Landshoff, 1985.

Luttervelt 1947 Luttervelt, R. van. *Schilders van het stilleven.* Naarden, 1947.

Mai 1990 Mai, Ekkehard. *Willem Kalf 1619–1693: Original und Wiederholung: Ein Prunkstilleben des 17. Jahrhunderts.* Cologne, 1990.

Mainardi 1995a Mainardi, Patricia. "Impertinent Questions." *French Historical Studies* 19, no. 2 (Fall 1995), 399–414.

Mainardi 1995b Mainardi, Patricia. "Maris, femmes, amants: Mazeppa ou l'adultère bourgeois." *Actes du Colloque Gericault.* (forthcoming)

Malloch 1956 Malloch, A. E. "The Techniques and Function of the Renaissance Paradox." *Studies in Philology* 53 (1956), 191–203.

Marvin 1989 Marvin, Miranda. "Copying in Roman Sculpture: The Replica Series." In *Reframing the Original,* pp. 29–45. Exhibition catalogue. Washington, National Gallery of Art, 1989.

Marx 1977 Marx, Karl. *Capital,* vol. 1. Trans. Ben Fowkes. 1867; reprint, New York, 1977.

McCauley 1991 McCauley, Anne. "François Arago and the Politics of the French Invention of Photography." In *Multiple Views: Logan Grant Essays in Photography 1983–89,* pp. 43–69. Ed. Daniel P. Younger. Albuquerque, 1991.

Meridian Sun Lodge 1913 *An Historical Sketch of Meridian Sun Lodge No. 158, F. and A. M., From 1818 to 1912, Inclusive.* Philadelphia, 1913.

Michelet 1981 Michelet, Jules M. *The Bird.* Trans. W. H. Davenport Adams. 1879; reprint, with intro. by Philip Thode, London, 1981.

Miedema 1964 Miedema, H. *Kraakporselein en overgangsgoed, catalogus, Gemeentelijk Museum Het Princessehof.* Leeuwarden, 1964.

Miller 1956 Miller, Henry K. "The Paradoxical Encomium with Special Reference to Its Vogue in England, 1600–1800." *Modern Philology* 53 (1956), 145–78.

Minneapolis 1987 *Cross References: Sculpture into Photography.* Exhibition catalogue. Minneapolis, Walker Art Center, 1987.

Morson and Emerson 1990 Morson, Gary Saul, and Caryl Emerson. *Mikhail Bakhtin: Creation of a Prosaics.* Stanford, 1990.

Münster 1979–80 *Stilleben in Europa.* Exhibition catalogue. Münster, Westfälisches Landesmuseum für Kunst und Kulturgeschichte; and Baden-Baden, Staatliche Kunsthalle, 1979–80.

Muylle 1986–87 Muylle, Jan. "Pieter Aertsen en Joachim Beuckelaer in de kunstliteratuur (ca. 1560–1610)." In *Joachim Beuckelaer: Het markt- en keukenstuk in de Nederlanden, 1550–1650,* pp. 14–17. Exhibition catalogue. Ghent, Museum voor Schone Kunsten, 1986–87.

Naples 1964 *La natura morta italiana.* Exhibition catalogue. Naples, Palazzo Reale, 1964.

New York 1939 *"Nature-Vivre" by William M. Harnett.* Exhibition catalogue. New York, Downtown Gallery, 1939.

New York 1993 *American Nineteenth and Early Twentieth Century Paintings, Watercolors and Sculpture: The Collection of Kathryn and Robert Steinberg New York.* Exhibition catalogue. New York, James Graham & Sons, 1993.

Nicolson 1962 Nicolson, Marjorie Hope. *The Breaking of the Circle: Studies in the Effect of the "New Science" upon Seventeenth-Century Poetry.* Rev. ed., New York, 1962.

Nixon 1962 Nixon, Richard M. *Six Crises.* Garden City, N.Y., 1962.

Nodier 1820 Nodier, Charles. "Introduction." In *Voyages pittoresques et romantiques dans l'ancienne France,* vol. 1. Ed. Baron J. Taylor, pp. 1–15. Paris, 1820.

Oakley 1986 Oakley, Ronald. *God's Country: America in the Fifties.* New York, 1986.

Opmeer 1611 Opmeer, Petrus van. *Opus chronographicum orbis universi a mundi exordio usque ad annum 1611.* Antwerp, 1611.

Osborne 1975 Osborne, Harold, ed. *The Oxford Companion to the Decorative Arts.* Oxford, 1975.

Ou-I-Tai 1959 Ou-I-Tai. "Chinese Mythology." *Larousse Encyclopedia of Mythology,* pp. 393–411. London, 1959.

Paap 1983 Paap, Norbert. "Economic Plants in Amsterdam: Qualitative and Quantitative Analysis." In *Integrating the Subsistence Economy,* ed. M. Jones. Symposia of the Association for Environmental Archaeology, no. 4. BAR International Series, 181, pp. 315–25. Oxford, 1983.

Paap 1984 Paap, Norbert. "Palaeobotanical Investigations in Amsterdam." In *Plants and Ancient Man: Studies in Palaeoethnobotany,* ed. Willem van Zeist and Willem A. Casparie, pp. 339–44. Rotterdam and Boston, 1984.

Pabst-Van Uitert 1987 Pabst, Fieke, and Evert van Uitert. "A Literary Life, with a List of Books and Periodicals Read by Van Gogh." In *The Rijksmuseum*

Vincent van Gogh, ed. Evert van Uitert and Michael Hoyle, pp. 68–84, 89–90. Amsterdam, 1987.

Pacheco 1956 Pacheco, Francesco. *Arte de la pintura: Edición del manuscrito original acabado el 24 de Enero de 1638.* 1649. Ed. Francisco Sánchez Cantón. Madrid, 1956.

Peale Memoranda Peale, Charles Willson. "Memoranda of the Philadelphia Museum." Historical Society of Pennsylvania, microfiche in *The Collected Papers of Charles Willson Peale and His Family.* Ed. Lillian B. Miller. 3 vols. Millwood, N.Y., 1980, 003339.

Peirson 1893 "Mortuary: C. C. Peirson." *Shoe and Leather Reporter* 55 (4 May 1893), 1120.

Peto Family Papers Peto Family Papers. Joy Peto Smiley, Island Heights, N.J.

Philadelphia 1880 *Illustrated Catalogue of the Second Annual Exhibition of the Philadelphia Society of Artists held at the Pennsylvania Academy of the Fine Arts.* Exhibition catalogue. Philadelphia, Pennsylvania Academy of the Fine Arts, 1880.

Philadelphia 1892 *Paintings of the Late W. M. Harnett.* Intro. by E. T. Snow. Exhibition catalogue. Philadelphia, Earle's Galleries, 1892.

Phillips 1983 Phillips, Christopher. "A Mnemonic Art? Calotype Aesthetics at Princeton." *October* 26 (1983), 34–62.

Pickvance 1974 Pickvance, Ronald. *English Influences on Vincent van Gogh.* Exhibition catalogue. London, Arts Council of Great Britain, 1974.

Pliny 1984 Pliny [Caius Plinius Secundus]. *Natural History.* Trans. H. Rackham. Vol. 9 of the Loeb Classical Library. Cambridge, Mass., 1984.

Poe 1983 Poe, Edgar Allan. "The Purloined Letter." 1844; reprinted in *Edgar Allan Poe: Poetry and Tales,* with notes by Patrick F. Quinn, New York, 1983.

Pollock 1980 Pollock, Griselda. "Vincent van Gogh and Dutch Art: A Study of Van Gogh's Notion of the Modern." Ph.D. diss., London University, 1980.

Potts 1992 Potts, Alex. "Male Fantasy and Modern Sculpture." *Oxford Art Journal* 15 (1992), 38–47.

Prown 1982 Prown, Jules David. "Mind in Matter: An Introduction to Material Culture Theory and Method." *Winterthur Portfolio: A Journal of American Material Culture* 17, no. 1 (1982), 1–19.

Quintilian *Quintilianus, Marcus Fabius. The Institutio oratoria of Quintilian.* Trans. H. E. Butler. 4 vols. London and New York, 1920–22.

Rae 1965 Rae, John B. *The American Automobile: A Brief History.* Chicago, 1965.

Raupp 1986 Raupp, Hans-Joachim. *Bauernsatiren: Entstehung und Entwicklung des bäuerlichen Genres in der deutschen und niederländischen Kunst, ca. 1470–1570.* Niederzier, 1986.

Reeves 1982 Reeves, Thomas C. *The Life and Times of Joe McCarthy: A Biography.* New York, 1982.

Rinaldi 1989 Rinaldi, Maura. *Kraak Porcelain*. London, 1989.

Ritsema van Eck and Zijlstra-Zweens 1993 Ritsema van Eck, Pieter C., and Henrica M. Zijlstra-Zweens. *Glass in the Rijksmuseum*. Vol. 2:I of Catalogues of the Applied Arts in the Rijksmuseum Amsterdam. Trans. Mary Maclure. Zwolle, 1993.

Rose 1989 Rose, Peter G., trans. and ed. *The Sensible Cook: Dutch Foodways in the Old and the New World*. Syracuse, 1989.

Rosenberg, Slive, and Ter Kuile 1966 Rosenberg, Jakob, Seymour Slive, and E. H. ter Kuile. *Dutch Art and Architecture, 1600 to 1800*. The Pelican History of Art. Baltimore, 1966.

Rosenberg 1979 Rosenberg, Pierre. *Chardin, 1699–1779*. Exhibition catalogue. Paris, Grand Palais; Cleveland Museum of Art; and Boston, Museum of Fine Arts, 1979.

Roskill 1979 Roskill, Mark. "Public and Private Meanings: The Paintings of Van Gogh." *Journal of Communication* 29 (1979), 157–69.

Rouillé and Marbot 1986 Rouillé, André, and Bernard Marbot. *Le Corps et son image: Photographies du dix-neuvième siècle*. Paris, 1986.

Ruskin 1904 Ruskin, John. "The Elements of Drawing." 1857; reprinted in vol. 15 of *The Works of John Ruskin,* ed. E. T. Cook and Alexander Wedderburn. London, 1904.

San Francisco 1991 *The Kiss of Apollo: Photography and Sculpture 1845 to the Present*. Exhibition catalogue. San Francisco, Fraenkel Gallery, 1991.

Sangers 1952 Sangers, Willem Jan. *De ontwikkeling van de Nederlandse tuinbouw (tot het jaar 1930)*. Zwolle, 1952.

Schama 1987 Schama, Simon. *The Embarrassment of Riches: An Interpretation of Dutch Culture in the Golden Age*. New York, 1987.

Schapiro 1973 Schapiro, Meyer. *Words and Pictures: On the Literal and the Symbolic in the Illustration of a Text*. The Hague and Paris, 1973.

Schapiro 1978 Schapiro, Meyer. "The Apples of Cézanne: An Essay on the Meaning of Still Life." In *Modern Art: Nineteenth and Twentieth Centuries, Selected Papers*, pp. 1–38. New York, 1978.

Schroder 1983 Schroder, Timothy B. *The Art of the European Goldsmith: Silver from the Schroder Collection*. Essay by J. F. Hayward. Exhibition catalogue. New York, The American Federation of Arts, 1983.

Segal 1982 Segal, Sam. *A Flowery Past: A Survey of Dutch and Flemish Flower Painting from 1600 until the Present*. Exhibition catalogue. Amsterdam, Gallery P. de Boer; and 's-Hertogenbosch, Noordbrabants Museum, 1982.

Segal 1983 Segal, Sam. *A Fruitful Past: A Survey of the Fruit Still Lifes of the Northern and Southern Netherlands from Brueghel till Van Gogh*. Exhibition catalogue. Amsterdam, Gallery P. de Boer; and Braunschweig, Herzog Anton Ulrich-Museum, 1983.

Segal 1988 Segal, Sam. *A Prosperous Past: The Sumptuous Still Life in the Netherlands, 1600–1700*. Ed. William B. Jordan. Trans. P. M. van Tongeren.

Exhibition catalogue. Delft, Stedelijk Museum Het Prinsenhof; Cambridge, Mass., Fogg Art Museum; and Fort Worth, Kimbell Art Museum, 1988.

Segal 1990 Segal, Sam. *Flowers and Nature: Netherlandish Flower Painting of Four Centuries.* Trans. Ruth Koenig. Exhibition catalogue. Osaka, Nabio Museum of Art; Tokyo Station Gallery; and Sydney, Art Gallery of New South Wales, 1990.

Segal 1991 Segal, Sam. *Jan Davidsz. de Heem en zijn kring.* Exhibition catalogue. Utrecht, Centraal Museum; and Braunschweig, Herzog Anton Ulrich-Museum, 1991.

Sensier 1881 Sensier, Alfred. *La Vie et l'oeuvre de J.-F. Millet.* Paris, 1881.

Shedd 1984 Shedd, Meredith. "A Neo-Classical Connoisseur and His Collection: J. B. Giraud's Museum of Casts at the Place Vendôme." *Gazette des Beaux-Arts* 103 (May–June 1984), 198–206.

Silver 1984 Silver, Larry. *The Paintings of Quinten Massys with Complete Catalogue Raisonné.* Montclair, N.J., 1984.

Sluijter 1986 Sluijter, Eric Jan. "De 'heydensche fabulen' in de Noordnederlandse schilderkunst, circa 1590–1670: Een proeve van beschrijving en interpretatie van schilderijen met verhalende onderwerpen uit de klassieke mythologie." Ph.D. diss., Rijksuniversiteit te Leiden, 1986.

Snyder 1976 Snyder, James. "Jan van Eyck and Adam's Apple." *Art Bulletin* 58 (1976), 511–15.

Spike 1983 Spike, John T. *Italian Still Life Paintings from Three Centuries.* Exhibition catalogue. New York, National Academy of Design; Tulsa, Philbrook Art Center; and Dayton Art Institute, 1983.

Sterling 1959 Sterling, Charles. *Still Life Painting from Antiquity to the Present Time.* Trans. James Emmons. Rev. ed., New York, 1959.

Stocking 1974 Stocking, George W., Jr. "Some Problems in the Understanding of Nineteenth-Century Cultural Evolutionism." In *Readings in the History of Anthropology,* ed. Regina Darnell, pp. 407–25. New York, 1974.

Stumpel 1989 Stumpel, Jeroen. "Compositie en constructie: kijken naar kunst uit de Renaissance." In *Waarnemen,* ed. L. Feenstra, N.H.H. Beyer, and R. O. Fock, pp. 105–33. Amsterdam, 1989.

Stumpel 1990 Stumpel, Jeroen. "The Province of Painting: Theories of Italian Renaissance Art." Ph.D. diss., Rijksuniversiteit Utrecht, 1990.

Sund 1988 Sund, Judy. "The Sower and the Sheaf: Biblical Metaphor in the Art of Vincent van Gogh." *Art Bulletin* 70 (1988), 660–76.

Sund 1992 Sund, Judy. *True to Temperament: Van Gogh and French Naturalist Literature.* Cambridge, New York, and Victoria, 1992.

Swenson 1963 Swenson, G. R. "What is Pop Art: Answers from Eight Painters, Part I." *Art News* 62 (1963), 26.

Talbot 1844 Talbot, Henry Fox. *The Pencil of Nature.* London, 1844; facsimile reprint, New York, 1969.

Talbot 1847 Talbot, Henry Fox. *English Etymologies.* London, 1847.

Taylor 1987 Taylor, Joshua C., ed. *Nineteenth-Century Theories of Art*. Berkeley, 1987.

Taylor 1988 Taylor, Susan L. "Fox Talbot as an Artist: The 'Patroclus' Series." *Bulletin: The University of Michigan Museums of Art and Archaeology* 8 (1986–88), 39–55.

Taylor 1995 Taylor, Paul. *Dutch Flower Painting 1600–1720*. New Haven and London, 1995.

Thompson 1987 Thompson, Richard. "Van Gogh in Paris: The Fortification Drawings of 1887." *Jong Holland* 3, no. 3 (September 1987), 14–25.

Time-Life 1970 Editors of Time-Life Books. *This Fabulous Century*. Vol. 6, 1950–1960. New York, 1970.

Tufts and De Luna 1985 Tufts, Eleanor, and Juan J. de Luna. *Luis Melendez: Spanish Still-life Painter of the Eighteenth Century*. Exhibition catalogue. Raleigh, North Carolina Museum of Art; Dallas, Meadows Museum; and New York, National Academy of Design, 1985.

Turner 1981 Turner, Frank M. *The Greek Heritage in Victorian Britain*. New Haven and London, 1981.

Van den Akker 1991 Akker, Paul van den. *Sporen van vaardigheid: De ontwerpmethode voor de figuurhouding in de Italiaanse tekenkunst van de renaissance*. Abcoude, 1991.

Van der Pijl-Ketel 1982 Pijl-Ketel, C. L. van der, ed. *The Ceramic Load of the Witte Leeuw*. Amsterdam, 1982.

Vandommele 1986–87 Vandommele, Herman. "Groenten en fruit in de Nederlanden in de zestiende eeuw." In *Joachim Beuckelaer: Het markt- en keukenstuk in de Nederlanden, 1550–1650*, pp. 71–77. Exhibition catalogue. Ghent, Museum voor Schone Kunsten, 1986–87.

Van Gogh 1991 Gogh, Vincent van. *The Complete Letters of Vincent van Gogh*. 3 vols. Boston, Toronto, and London, 1991.

Van Haaster 1992 Haaster, Henu van. "Phyto-archeologie en middeleeuwse tuincultuur." In *Tuinen in de middeleeuwen*, ed. René E. V. Stuip and Cornelis Vellekoop, pp. 103–13. Utrechtse Bijdragen tot de Mediëvistiek. Hilversum, 1992.

Van Haaster 1995 Haaster, Henu van. "Oecologisch onderzoek St. Janskerkhof." In *Kroniek van bouwhistorisch en archeologisch onderzoek 's Hertogenbosch*, ed. Hendrik Willem Boekwijt and Hans Leendert Janssen. Vol. 2, s'Hertogenbosch, Stichting Bouwhistorie en Archeologie, 1995 (forthcoming).

Van Tilborgh 1987 Tilborgh, Louis van. "Vincent van Gogh and English Social Realism: 'And the Truth is that there is more Drudgery than Rest in Life'." In *Hard Times: Social Realism in Victorian Art*, by Julian Treuherz, pp. 119–25. Exhibition catalogue. Manchester City Art Galleries, 1987.

Van Tilborgh 1988 Tilborgh, Louis van. "De Bijbel van Vincents vader." *Van Gogh Bulletin*. 3 (1988), n.p.

Van Uitert 1976 Uitert, Evert van. *Vincent van Gogh*. Amsterdam, 1976.

Van Winter 1982 Winter, Johanna Maria van. "Ernährung im spätmittelalterlichen Hanseraum." In *Aus dem Alltag der mittelalterlichen Stadt*, pp. 175–80. Hefte des Fockemuseums, 62. Bremen, 1982.

Van Winter 1986–87 Winter, Johanna Maria van. "Voedselverbruik in de Nederlanden in de vijftiende en zestiende eeuw." In *Joachim Beuckelaer: Het markt- en keukenstuk in de Nederlanden, 1550–1650*, pp. 63–65. Exhibition catalogue. Ghent, Museum voor Schone Kunsten, 1986–87.

Vatter 1963 Vatter, Harold G. *The U.S. Economy in the 1950s*. New York, 1963.

Vermeeren 1990 Vermeeren, Caroline. "Botanisch onderzoek van middeleeuwse beerputten uit Kampen." In *Verscholen in vuil: Archeologische vondsten uit Kampen, 1375–1925*, ed. Hemmy Clevis and Mieke Smit, pp. 139–59. Kampen, 1990.

Vorenkamp 1933 Vorenkamp, Alphonsus Petrus Antonius. *Bijdrage tot de geschiedenis van het Hollandsche stilleven in de XVII eeuw*. Leiden, 1933.

Vroom 1945 Vroom, N.R.A. *De schilders van het monochrome banketje*. Amsterdam, 1945.

Vroom 1980 Vroom, N.R.A. *A Modest Message as Intimated by the Painters of the "Monochrome Banketje."* 2 vols. Schiedam, 1980.

Warner 1928 Warner, Ralph. *Dutch and Flemish Flower and Fruit Painters of the XVIIth and XVIIIth Centuries*. London, 1928.

Washington 1989–90 *American Paintings from the Manoogian Collection*. Exhibition catalogue. Washington, National Gallery of Art; and three other museums, 1989–90.

Watson 1979 Watson, Donald Gwynn. "Erasmus' *Praise of Folly* and the Spirit of Carnival." *Renaissance Quarterly* 32 (1979), 333–53.

Weaver 1986 Weaver, Mike. "A Photographic Artist: W.H.F. Talbot." In *The Photographic Art: Pictorial Traditions in Britain and America*, pp. 10–15. New York, 1986.

Weaver 1989 Weaver, Mike. "Henry Fox Talbot: Conversation Pieces." In *British Photography in the Nineteenth Century: The Fine Art Tradition*, ed. Mike Weaver, pp. 11–23. Cambridge and New York, 1989.

Weber 1989 Weber, Gregor J. M. *Stilleben alter Meister in der Kasseler Gemäldegalerie*. Kassel [1989].

Welsh-Ovcharov 1974 Welsh-Ovcharov, Bogomila. *Van Gogh in Perspective*. Englewood Cliffs, N.J., 1974.

Werness 1980 Werness, Hope B. "Some Observations on Van Gogh and the *Vanitas* Tradition." *Studies in Iconography* 6 (1980), 123–36.

Wilmerding 1983 Wilmerding, John. *Important Information Inside: The Art of John F. Peto and the Idea of Still-Life Painting in Nineteenth-Century America*. Exhibition catalogue. Washington, National Gallery of Art, 1983.

Wilmerding, Powell, and Ayres 1981 Wilmerding, John, Earl A. Powell, and

130

Linda Ayres. *An American Perspective: Nineteenth-Century Art from the Collection of Jo Ann and Julian Ganz, Jr.* Exhibition catalogue. Washington, National Gallery of Art, 1981.

Wittkower 1965 Wittkower, Rudolf. *Art and Architecture in Italy, 1600 to 1750.* The Pelican History of Art. 2d rev. ed., Baltimore, 1965.

Woodstock 1991 *The Surrogate Figure: Intercepted Identities in Contemporary Photography.* Exhibition catalogue. Woodstock, N.Y., Center for Photography, 1991.

Wuyts 1986–87 Wuyts, Leo. "Joachim Beuckelaers Groentemarkt van 1567. Een iconologische bijdrage." In *Joachim Beuckelaer: Het markt- en keukenstuk in de Nederlanden, 1550–1650,* pp. 27–38. Exhibition catalogue. Ghent, Museum voor Schone Kunsten, 1986–87.

Ydema 1991 Ydema, Onno. *Carpets and Their Datings in Netherlandish Paintings, 1540–1700.* Zutphen, 1991.

Index

Abbe, James T., 76n.15
Abstract Expressionism, 99, 102
advertising, 107, 113
Aertsen, Pieter, 4, 7, 13–27; in Amsterdam, 15; in Antwerp, 15
—WORKS: *Kitchen Maid* (Musées Royaux des Beaux-Arts, Brussels), 26n.20, 27n.44; *Kitchen Scene* (Museum Mayer van den Bergh, Antwerp), pp. 19–20, fig. 10; *Landscape with Christ Carrying the Cross* (formerly Kaiser Friedrich Museum, Berlin), 18, 20, figs. 8, 9; *Market Scene with Christ and the Adulterous Woman* (Nationalmuseum, Stockholm), 26nn.20, 21; *Market Scene with Vegetables and Fruit* (Gemäldegalerie, Staatliche Museen Preussischer Kulturbesitz, Berlin-Dahlem), 13, 17, 20, 21, fig. 1, pl. I; *Meat Stall* (Universitets Konstsamling, Uppsala), 13, 27n.44, fig. 3; *The Praise of Pancakes* (Museum Boymans-van Beuningen, Rotterdam), 25, fig. 15; *Preparation for the Market* [*The Praise of Crops*] (Museum Boymans-van Beuningen, Rotterdam), 17, 21–22, 25, fig. 6; *Vegetable and Fruit Market* (Hallwylska Museum, Stockholm), 17, 20, fig. 7
Alberti, Leon Battista, 20–22, 26n.30
Alciati, Andrea, 84, 94n.1, fig. 58
almonds, 14, 17, 36, 39n.40
Amstel, Jan van, 18
ancestry, 42, 44–50, 53, 54
Anderson, Hans Christian, 91
anthropology, 46, 47
Antinous, 46–47, 57nn.19, 20; and Hadrian, 46; and Homer, 46
aphrodisiacs, 19, 20, 23, 26n.25
apple, 5–6, 14, 15, 17, 18, 26n.25, 36, 88, 105–6, 110, 112, fig. 86
apricot, 14

Archer, S. W., fig. 79
artichoke, 14
artifice, 17, 32, 62
Atlas, 36

Bacchus, 48, 49
Bakhtin, Mikhail, 9, 11n.14, 24
Baudelaire, Charles, 43–44, 92
Bayard, Hippolyte, 41, 44–48, 49, 53, 54; as collector, 45; life of, 44–45; working process of, 45, 47; figs. 25–28, 32
beans, 14, 15, 16, 18
Beaumont, E. de, 94n.9, fig. 60
beet, 14, 16, 27n.39
beholder, participation of, 3, 5, 10, 13, 14, 23–24, 25, 29, 33, 34–35
Bergström, Ingvar, 9, 11–12n.16
Beuckelaer, Joachim, 16–17, 18, 19, 20
—WORKS: *Fish Market* (Musée des Beaux-Arts, Strasbourg), 20, fig. 12; *Market Scene* (Rockoxhuis, Antwerp), 20, fig. 11; *Market Scene with Ecce Homo* (Uffizi, Florence), 20, fig. 13; *Market Scene with Vegetables and Fruit* (Gemäldegalerie der Staatlichen Kunstsammlungen, Kassel), 17, fig. 4; *Market Scene with Vegetables and Fruit* (Museum voor Schone Kunsten, Ghent), 17, fig. 5
Bible, 19, 34, 83, 87–88, 95nn.17, 18
bilberry, 16
birds' nests, 89–90, 96n.28
blackberry, 14
Bles, Herri met de, 18
Bonaparte, Napoleon, 91
book illustration, 5, 85–86, 89, 93, 94n.9. See also emblem; tailpiece; headpiece
Bosschaert, Ambrosius, 8, 9
bramble, 16, 17
brand names, 100–102, 104–12
Braudel, Fernand, 8, 11n.14

133

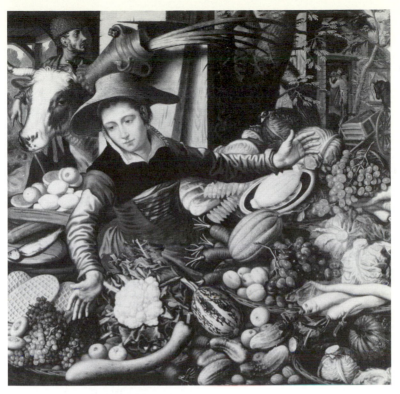

1. Pieter Aertsen,
*Market Scene with
Vegetables and Fruit*,
1567, oil on panel

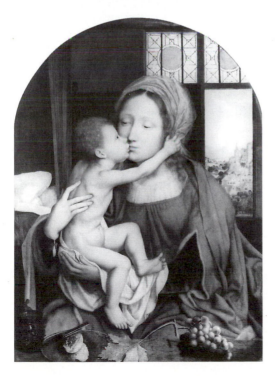

2. Quinten Massys,
Madonna and Child,
1529, oil on panel

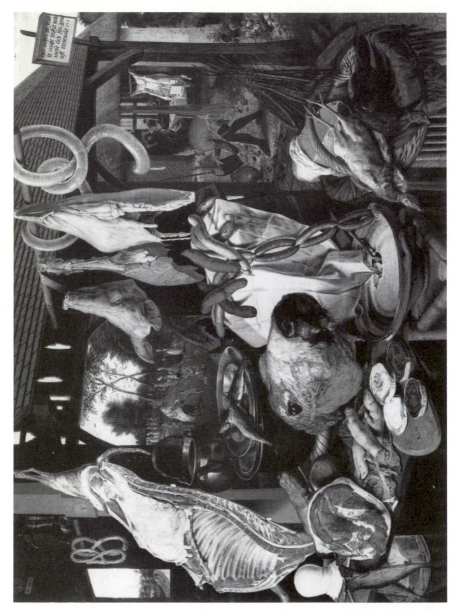

3. Pieter Aertsen, *Meat Stall*, 1551, oil on panel

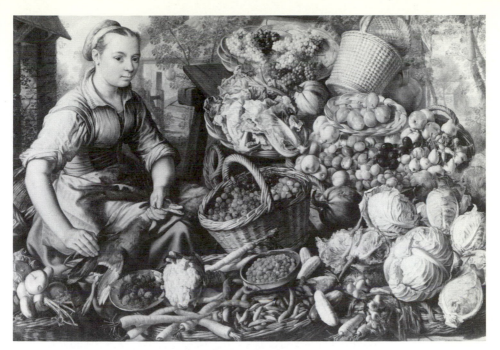

4. Joachim Beuckelaer, *Market Scene with Vegetables and Fruit*, 1564, oil on panel

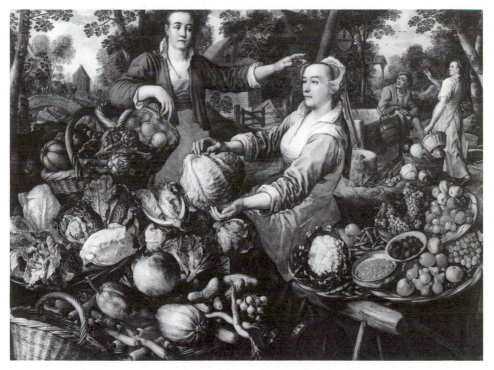

5. Joachim Beuckelaer, *Market Scene with Vegetables and Fruit*, 1569, oil on canvas

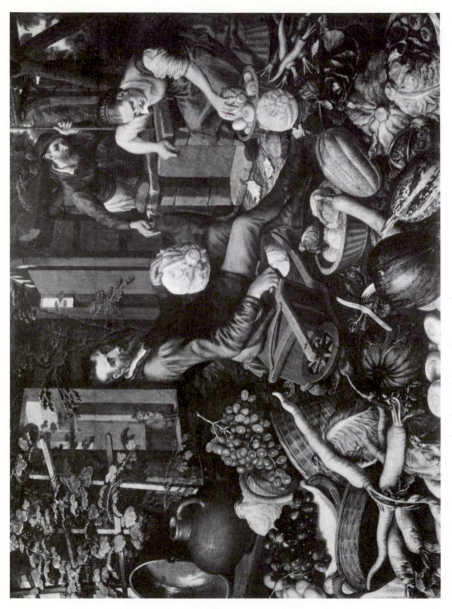

6. Pieter Aertsen, *Preparation for the Market*, oil on panel

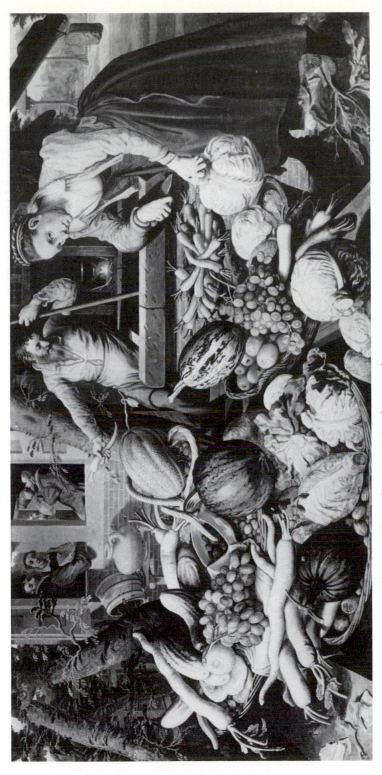

7. Pieter Aertsen, *Market Scene with Vegetables and Fruit*, 1569, oil on panel

8. Pieter Aertsen, *Landscape with Christ Carrying the Cross*, 1552, oil on panel

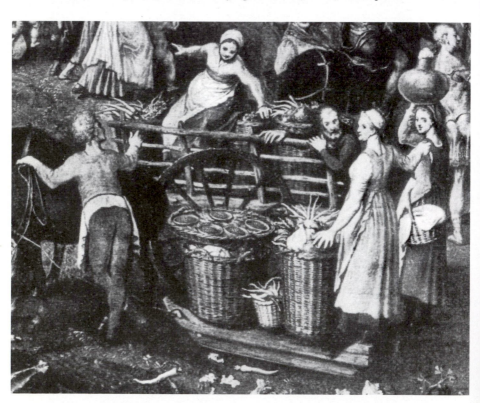

9. Pieter Aertsen, *Landscape with Christ Carrying the Cross* (figure 8), detail

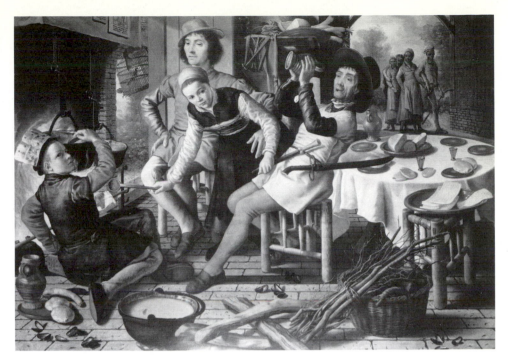

10. Pieter Aertsen, *Kitchen Scene*, 1556, oil on panel

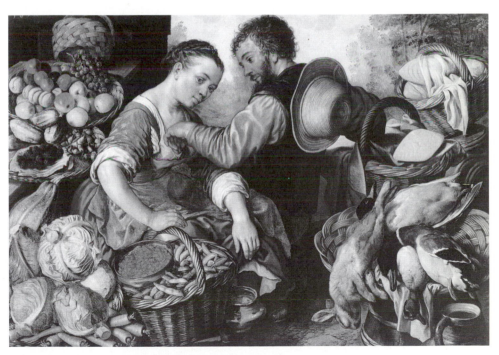

11. Joachim Beuckelaer, *Market Scene*, 1567, oil on canvas

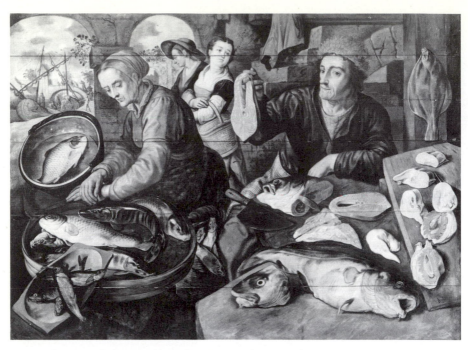

12. Joachim Beuckelaer, *Fish Market*, 1568, oil on panel

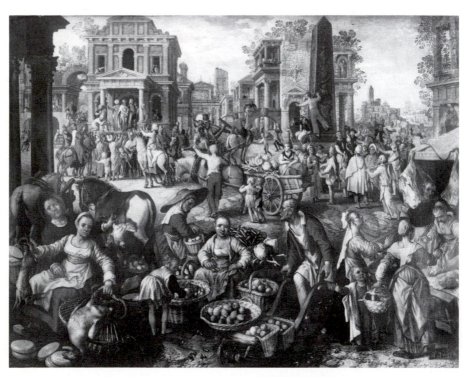

13. Joachim Beuckelaer, *Market Scene with Ecce Homo*, 1566, oil on panel

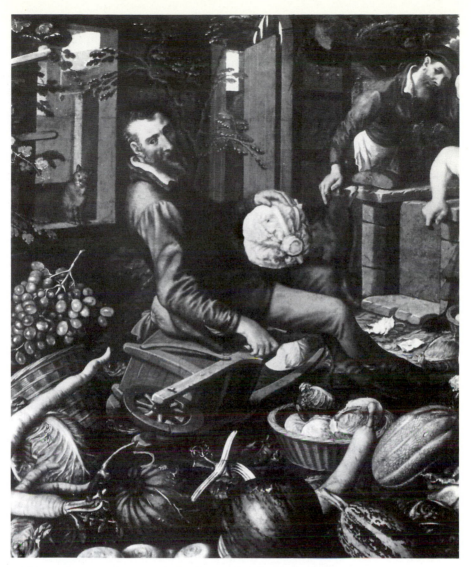

14. Pieter Aertsen, *Preparation for the Market* (figure 6), detail

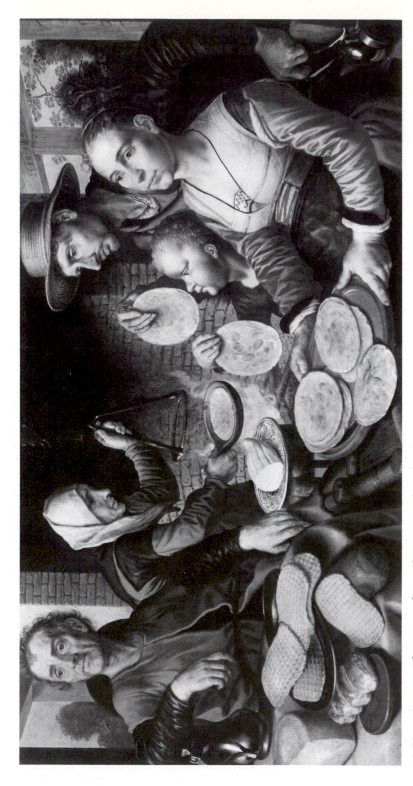

15. Pieter Aertsen, *The Praise of Pancakes*, 1560, oil on panel

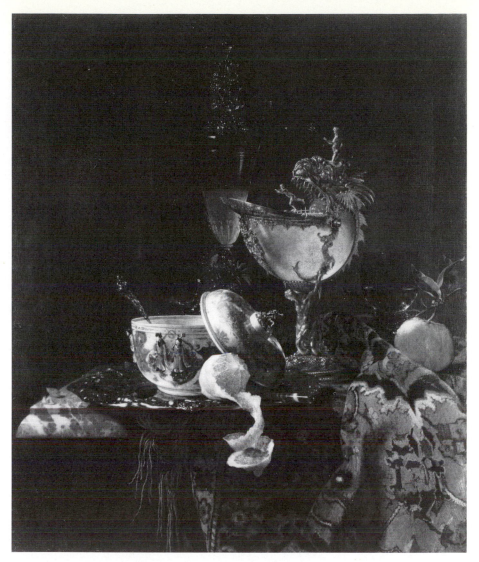

16. Willem Kalf, *Still Life with a Nautilus Cup*, 1662, oil on canvas

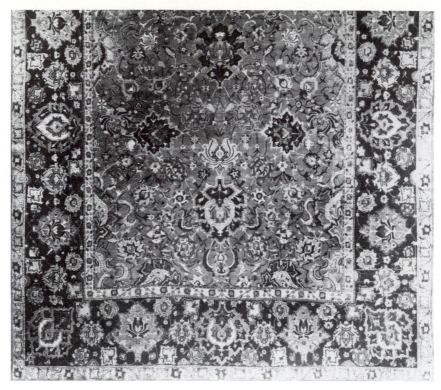

17. Herat carpet, seventeenth century, detail

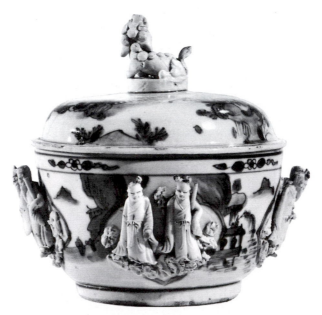

18. Bowl with lid, Chinese, seventeenth century, porcelain
decorated in underglaze blue

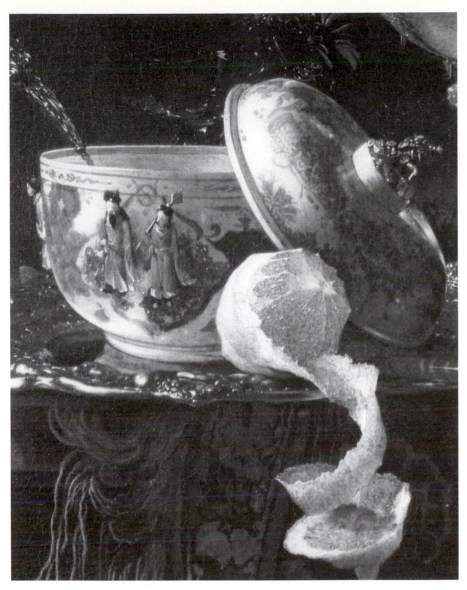

19. Willem Kalf, *Still Life with a Nautilus Cup* (figure 16), detail

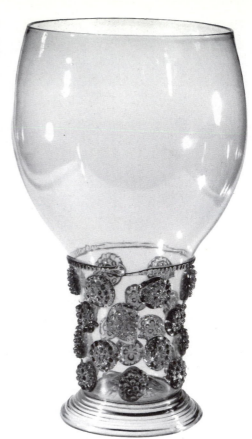

20. Roemer, Dutch or German, about 1650-60, clear green glass

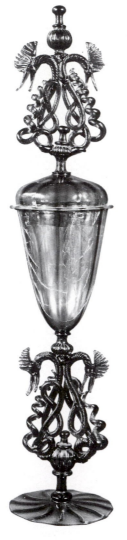

21. Covered goblet, Northern European of Venetian make, seventeenth century, translucent ribbed blue-green glass in the façon de Venise

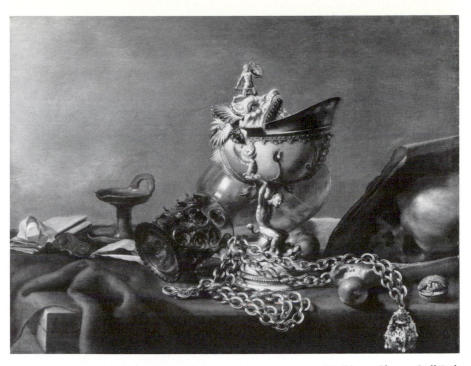

22. Pieter Claesz, *Still Life with a Nautilus Cup*, 1636, oil on panel

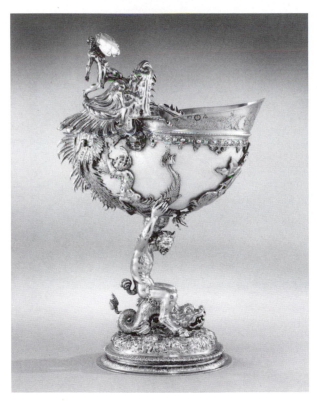

23. Jan Jacobsz. van Royesteyn, nautilus cup, 1596, silver-gilt and nautilus shell

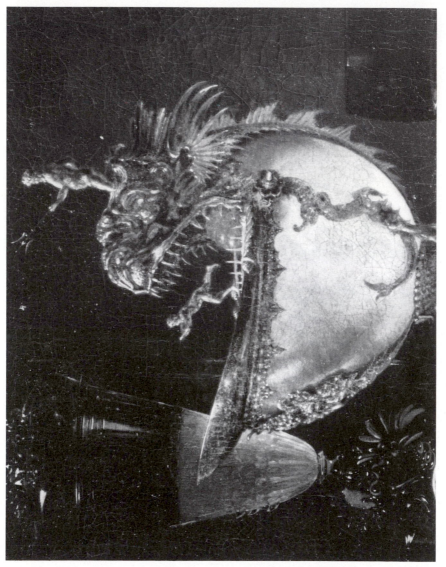

24. Willem Kalf, *Still Life with a Nautilus Cup* (figure 16), detail

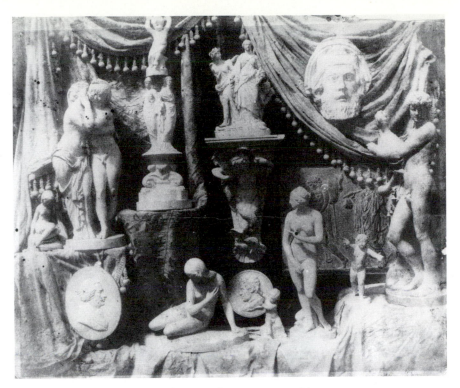

25. Hippolyte Bayard, untitled, 1840, direct paper positive

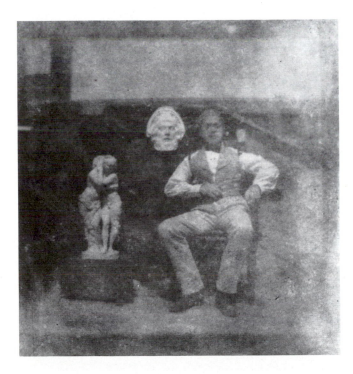

26. Hippolyte
Bayard, untitled,
about 1840, direct
paper positive

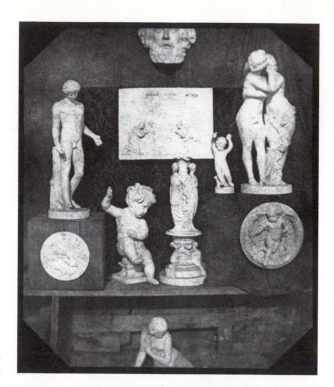

27. Hippolyte Bayard,
untitled, about 1840,
paper negative

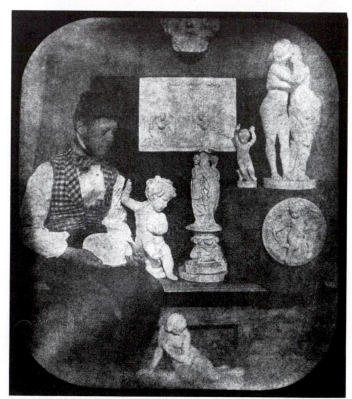

28. Hippolyte
Bayard, untitled,
about 1840,
paper negative

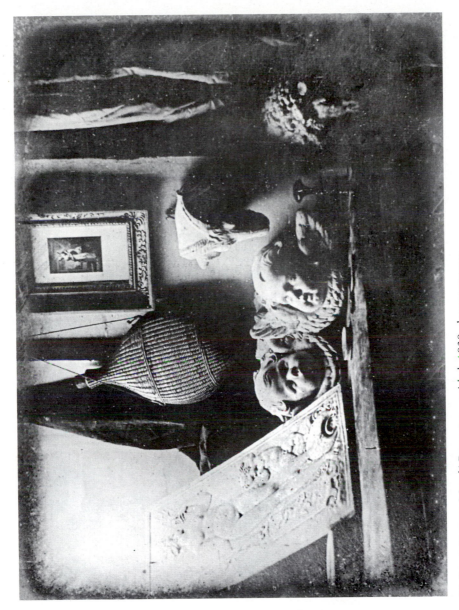

29. Louis Jacques Mandé Daguerre, untitled, 1839, daguerreotype

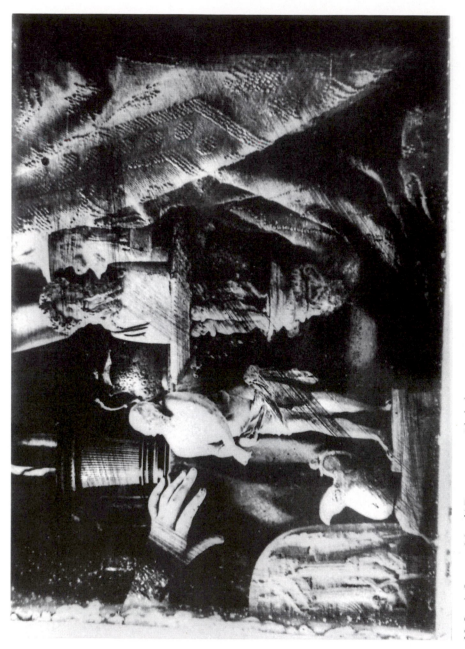

30. Louis Jacques Mandé Daguerre, untitled, daguerreotype

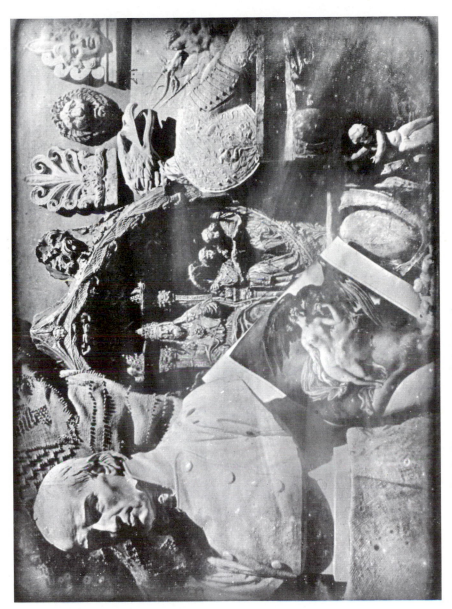

31. Anonymous, possibly by Daguerre, untitled, 1837, daguerreotype

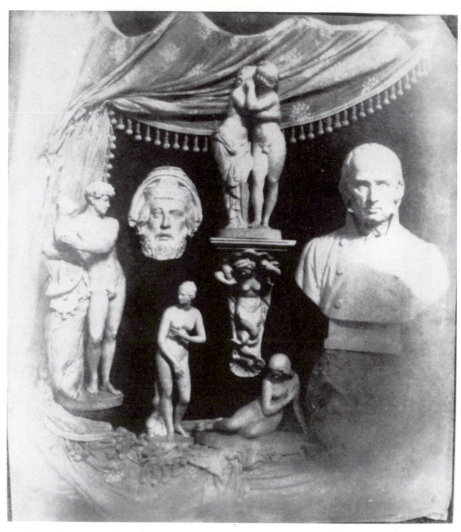

32. Hippolyte Bayard, untitled, about 1839, direct paper positive

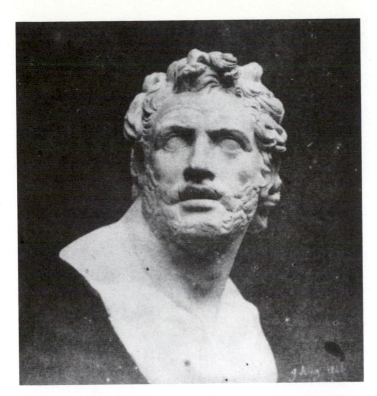

33. William Henry
Fox Talbot, *Bust
of Patroclus*, 1840,
salted paper print
from a paper
negative. Plate 5 of
The Pencil of Nature

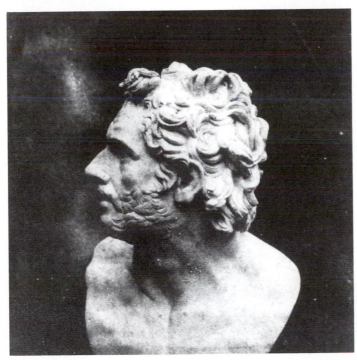

34. William Henry
Fox Talbot, *Bust
of Patroclus*, 1840,
salted paper print
from a paper
negative. Plate 17
of *The Pencil of
Nature*

35. William Henry Fox Talbot, *Articles of Glass*, salted paper print from a paper negative. Plate 4 of *The Pencil of Nature*

36. Susan Wides, *You'll be history*, 1990, chromogenic color print

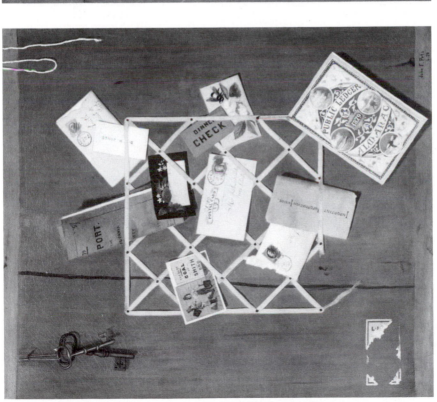

37. John F. Peto, *Office Board for Smith Bros. Coal Co.*, 1879, oil on canvas

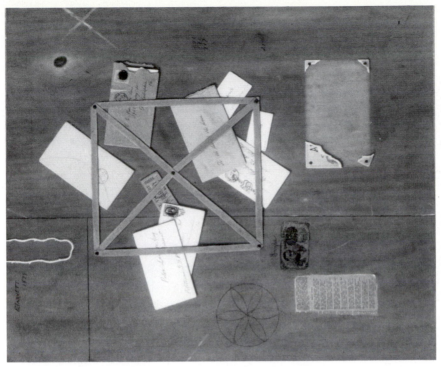

38. William M. Harnett, *The Artist's Letter Rack*, 1879, oil on canvas

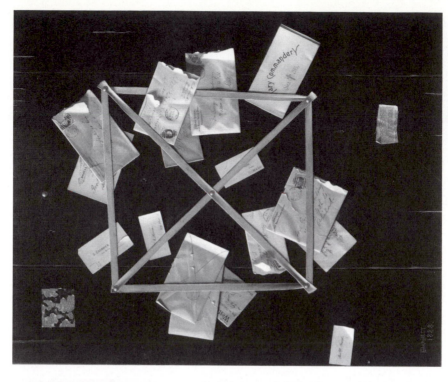

40. William M. Harnett, *Mr. Hulings' Rack Picture*, 1888, oil on canvas

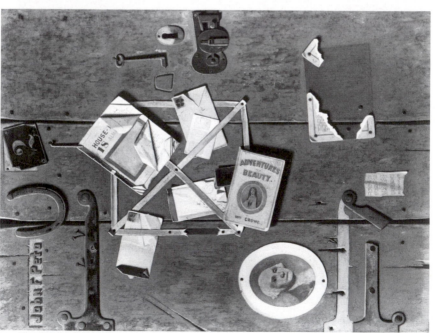

39. John F. Peto, *A Closet Door*, 1904-6, oil on canvas

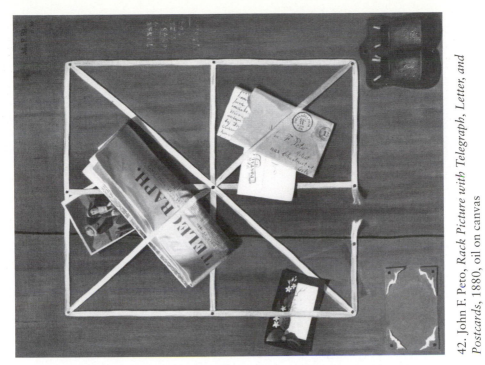

42. John F. Peto, *Rack Picture with Telegraph, Letter, and Postcards*, 1880, oil on canvas

41. John F. Peto, *The Ocean County Democrat*, 1889 (?), oil on canvas

44. Masonic apron worn by William S. Bright, M.D., in 1855

43. John F. Peto, *Office Board for Christian Faser*, 1881, oil on canvas

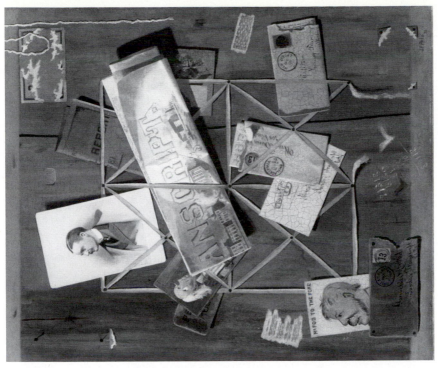

46. John F. Peto, *Rack Picture for William Malcolm Bunn*, 1882, oil on canvas

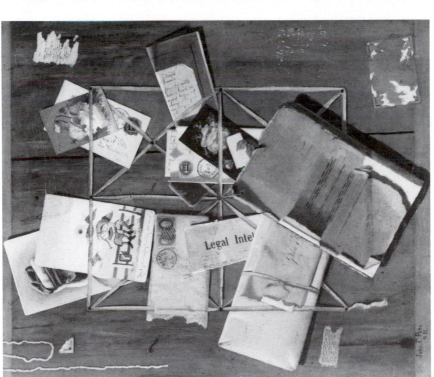

45. John F. Peto, *The Rack*, 1882, oil on canvas

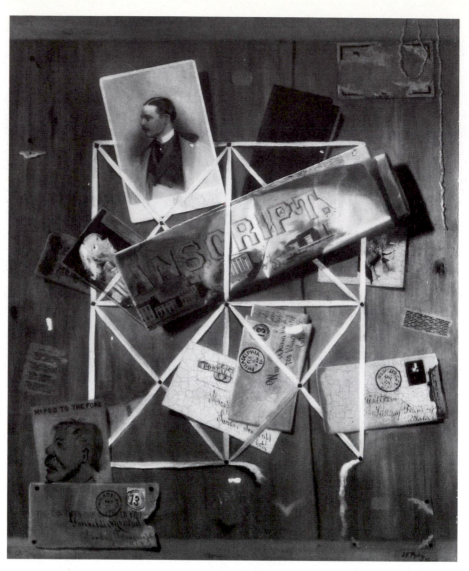

47. Infrared photograph of Peto, *Rack Picture for William Malcolm Bunn* (figure 46)

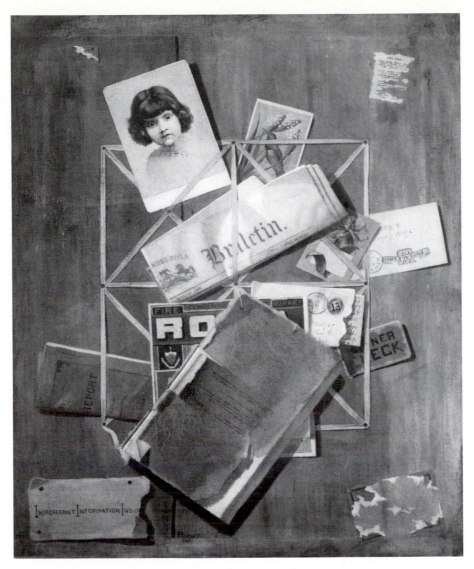

48. John F. Peto, *Old Souvenirs*, about 1881-1900, oil on canvas

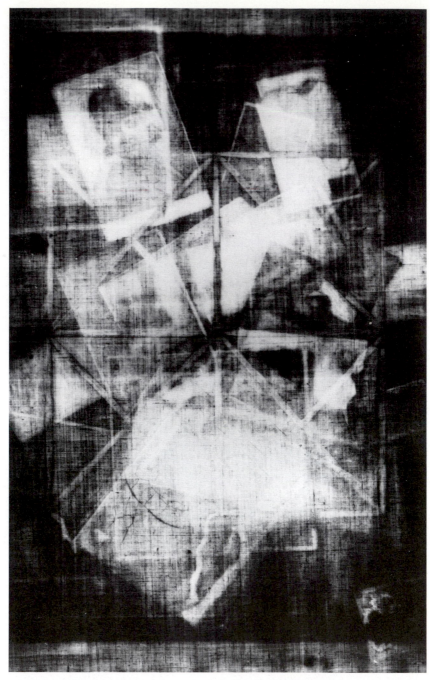

49. X-radiographs of Peto, *Old Souvenirs* (figure 48)

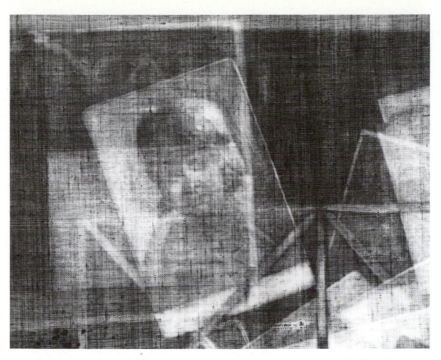

50. X-radiograph of
Peto, *Old Souvenirs*
(upper center; figure 48)

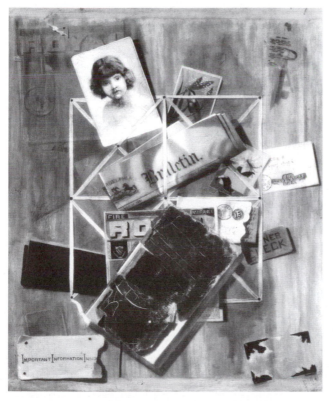

51. Infrared photograph
of Peto, *Old Souvenirs*
(figure 48)

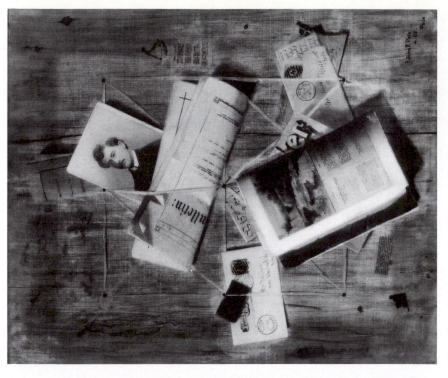

53. Infrared photograph of Peto, *Office Board* (figure 52)

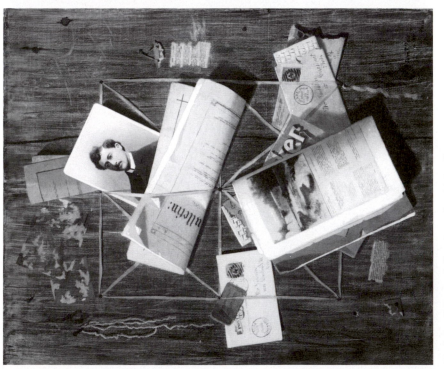

52. John F. Peto, *Office Board*, 1885, oil on canvas

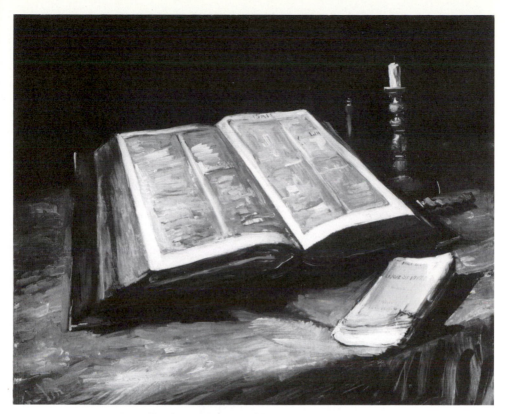

54. Vincent van Gogh, *Still Life with Open Bible, Candle, and Book*, Nuenen, 1885, oil on canvas

55. Hadrianus Junius (Adriaen de Jonge), *Vita mortalium vigilia*, emblem from *Medici Emblemata* (Antwerp, 1555)

56. Mathias Holtzwart, *Qui liber vivit, optimae vivit*, emblem from *Emblematum Tyrocinia* (Strasbourg, 1581)

57. E. Froment, *en-tête* in Victor Hugo, *Le Livre des mères. Les enfants* (Paris, 1861)

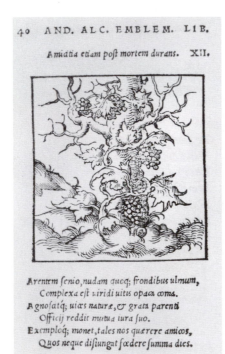

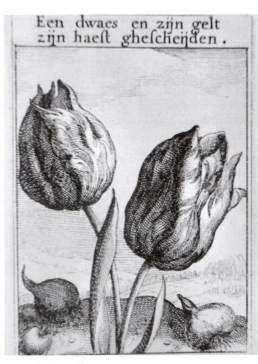

58. Andrea Alciati, *Amicitia etiam post mortem durans*, emblem from *Emblematum Libellus* (Paris, 1536)

59. Roemer Visscher, *Een dwaes en zijn gelt zijn haest gescheijden*, emblem from *Sinnepoppen* (Amsterdam, 1614)

60. E. de Beaumont,
cul-de-lampe in Victor
Hugo, *Notre Dame
de Paris* (Paris, 1844)

61. Gustave Brion,
text illustration in
Victor Hugo, *Notre
Dame de Paris*
(Paris, 1844)

62. F. A. de Lemud,
en-tête in Victor
Hugo, *Notre
Dame de Paris*
(Paris, 1844)

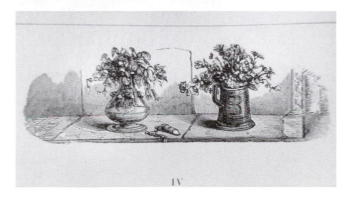

63. Vincent van Gogh, *Still Life with Three Books*, Paris, 1887, oil on panel

64. Anonymous, *cul-de-lampe* in Victor Hugo, *Notre Dame de Paris* (Paris, 1844)

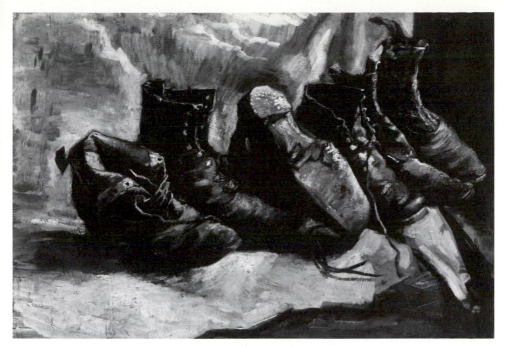

65. Vincent van Gogh, *Three Pairs of Shoes*, Paris, 1886-87, oil on canvas

66. Félicien de Myrbach-Rheinfeld,
en-tête in Alphonse Daudet,
Sapho (Paris, 1887)

67. Jean-François Millet,
Wooden Shoes, pencil
drawing reproduced in Alfred
Sensier, *La Vie et l'oeuvre de
J.-F. Millet* (Paris, 1881)

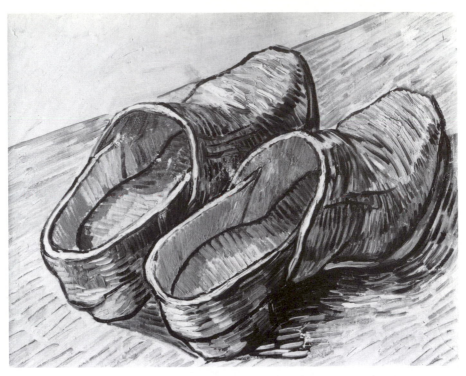

68. Vincent van Gogh, *A Pair of Wooden Shoes*, Arles, 1888, oil on canvas

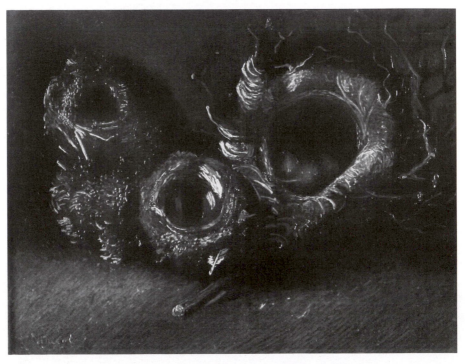

69. Vincent van Gogh, *Three Birds' Nests*, Nuenen, 1885, oil on canvas

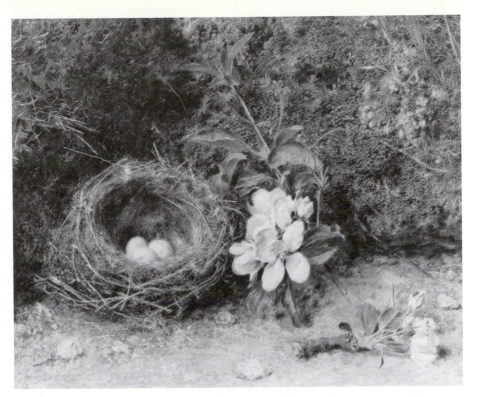

70. William Henry Hunt, *Bird's Nest with Sprays of Apple Blossom*, watercolor

71. Hector Giacomelli, vignette in Jules Michelet, *L'Oiseau* (Paris, 1867)

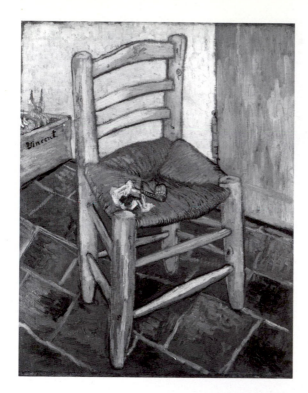

72. Vincent van Gogh,
Vincent's Chair, Arles,
1888, oil on canvas

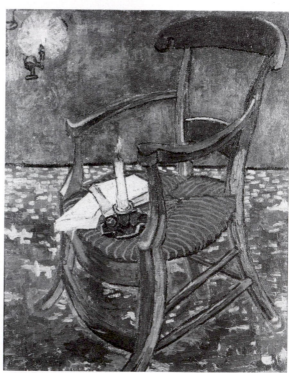

73. Vincent van Gogh,
Gauguin's Chair, Arles,
1888, oil on canvas

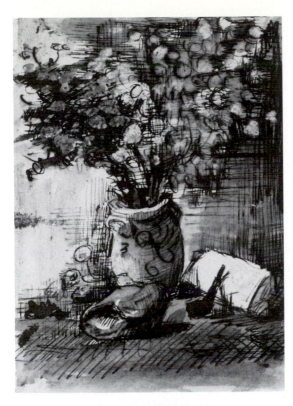

74. Vincent van Gogh,
Still Life with Satin Flowers,
Nuenen, 1885, pen drawing
in letter 398

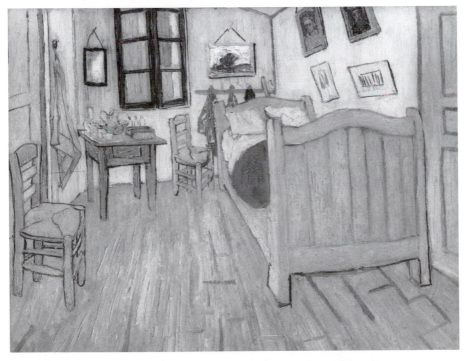

75. Vincent van Gogh, *The Artist's Bedroom in Arles*, Arles, 1888, oil on canvas

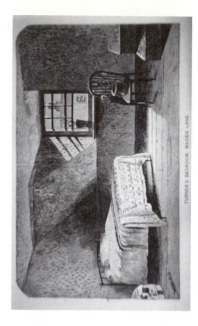

77. Goethe's bedroom in Weimar, postcard, about 1920

79. S. W. Archer, *Turner's Bedroom, Maiden Lane,* vignette in Walter Thornbury, *The Life of J.M.W. Turner, R. A.* (New York, 1877)

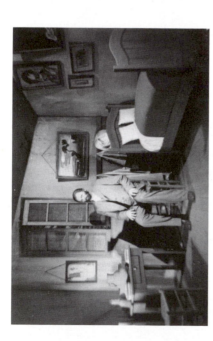

76. Van Gogh diorama, Palace of Living Art, Movieland Wax Museum, Buena Park, California

78. S. Luke Fildes, *The Empty Chair, Gad's Hill—Ninth of June 1870,* wood engraving

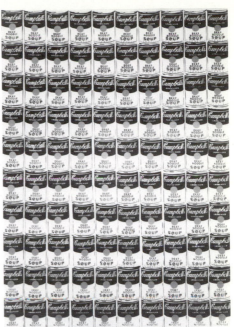

80. Jasper Johns, *Painted Bronze*, 1960, painted bronze

81. Andy Warhol, *100 Cans*, 1962, oil on canvas

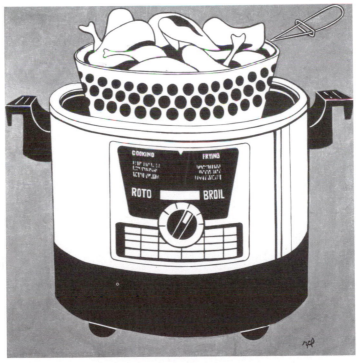

82. Roy Lichtenstein, *RotoBroil*, 1961, oil on canvas

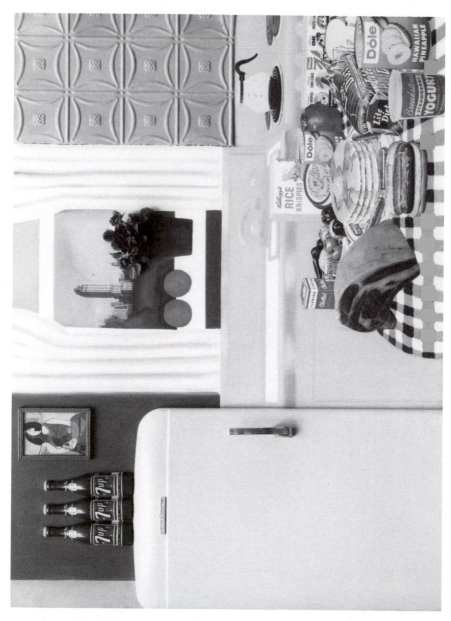

83. Tom Wesselmann, *Still Life #30*, 1963, oil and mixed media on board

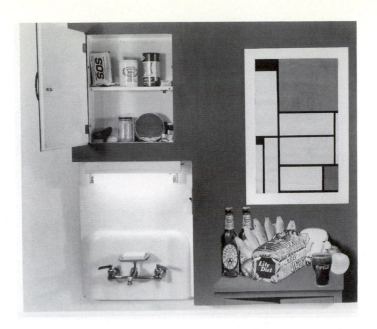

84. Tom Wesselmann, *Still Life #20*, 1962, mixed media on board

FIG. 2-1. Quality and identification of apples are made by outside and inside character-istics. The top apple shown here is a Winesap. It is a medium-sized apple, red-streaked with darker stripes and a crisp, white flesh. Note slight lobing. The middle apple is a Roman Beauty, large in size, red-flecked with white spots. The flesh is clear, white and fine grained. The Newtown Pippin on the bottom is also called Yellow Newtown. It can be identified by its yellow exterior, with red blush at the base, and its yellowish flesh. Courtesy National Apple Institute.

85. "Push a Button, Get a Meal," illustration of General Electric kitchen appliance, 1962

86. Quality and Identification of Apples, figure 2-1 in Lendal H. Kotschevar, *Quantity Food Purchasing*

87. Andy Warhol, *Tunafish Disaster*, detail, 1963, silkscreen ink on synthetic polymer paint on canvas